Floyd Norman

Animated Life

A Lifetime of Tips, Tricks, and Stories from a Disney Legend

Routledge
Taylor & Francis Group

Routledge
Taylor & Francis Group

LONDON AND NEW YORK

First published 2013
by Focal Press

2 Park Square, Milton Park, Abingdon, Oxon OX14 4RN
711 Third Avenue, New York, NY 10017, USA

First issued in hardback 2017

*Routledge is an imprint of the Taylor & Francis Group, an
informa business*

Library of Congress Cataloging in Publication Data
Norman, Floyd.
Animated life : a lifetime of tips, tricks, and stories from a
Disney legend / Floyd Norman.
pages cm
1. Norman, Floyd. 2. Animated films—United States—History
and criticism. 3. Disney, Walt, 1901-1966—Criticism and
interpretation. I. Title.
NC1766.U52N65 2012
791.43'34092–dc23
[B]
2012006056
ISBN 13: 978-0-240-81805-4 (pbk)
ISBN 13: 978-1-138-42846-1 (hbk)

Acknowledgements

There are far too many talented artists who have generously given their time and knowledge to list them all on this page. However, I would like to thank my wonderful mentors who guided my storytelling efforts. Many thanks to Disney writers Don Ferguson, Vance Gerry, and the "Two Joes," Grant and Ranft.

Thanks to Jim Hill for shaking me out of my retirement slumber and encouraging me to start writing this stuff down. Thanks also to Disney story veteran Carl Fallberg for our chats in downtown Pasadena and for reminding me that what we lived at Disney in years past is well worth sharing today.

Thanks to Ken Shue, Bent Ford, and the tireless team at Disney Publishing for providing a home for this Disney veteran who absolutely refused to retire.

Finally, thanks to my editorial director, Katy Spencer, for believing I actually had a book worth publishing. And thanks to my tireless technical editor, Tom Sito, for keeping me on the mark as I made my trip down the animation highway. I'll wrap this up with a big thank you for my lunchtime pals and colleagues who meet at Lancer's Restaurant in Burbank every Friday. Great friendship trumps great food any day.

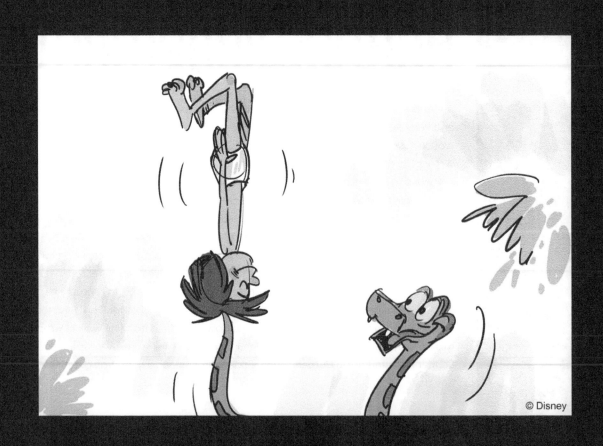

Acknowledgments iii

Introduction ix

Contents

PART 1	INSIDE THE MAGIC FACTORY	3
Chapter 1	Wonderland	5
Chapter 2	The Disney Bullpen	13
Chapter 3	The Assistant Animator	23
Chapter 4	The Workers' Paradise	31
Chapter 5	Disney's Night School	37
Chapter 6	Something About Mary Poppins	43
Chapter 7	Taking My Best Shot	51
Chapter 8	*The Jungle Book*	57
Chapter 9	Your Host, Walt Disney	71
Chapter 10	Spotted Puppies and a Bold New Direction	77
Chapter 11	Transition	83
Chapter 12	Roy's Camera	87

Chapter 13 Perfect Partnership 91

Chapter 14 The Other Floyd 97

Chapter 15 Monster in the Bell Tower 105

Chapter 16 Digital Dinosaurs 113

Chapter 17 Playing with Toys 119

Chapter 18 Monster's Brawl 141

Chapter 19 Elephant in the Room 149

Chapter 20 Inside Man 157

Chapter 21 Life After Disney 161

PART 2 TIPS, TECHNIQUES, AND ANIMATED OBSERVATIONS 167

Chapter 22 Attending Your Own Film School 169

Chapter 23 The Vance Advantage 173

Chapter 24 A Mistaken Notion 177

Chapter 25 Stay Hungry 181

Chapter 26 Sacked 185

Chapter 27 The Crazy Young Kids 189

Chapter 28 Perfect Combination 193

Chapter 29 Endless Development 197

Chapter 30 Nothing to Lose 201

Chapter 31 The Wow Factor 205

Chapter 32 Telling Stories 209

Chapter 33 In Defense of Mavericks 215

Chapter 34 The Reluctant Partnership 221

Chapter 35 Working Without a Net 225

Chapter 36 Marketing Animation 229

Chapter 37 Racial Politics from a Cartoony Perspective 233

Chapter 38 Walt Disney, Steve Jobs, and What Might Have Been 239

Chapter 39 Infinity and Beyond 245

WORKBOOK PAGES 249

Index 269

Introduction

I fell head over heels in love with animation when I was a kid. However, books on the subject of animation remained few and far between, so I made do with Robert Field's *The Art of Walt Disney* (Macmillan, 1942) and Preston Blair's wonderful *How to Draw Animated Cartoons* (Walter Foster, 1994). When I finally became an animation professional, I spoke to a number of animation veterans about writing a book that would catalog their experiences and things they learned while working for Walt. Some expressed interest, but few ever did anything. Even in retirement, authoring a book seemed a daunting task, I suppose. The exceptions were Frank Thomas and Ollie Johnston. These two Disney veterans left us with several great books on their years at Disney.

After I "retired" some years later, I decided it was time that I put a few thoughts on paper. What was it like to work at the Walt Disney Studios in the 1950s, apprentice with the Nine Old Men, and even attend story meetings with the Old Maestro himself? There could be a few students and historians who might appreciate such insights on the Walt Disney Studios in the 1950s and 1960s.

This book is a collection of my animated memories and the things I learned while spending nearly 50 years in Walt's magic factory. From February 1956 to August 2000, I managed to survive the animation roller coaster and three

separate managements. Even better, I did all this while working with a host of talented writers, artists, entertainers, and craftsmen helping to create the Disney legacy.

If you've ever wondered what it was like to work on everything from *Sleeping Beauty* to *Toy Story 2*, take a moment to relive some Disney history from a guy who observed it all firsthand.

PART 1

INSIDE THE MAGIC FACTORY

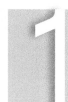

Wonderland

Inside the Real Magic Kingdom

Let's take a trip back in time, to a time when traffic was light on the freeways, Hollywood was clean and tidy, and only the locals knew the location of film studios. Today, the Walt Disney Studios presides over Burbank like the Colossus of Rhodes, but back then the nondescript campus on Alameda Avenue gave not a hint of the activity inside.

In February 1956, nine starry-eyed youngsters reported for work at 500 South Buena Vista Avenue, eager to begin their careers in the cartoon business. Having a great job was only part of the deal, because an added bonus was finally getting inside Walt Disney's magic factory. Unlike today, there were few, if any, books on animation, and only an insider knew what a cartoon studio even looked like. Studio tours were practically nonexistent, and few people ever breached the studio gates. For us, all that had suddenly changed: like Alice, we had entered Wonderland.

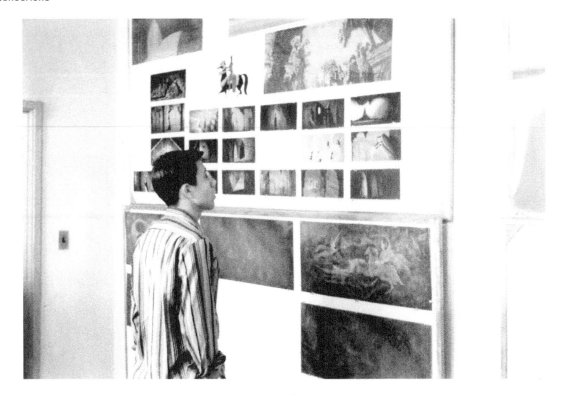

Most people, if they thought at all about how Disney cartoons are made, assumed that Uncle Walt was drawing it all himself. An animated feature comprises hundreds of thousands of drawings and paintings completed over several years. Most people probably don't give it a second thought. It's all magic. But for an aspiring animation cartoonist, getting a job at Walt Disney was like hitting the major leagues—the Rolls Royce of animation.

Now here we were walking down Dopey Drive and making a right at Mickey Avenue. We were shown our office on the first floor of the animation building. It was a large room with several desks and a view of the studio theater and recording stage. The room number was 1B-1, and it was to be our home for a month as we worked to prove ourselves worthy of a position—even a lowly position—at the Walt Disney Studios. An animated film was the result of an assembly line of artists with very specific job responsibilities. When they start, one artist creates concept designs and another creates the storyboards, which are like the planning of the entire film—many times created without a script and written as they went along. Still another artist did "layout" drawing, the staging of the area the character would be standing in. Someone was recording the soundtrack and "breaking down" the actors' words to single frames for the animator to draw to. Then came the animator, the clean-up crew, inbetweens and a quality control person called a checker. Then the drawings were Xeroxed, painted, and photographed on the painted background. Finally, an editor would take the film footage and cut it into the building work reel of the final movie. All these job classifications had levels of proficiency and years of experience. It was like joining a small army. Gee, I thought I left that stuff in Korea in 1958! Armed with pencil and paper, we sat about learning our animation craft, but break time meant a cup of coffee and a walk around the Walt Disney Studios campus.

Indeed, the Walt Disney Studios was more campus than movie lot. Unlike most tacky Hollywood studios, Disney had well-swept streets and trimmed hedges. Squirrels scampered about manicured lawns, park benches, and shady trees. It was a casual, relaxed atmosphere and one couldn't help but feel at home in this artist's paradise. But our first order of business was getting to know the Animation Building. This wonderful, three-story 1938 Art Deco facility was home to Walt's animation department. Having finally escaped the cramped quarters of the Hyperion bungalows in Silverlake, Disney's staff finally had a wonderful new workplace to call home. Ward Kimball called it "the first place I ever worked in where the furniture all matched!" Disney even secured the services of noted designer Kem Weber to custom-build chairs and furniture in the Arte Moderne style.

(TOP LEFT) STUDYING THE BACKGROUNDS Rick Gonzales studies the backgrounds of color stylist Eyvind Earle while working on *Sleeping Beauty*.

(BOTTOM LEFT) MOON ROCKET One of the many scale models in Ward Kimball's unit.

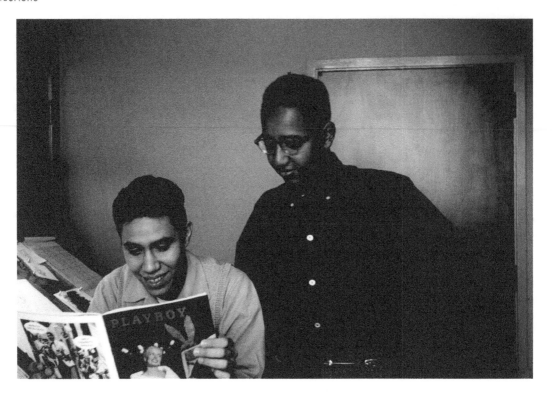

We began by touring the hallways of the first floor. Each studio wing had a small lobby with a directory and receptionist's desk. Once inside, we noticed that all but a few animation artists kept their office doors closed, so we felt comfortable entering and checking out the wonderful sketches on their drawing boards. We found the Effects department of C-Wing fascinating, as Disney's effects animators were busily creating wind, rain, and fire. Across the hall in D-Wing, we were advised to keep our voices down and make our visit short. We later learned that this wing was the domain of Disney's "Nine Old Men" and that visiting, though not discouraged, was not necessarily welcome.

As we moved down the hallway of the Animation Building, we noticed steps that led downstairs. Was there a basement floor, we wondered? So our little group decided to venture down into the catacombs of animation. What might be contained in this underground labyrinth? Was it the studio archives, Walt's bunker, or maybe an underground cartoonist or two?

Nope. This underground passageway provided a simple and practical way of moving the precious Disney art from animation to the Ink & Paint and Camera Buildings. Animation art could not be damaged by being exposed to the weather on a rainy California day. Later we would come to learn that these passageways provided another, less official function. Amorous young men and women would use these darkened hallways for many a midday rendezvous.

Emboldened by our tour of the Animation Building's first floor, we decided to explore the second floor of this creative complex. As you might expect, we were stunned by what we saw as we entered B-Wing right off the stairs. The hallway was filled with the beautiful background paintings of color stylist Eyvind Earle as he labored away on the new feature film *Sleeping Beauty*. It's difficult to explain how we felt that day as we stared slack-jawed at the most incredible artwork we had ever seen. One young artist in our group was so inspired that he made becoming a Disney background artist his lifetime goal—a goal, I'm happy to say, that he finally achieved.

Across the hallway in 2-A, the Ham Luske unit was hard at work developing new shows for the TV show *Disneyland*, and a short walk down the hallway took us to 2-D, the home of Ward Kimball's Space unit. Because of his fascination with space travel and extraterrestrial life, Walt Disney saw that Kimball was uniquely qualified to helm this unit, currently producing films that were more science fact than fiction. The hallway was filled with scale models of the moon rocket; futurist illustrator Chesley Bonstell–inspired space station, and the multistage rocket ship that would one day be realized as the Space Shuttle. Storyboards, graphs, and scientific schematics also filled the hallway. The unit had more of an appearance of a top government development facility than a cartoon studio, and even President Dwight Eisenhower requested a viewing of Kimball's films.

(TOP LEFT) ANIMATION RESEARCH
Every good artist should be knowledgeable when it comes to anatomy. Rick and Floyd take their studies seriously.

(BOTTOM LEFT) TAKING A BREAK
Gus Depace, Jim Fletcher, and Gordon Bellamy take a morning break outside the Animation Building.

Venturing into the inner offices of Kimball's unit revealed animator and gagmen Charlie Downs and John Dunn working on a funny sequence in an upcoming film. In another room, master layout artists Ken O'Connor and Tom Yakutis sat at their desks working out a complex scene involving a spaceship orbiting the earth, while background artist Bill Layne painted the Martian landscape. Across the hall, strange Martian creatures were being created by development artist Con Pederson, who would one day work for Stanley Kubrick on *2001: A Space Odyssey*. There was one large office we thought it best not to enter. The slide trombone sitting on the desk was a pretty good indication this was the office of the boss, Ward Kimball. The directing animator was well known for fronting his own Dixieland band, the Firehouse Five plus Two.

A walk down the second-floor hallway took us past 2-C and Jack Kinney's unit, where the Goofy shorts were still being produced. In 2-F, director Bill Justice was still doing Donald Duck cartoons, and directly across the hall, Supervising Director Gerry Geronimi was riding herd on Disney's upcoming animated feature, *Sleeping Beauty*. The last wing at the north end of the building was 2-G. This was the office of animator and director Les Clark, who was hard at work on a featurette on the life of Paul Bunyan. Clark shared the wing with C. August (Nick) Nichols, a former animator now directing the *Mickey Mouse Club* with Donald O'Connor's partner, Sidney Miller.

As we made our way down the hallway, we saw a rather odd-looking old gent sporting a vest and a pork-pie hat. He spoke to us and continued on his way. One guy in our group remarked that the man looked like a walking cartoon character. He wasn't far from the truth: the old gentleman was Cliff Edwards, the voice of Jiminy Cricket. A large room at the end of the hallway revealed a group of artists working on television commercials. This was the 1950s, and color television was still a dream of the future, so the commercials were being painted in black and white, or, more accurately, in shades of gray. Since 1954, Walt had insisted that his TV show *Disneyland* be filmed in full color, because he said someday they'll be watching it that way. But commercials were seen as ephemeral as today's newspaper, so black and white would suffice. A commercial director would occasionally hold up to his eye a little lens he wore on a string around his neck. This lens reduced color artwork to black and white values. He did so to check that the values wouldn't wash out when broadcast. If working in colors, some hues like tan-ochre or fuchsia would just turn white on black and white film. Likewise, violet and ultramarine blue would just turn black.

It had been quite a tour, and our little group wondered whether we should press our luck and take a peek at the third floor of the Animation Building. The third floor was the domain of Disney's top story men, as well as the stomping grounds of Walt Disney himself. What would the Old Maestro think, should he catch us loitering in the hallway? Considering our lowly status as unproven apprentice inbetweeners, we agreed that discretion was the better part of valor and that this might be a tour reserved for a later day.

© Disney

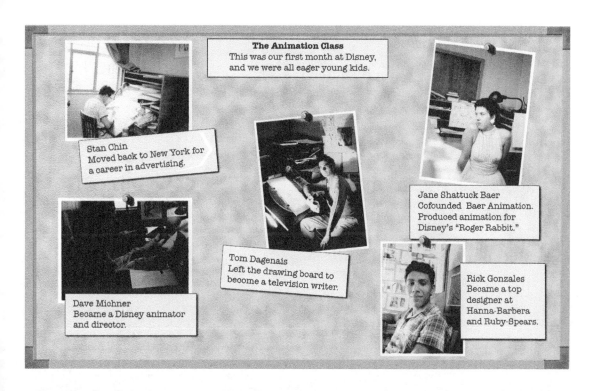

The Animation Class
This was our first month at Disney,
and we were all eager young kids.

Stan Chin
Moved back to New York for
a career in advertising.

Jane Shattuck Baer
Cofounded Baer Animation.
Produced animation for
Disney's "Roger Rabbit."

Tom Dagenais
Left the drawing board to
become a television writer.

Dave Michner
Became a Disney animator
and director.

Rick Gonzales
Became a top
designer at
Hanna-Barbera
and Ruby-Spears.

The Disney Bullpen

Basic Training

The Walt Disney
Studios

The animation
students move into
production.

If you were a young animation artist and had just scored your first job at the Walt Disney Studios in Burbank California, it was more than likely you would report to your new workspace in the original Animation Building. It would be a large office known as the "Bullpen."

The Bullpen was the first office you encountered when you entered any wing of the Animation Building. It seated at least seven or eight animation artists, each with their own desk. It was the animation equivalent of the secretarial pool in the modern office environment. It was a training ground for the young artists, as well as a resource for animators needing assistants to complete their scenes.

Inbetweens are the additional drawings created in between the major poses, or keyframes, to fill out a movement. An animated scene is a large stack of drawings that delineate the actions of a character. The animator draws the major landmark poses and leaves notes as to how many additional drawings or "inbetweens" will be required. More inbetweens would slow down a movement; fewer would speed things up, The animator's assistant refines or cleans up the

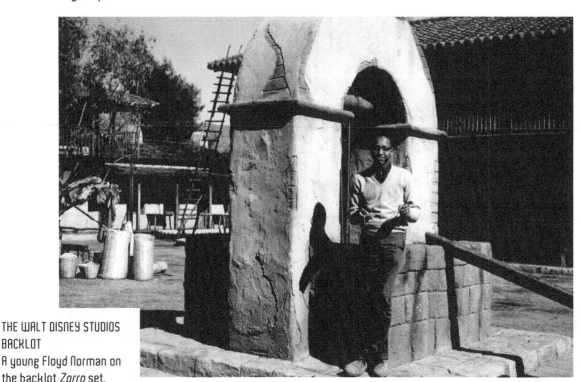

THE WALT DISNEY STUDIOS
BACKLOT
A young Floyd Norman on
the backlot *Zorro* set.

animators' key-pose drawings, then assigns the task of doing the remaining drawings to an inbetweener. The assistant was the right arm of the animator and would know how to draw the animator's character better than he did. This assistance gave the animator the freedom to focus on the acting performance of the character, not the details. Often in the Disney system, animation assistants had their work gone over not only by the animator to see if they interpreted his work correctly but also by a lead-key assistant— one for each major character. His or her responsibility was to ensure that the characters' details were drawn consistently throughout the movie so that Princess Aurora's hair or the buttons on Pinocchio's pants would not change from scene to scene. Like in the army, an animation production had a chain of command. The inbetweener reported to the assistant animator or inbetween supervisor, who reported to the animator. The animator reported to the lead animator, who reported to the director, who reported to Walt.

Every young artist dreamed of moving out of the Bullpen and occupying a seat next to a real Disney animator. In time, they might well be the animator in that coveted window seat. The ultimate dream, of course, was to eventually have a private office. Only Milt Kahl, Frank Thomas, and the other animation masters were accorded such special digs. For now, the inbetweener was the bottom rung of a long ladder up.

CARTOON CORRECTIONS
Animation artist Lois Blumquist corrects a drawing by trainee Rick Gonzales.

My first Bullpen was 1F-1 on the first floor of the Animation Building, and although this was fifty years ago, it still seems like yesterday. My officemates were a crazy collection of cartoon types eager to make their way in the animation business. Each had their own quirky story regarding the path that led them to the Walt Disney Studios and ultimately to a lifetime career in the cartoon business.

Let's start with Rick Gonzales, the young artist seated by the door. He had traveled from Texas with his mom to apply for this job and was delighted to be at Disney. After the completion of *Sleeping Beauty* and the subsequent downsizing, Rick moved on to Hanna-Barbera and Ruby-Spears, where he became a top character designer. Sadly, Rick passed away a few years ago, ironically not long after returning to Disney—ending his career where it had begun so many years ago.

My desk was between Rick's and that of a guy next to the window named Jacques Charvet. A talented artist, Charvet had journeyed from France to begin his artistic career at Disney. It was an odd turnabout, as most Americans would consider Paris the ideal place to study art. Passionate and outspoken, Charvet loved to argue about any subject introduced. He was affectionately known as "the Crazy Frenchman."

© Disney

John Leslie was born in Glasgow, Scotland, and occupied the next window seat. John bore an uncanny resemblance to the late actor James Dean and was continually kidded about his appearance. He even wore a leather jacket like the troubled Hollywood teen idol. Because this was the un–politically correct 1950s, we all felt free to bag on each other. Leslie, a true Scotsman, was continually accused of being tight with money. He even bought one of the first VW Beetles because he could save on gasoline.

Sam Jaimes was seated at the far window and claims to have gotten his job by simply stopping by the Disney lot one day on his way home. Sam lived in Arizona and was headed for the highway when he spotted the Walt Disney Studios. On a lark, he thought he would stop and see whether artists were being hired. They were, and Sam's career in animation lasted more than 50 years.

Vernon Riek occupied the next desk. Vern was a funny guy with a very dry sense of humor. Though he liked animation, Vern dreamed of a career as a comic strip writer and artist. He had developed a cute family comic strip about a frantic father raising two rambunctious boys. The strip was entitled "Heir Raising." Recently married, who knows what Vern might have accomplished had his career not suddenly and tragically been cut short. Preparing for work one morning, Vern was shaving and fell to the floor, dead of a heart attack. He was only in his early thirties.

Finally, Ruben Apodaca occupied the other corner of the office. A tall, good-looking guy, Ruben had his eye on a young assistant from D-Wing. We told Ruben to get over his shyness and speak to the attractive young woman, even though she was our supervisor. Luckily, Ruben and Doris finally began dating. After his years at Disney, Ruben made a name for himself as an animation instructor, mentoring a new generation of animators. Though both my dear friends are no longer with us, they had an impressive career in the animation business.

As you can imagine, it was often entertaining to share an office with this wacky group. The work of inbetweener did not require a lot of concentration; the animator's job was to do all the thinking on a scene. By the time it got to us, it was just elbow grease and long stretches sitting in your chair and drawing up mountains of paper. A good inbetweener could average about 14 drawings a day. So there was time for small talk as we worked. We discussed everything, including art, women, and politics. Our European colleague Jacques Charvet was not pleased by our visitors. He was referring to the consultants who were the top German rocket scientists from World War II: Dr. Werner Von Braun,

(TOP LEFT) YOUNG ARTISTS IN THE BULLPEN
Sam Jaimes works at his desk while Lois glances back at the camera.

(BOTTOM LEFT) ANOTHER BULLPEN ARTIST
John Leslie traveled all the way from Scotland to work for Walt Disney.

(TOP RIGHT) INSIDE
THE BULLPEN
Disney artist Jane
Shattuck relaxes during
break time.

(BOTTOM RIGHT) ARTIST
AT WORK
Chuck Williams at work
on *Sleeping Beauty*.

Willy Ley, Heinz Haber, and others who were working on Disney's space films. These men were brought by the military from Europe after the war for work on the government's space program. Charvet had fought in the French resistance against the Germans, so he was not pleased with the warm welcome the scientists were being given at the studio. But, our discussions were not always so weighty. We often discussed the merits of the animation styles of competing studios around town, such as Warner Bros, MGM (Metro-Goldwyn-Mayer), and UPA (United Productions of America).

My early assignment was on the Mickey Mouse Club doing the Jiminy Cricket "I'm No Fool" series. My boss was a gregarious young assistant animator named Rolly Crump. Rolly had an outrageous sense of humor that was often displayed in funny drawings of the Disney characters doing some unexpected Disney things. Rolly was like a big brother to me and showed great patience as this young newbie struggled to learn the Disney ropes. In time, Rolly Crump was transferred over to what was then known as WED Enterprises, the unit that did theme park design for Disneyland. Crump was discovered by no less than Walt Disney himself, who regularly prowled the hallways at night, curious as to what his staff was up to. Rolly had been building little rotating pinwheels out of colored paper, and his office was filled with these little gadgets driven by the building's air conditioning system. Some might consider such ingenuity a stroke of genius. Walt sure thought so.

Even though 50 years have passed, I can still remember the assignments that came my way in the Bullpen. I was given Donald Duck scenes animated by Volus Jones, Bob Carlson, and Al Coe. I did inbetweens for the talented Cliff Nordberg on "Our Friend the Atom." I helped complete scenes for Jack Parr and Jerry Hathcock on many of the Disney shorts. Another great guy I worked for was John Sibley, an incredible animator who could move anything on paper. These guys were not considered Disney's elite, but all were darn good animators and worthy of more respect than they ever received.

As expected, the artists in 1F-1 moved up the animation ladder to more advanced assignments. We were replaced, of course, by a new group of animation newbies, who—like us—were eager to become Disney animators, story artists, and the like. Leaving the Bullpen was a graduation of sorts. It was a moving up and moving on, as not all in our little group decided to remain with the Walt Disney Studios as a career.

ARTIST IN THE DARK
Like most artists,
Tom Dagenais preferred a
low-light environment.

The Bullpen was the Disney artist's first step in becoming an animation professional. It was a training ground as well as a community. Working in the Bullpen was not unlike being in a college dorm. Some of my colleagues became friends for life, and some I never saw again. It was the beginning of my career in animation at the Walt Disney Studios—a very special beginning that this animation old-timer will not forget.

The Assistant Animator

The Assistant
Animator

The animation
assistant often
played a very
important role in
the creation of an
animated film.

You've finally finished your animation apprenticeship, and you've learned the ropes as a fledgling inbetweener and breakdown artist. Now that the cartoon basics have been instilled, you're ready to take the next big step. No, don't get too anxious. You're not an animator yet. You've another important role to fill before continuing your climb up the ladder. It's time to become an assistant animator.

I was apprehensive when my boss, Andy Engman, informed me of my promotion. It was a mixture of delight and terror. Now I would be assuming responsibility for the animator's scene, and I wondered if I was up to the task. Was my drawing strong enough, and did I have the animation chops? I picked up my first scene, headed back to the drawing board, and this is what I learned in the process.

This is how it begins. You remove the stack of rough drawings sandwiched between the stiff cardboard. Holding the drawings in one hand, you "roll" the scene and immediately get a sense of the action and the animator's timing. The moment of truth comes once you've placed the drawings on your disk and picked up your pencil.

IMPORTANT JOB
The assistant animator
at work.

The job of the assistant animator will be to clean up or finalize the animator's rough scenes. You may have follow-up artists such as breakdown and inbetweeners, or you might complete all the drawings yourself. Naturally, the challenge facing the assistant is to give each drawing a finished line without losing the energy and vitality of the rough animation. The purpose of animation is to create the illusion of life, and your pencil sketches need to remain "alive." While you're cleaning up, keep in mind the basic animation principles you've learned, such as squash and stretch and overlap and followthrough. Remember the "path of action" while you're doing your drawings, because the animator will be focusing on these things as he or she examines the completed scene.

Don't ignore the timing charts, because the animator will expect them to be followed. Some animators, such as Eric Larson, love to time drawings on thirds. So instead of creating drawings by calculating the mid-distance between the character's two extreme poses, you had to estimate what the distance one-third to the next pose might look like. This often made inbetweening more of a challenge, but Eric thought it added to his animation. One thing is sure: you'll find that all animators are not all alike, and you'll have to continually adjust if you hope to be a good fit.

THE ARTIST AT WORK
Rick Gonzales finalizes
the animator's rough
drawings.

All this is a good thing, of course. After serving under several bosses, you'll learn what works for you. Regardless of their technique or work style, glean what you can. These things will serve you well once you pick up the animator's pencil.

Learn to Draw

The first word of advice received from veteran animators was always the same. "Learn to draw," they would say. Along with all the other things a young animation artist should know, learning to draw was always paramount. In fact, these were the words Walt Disney gave a young aspiring animator while visiting the Midwest. The young student approached the Old Maestro and asked, "Mr. Disney, how can I get a job at your studio?" Walt's reply was gruff and direct. "Learn to draw, kid! Learn to draw!"

Learning to draw requires decades, not days. Unless you're one of the gifted individuals in this business (and there are a few), you'll be working at this for a while. I have done so throughout my career. After some 50 years or so, my drawings are beginning to show signs of improvement, but there's still a long way to go.

Animators Are Unique

In the traditional system of animation production, an assistant animator got the chance to work in close collaboration with an animator. Chances are good that you'll be working with more than one animator during your career, which is a good thing. Take advantage of the opportunities, because you'll learn a lot. Each animator you assist will have his or her own particular style or technique. Though you'll find some more appealing than others, pay attention and use all you learn. This knowledge will help make you a better animator one day. During my years as an assistant at the House of Mouse, I was fortunate enough to be teamed with some of the finest animators who ever sharpened a pencil. And each partnership was an object lesson in technique and discipline.

Frank Thomas

I'll begin with the toughest of the bunch, and his is a name you'll probably know. Frank Thomas (1912–2004) was an exceptionally gifted animator who created such great moments in Disney films like Bambi and Thumper on the ice, Pinocchio singing "I've Got No Strings," King Louie's song "I Wanna Be Like You," and many more. His personal technique meant that he often animated in what some would call a "straight-ahead" style. That meant that instead of blocking out the major key poses of a character first, Frank drew drawing 1 to 2 to 3 to 4 in order. This was difficult to control, but it gave the movement a raw spontaneity. Frank's style was free and organic, leaving his extremely rough drawings difficult to pin down. One thing they never explained to you about being an assistant was that you sometimes needed the skill of a pharmacist at reading prescriptions to understand what the animator is intending. Cleaning up a Frank Thomas scene required a laser focus, because a wrong pencil line could spell disaster. Luckily, Thomas had the gifted Dale Oliver as his key assistant. Dale had been a paratrooper at the D-Day invasion, so he knew a lot about hazardous duty. Dale was able to "see" the Thomas drawing buried in the rough pencil sketch and define it with a clean line. Needless to say, following up Frank Thomas was not an easy task, and the smug and over-confident needed not apply. I say this from firsthand experience after screwing up a Frank Thomas scene back in the 1960s and learning a valuable lesson. After ten years in Disney's animation department, I thought I knew a thing or two. I cleaned up a scene for the master animator, and my efforts were less than stellar. Once Thomas saw what I had done to his scene, I had my head handed to me in legendary D-Wing. I thought for sure I would be banished forever from the special wing where the Nine Old Men took up residence. Thankfully, Dale Oliver was able to save the scene, but this over-confident animation assistant learned a lesson in humility that I'll never forget.

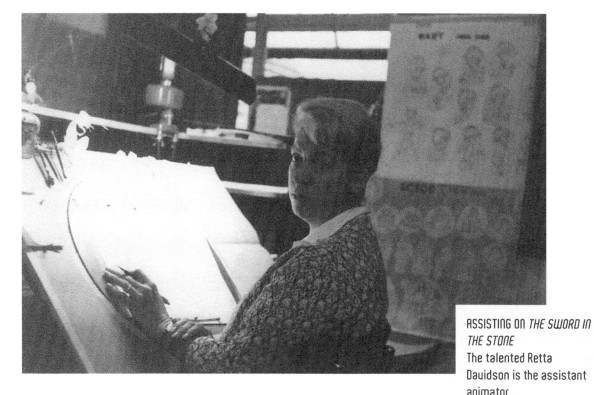

ASSISTING ON *THE SWORD IN THE STONE*
The talented Retta Davidson is the assistant animator.

Milt Kahl

Our next animator is also legendary and had a more deliberate style. Milt Kahl (1909–1987) was more than a leader in Disney's animation department: he was a force. His pencil gave life to Shere Khan in *The Jungle Book*, Merlin in *The Sword in the Stone*, Tramp in *Lady and the Tramp*, and many more. My colleague Andreas Deja excels at defining Kahl's animating style, and should you truly require animation insights, I recommend that you speak with him. What I can tell you is that Milt Kahl was an incredible draftsman and that cleaning up his scenes was not as difficult as I had imagined. That's because Kahl had pretty much done all the work for you. His roughs were clear and concise, and there was little to do except clean them up. On the film *The Sword in the Stone* we used a technique called "touch-up" in which we worked directly over the animator's drawings with no clean sheets of paper involved. If you had any drawing ability at all, it didn't take much to tighten Milt's inspired sketches. Holding Kahl's drawings in your hands, you were always amazed at his remarkable draftsmanship, composition, and staging. In addition, Milt thought things through before ever putting pencil to paper. I'm convinced that this master animator had already animated the scene in his head before picking up his pencil. Naturally, you became a better artist simply by working for Kahl. In his own way, Milt set the standard for animators at Disney, and he raised the bar so high that few could ever hope to achieve it.

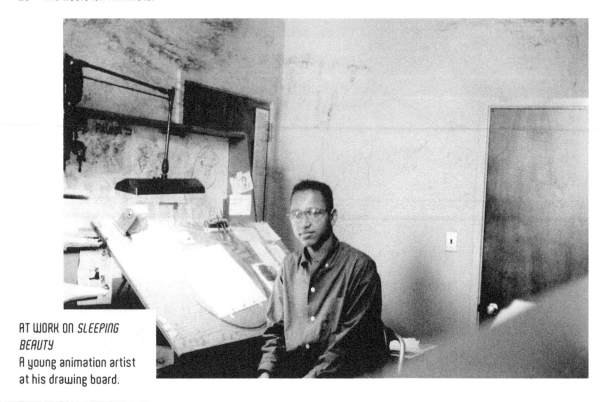

AT WORK ON *SLEEPING BEAUTY*
A young animation artist at his drawing board.

Ward Kimball

In the 1960s, directing animator Ward Kimball (1914–2002) returned to the drawing board. The reason Kimball was animating again is another story in itself, but we won't go into that here. However, it provided an opportunity for me to follow up one of my favorite animators.

When I was a kid, Fred Moore and Ward Kimball were already two of my favorite Disney animators. Unfortunately, I arrived at Disney in the late 1950s, after Fred Moore had passed on. However, Ward Kimball was hard at work running his own unit as a producer and director. In his career, Kimball was responsible for Jiminy Cricket, Ichabod Crane, the Mad Hatter, and many more. He spent much of the 1950s directing animation for the Disney TV shows and science shorts. When Kimball returned to the animation drawing board in the 1960s, he had a number of veteran assistants, including Fred Kopietz. Naturally, a master like Ward could churn out reams of footage, so additional assistant animators were needed. Finally, I was given the opportunity to assist my hero.

Following Ward Kimball was an unique experience. The first thing you'd notice about Kimball's animation was how little there was on the paper. Ward never gave us much to work with, but in all honesty, it was more than enough—an oval for a head and a line noting a path of action was

sometimes all the drawing we received. Ward didn't have time to draw the character, and he knew we could do that. He had already given us the timing and rough poses. The rest of the job was left up to us. However, the lines on paper conveyed the heart of the scene, along with Kimball's special energy and vitality that made him such a standout animator. Cleaning up a Ward Kimball scene was a workout, to be sure. But I sure felt good afterward.

Of course, there are many more animators I could name, and each had his or her own individual style. Take the time to study their approaches and techniques, because all were masters of their craft. However, don't take being an assistant animator lightly, because they too are talented individuals. Sadly, many did stellar work for decades without ever receiving a credit on the big screen. These individuals toiled in the background, and their labor is clearly evident in the finished animation. The Walt Disney Studios had many exceptional key animation assistants, and I need to name a few. They include Dale Oliver, Stan Green, Iwao Takamoto, Sylvia Niday, and John Freeman. Seldom viewed as stars, assistant animators played a key supporting role in the creation of an animated scene, and in that respect they were often as important—if not more important—than the animator.

The Workers' Paradise

The Creative Environment Matters

A group of young guys and gals gathered in the office of a Disney veteran on the third floor of the Animation Building. "Boy, you missed it," the old timer rhapsodized as he spoke about the good old days of the late 1930s and early 1940s. "This used to be a great place to work, but the strike ended all that."

If you know your Disney history you're probably aware of what might be called Walt Disney's paternalism during the early days of the Hyperion Studio. That was Walt's studio, on Hyperion Boulevard, until he built the big movie lot in Burbank in 1939. Disputes between labor and management were hardly an issue during the 1930s depression. Most young guys and gals were happy to have a job, and a job at Walt's cartoon factory was better than most. Walt's midwestern philosophy of an honest day's work for a fair wage appeared to prevail at the fledgling studio. There was no need to speak of unions or workers' rights when there was no guarantee that the studio would even be in business the following week.

The old guys I've spoken with told me they were delighted to quit their jobs as delivery boys or soda jerks in order to earn a wage at the drawing board. Better yet, Walt Disney even tossed in a few extra bucks for those industrious enough to come up with gags or ideas for future cartoon shorts.

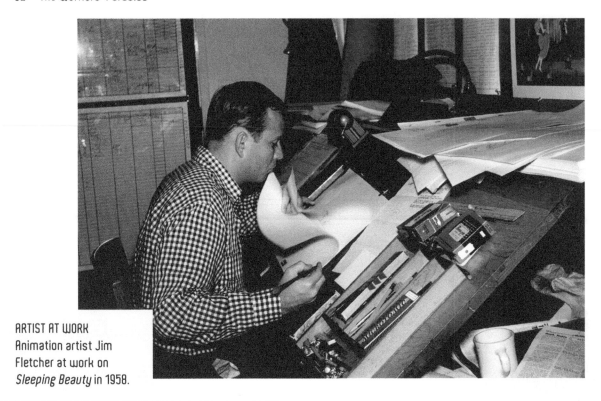

ARTIST AT WORK
Animation artist Jim
Fletcher at work on
Sleeping Beauty in 1958.

Walt Disney's fatherly attitude continued when the studio moved to its new Burbank facility in the San Fernando Valley. Although there was a loss of intimacy provided by the overcrowded Hyperion plant, it was more than made up for by the efficiency of the new studio. Still, Walt Disney provided his staff with an ideal artist's environment. While the nation crawled out of a crippling depression, the Disney animators enjoyed a workers' paradise.

Yet even in paradise, all was not well. Walt found it difficult to create Disney magic when his animation staff was increasingly divided by a contentious labor action. The studio had grown from a storefront of friends to a big plant of more than 2,000 employees. In 1941, when the artists asked for the same kind of union representation the other Hollywood studio workers were getting, Walt boiled over. The big Walt Disney Studios strike in the summer of 1941 made national headlines. There was a national boycott of Disney products, and Walt almost had a nervous breakdown. It took a federal mediator sent out by Washington to settle everything. After that, Disney would be a union contract studio like the other ones in Hollywood. Because he wanted no further trouble, Walt now insisted everyone—even the gardeners—have a union. The bitterness created by the 1940s strike

TAKING A BREAK
Animation artists
Fernando Arce and Chuck
Williams take their
morning break from
Sleeping Beauty.

could not be easily dismissed, and it would change forever the relationship between Walt and his artists. The legacy of the Disney labor action ushered in "the Bad Old Days." No longer would Walt's artists and staffers enjoy the perks and privileges of the studios' glory days. From now on Walt Disney would run a tough, hard-as-nails, no-nonsense business. The fun and games were over.

Well, that's the way the old guys tell the story. However, I'll have to add, "You could have fooled me!" You see, when I found the Walt Disney Studios—allegedly at its worst—it was still better than most studios at their best. This, however, might take some explaining.

This young kid arrived at Disney in the early 1950s with scant knowledge of the studio's labor history. So, when the old guys informed me that Walt had stripped away all the "goodies," I didn't know what the heck they were talking about. From this kid's naïve point of view, everything looked just great. Yet I was reminded continually that we were bearing the brunt of the 1940s strike, and all of us were being reprimanded by the boss. So I decided to compile a list of ways we were being "punished."

First of all, let's talk about working conditions. Most of us had a private office or at least shared one with a colleague. In this case, I mean a real

DISNEY ARTIST
Assistant animator
Don Albrecht.

office with a door and a window with a view. Walt's studio commissary operated at cost as a convenience for the workers. If you've ever had the pleasure of viewing a 1950s menu from the Disney cafeteria or lunch counter, you were probably in shock. Even though most didn't earn much, we could still dine at lunchtime for around a dollar. If you chose wisely, you might even return to your drawing board with change in your pocket. The commissary included a studio store that actually sold some pretty special toys and gadgets. Not the cheap, cheesy stuff so often seen today.

Walt Disney also provided an onsite post office where employees could purchase stamps and mail packages. No need to hop in your car and leave the studio lot when everything needed was a few doors away. There was ample wall space in the second-floor studio library for artists to exhibit their personal artwork. Should you be lucky enough to sell all your paintings or sketches, the earnings were yours to keep.

There were free classes and lectures by the Disney Masters on the subjects of animation, layout, and story. All were provided without charge and conducted at the studio after work. The Disney veterans donated their time in order to provide training for a new generation of animation artists.

ANIMATION ARTIST
That's artist Bill Eigle in
his dark lair.

We had a carpenter shop, a machine shop, and an electronics
department that would gladly help you solve problems. Of course, this was
in addition to their regular duties. The electronics department repaired my
tape recorder, and Disney's machine shop helped me build an animation
camera stand. All freely given because we were "part of the family."

Finally, Walt Disney provided working conditions like no other studio in town.
While most movie employees labored in grungy, factorylike facilities, the
Walt Disney Studios lot was a landscaped campus, complete with squirrels
that scampered across manicured lawns. Every building had central air
conditioning, which in hot Southern California was still an unheard-of luxury.

I began my animation career working in these "dreaded conditions,"
clearly being punished for the sins of my predecessors. The funny thing
is that because I didn't know Walt was punishing me, I assumed I was
working in paradise. If you were lucky enough to work for Disney back in
the 1950s when Walt and Roy ran the place, you might have had a few
gripes about things. However, you'd be less than honest if you didn't admit
that Walt Disney Productions at its worst had to be an incredible studio.
And if you decided to remain in the cartoon business for the remainder of
your career, it would never, ever be this good again.

Disney's Night School

Animation Master Class

The Walt Disney
Studios

Our work often
continued into the
evening.

Did you know that Walt Disney Studios once provided what could be considered the finest animation course ever offered? That's right, kids. If you've shelled out the big bucks for an animation education at such institutions as California Institute of the Arts or Sheridan College, you might be surprised to learn that Disney once provided all this and more—at absolutely no cost.

What was this animation course? Well, back in the 1950s, Disney's animation staff included 600 talented artists, most of whom were laboring away on *Sleeping Beauty*. The rest divided their time on the ABC television show *Disneyland* or the rapidly diminishing shorts program. Yet even back then, when the Nine Old Men and many others were still going strong, Disney came to realize that they would soon need to replenish the ranks if animated filmmaking was to continue.

Those of you who know your Mouse House history will remember that Walt Disney encouraged his artists to attend night classes at Chouinard Art Institute in Los Angeles. His was the first studio to take a serious interest in training to improve the skills of his artists. Walt Disney even took the time to drive some of

his young artists to class in the evening. But in the 1950s, the Walt Disney Studios was in no need of an outside teaching staff because the company had, over time, developed one of its own. After all, if you were looking for brilliant animators, gifted layout artists, and awesome background painters, where would you go? The Walt Disney Studios had all this talent under one roof. Disney also brought in famous fine artists like Frank Lloyd Wright and Salvador Dali to lecture his artists. At one point, the Walt Disney Studios was spending $100,000 dollars a year on artistic training.

Though the studio offered this incredible opportunity, few artists took advantage of it. To be fair, most artists were probably beat after a long day at work and looked forward to going home and being with their families. So despite an animation staff that numbered in the hundreds, only a couple dozen of us decided to attend "night school."

The classes would begin at seven, so that gave all of us a chance to run down to Bob's Big Boy (yes, it was there even back then) for a quick bite. After dinner, we rushed back to the Disney lot to begin another evening of instruction. Most of my classmates were pretty young. The older employees were married and had other responsibilities. The women, as usual, were few in number. Even in the 1950s, few opportunities were available for young women. Like the early 1930s, women were still relegated to positions in the Ink & Paint Department.

The classes were usually held in one of the large screening rooms on the third floor of the Animation Building. On one night, our instructor was the talented Joshua Meador, one of Disney's premier effects animators. Josh was also an accomplished painter and loved using a palette knife rather than a brush. Meador was also the creator of those wonderful animated introductions preceding Disney's True Life Adventures series. In 1956, Josh and his effects team were leased out by Walt to MGM Studios to create the visual effects on the first big-budget science-fiction movie *Forbidden Planet*. That film is considered today the granddaddy of all the big space-effects movies such as *Star Wars*. Josh let us in on the secrets that made Disney's effects animation better than any other studio in town.

On another occasion, our instructor was the great layout artist Ken O'Connor, who looked more like a science professor than an animation artist. O'Connor was responsible for the incredible design and layout in the *Fantasia* segment "Dance of the Hours." Of course, practically all of the original artwork was still available, and Ken took us through every step of the design and development of "Dance of the Hours."

Of course, animation was the main focus of this series of classes. The majority of our class members aspired to be animators one day, so a rigorous series of pencil animation tests were required. I still remember being impressed by the work of young John Sparey, who went on to become an

(TOP LEFT) LEARNING CONTINUES
Artist Bob Longo was part of the Maleficent team that finalized the drawings of the evil fairy.

(BOTTOM LEFT) TAKING A BREAK
Animation artist Gene Foucher had dreams of becoming a painter one day.

PLANNING AHEAD
Artist Herb Stott would one day head his own animation studio in Hollywood.

animator and was regarded as a major talent. However, I still cringe when I remember my early attempts at animation. I was awful, and I'm glad my future wasn't determined by those early tests.

Not all of Disney's Nine Old Men participated in this mentoring program. However, Frank Thomas and Ollie Johnston seemed to enjoy teaching. I remember one evening when these two animation greats made it clear that not everyone has the chops to become a director. They made their point by screening a short cartoon called "The Golden Touch" that was directed by none other than the boss himself. Though Walt was a brilliant story editor, his directing left a lot to be desired. The film was poorly paced and the timing seemed off. It was obvious that a good director needed a different skill set, and Walt clearly didn't have it. Walt Disney had been smart enough in the 1920s to realize he could get artists who were far better than himself to work for him. But it took a little more self-discipline for him to realize, by the 1930s, that he now had better directors than he was working for him. As a studio head, he had many more things on his mind than directing one short. Despite encouraging a free-flowing critique of other artists' work, when it came to his own directing, sometimes Walt could be a bit thin-skinned when the criticism hit too close to the bone. I'm still amazed that Frank and Ollie could take a few shots at Walt Disney without suffering retribution.

I thought I was fairly knowledgeable concerning Disney history, but I still had a lot to learn. Animator Bob McCrea took us through the turbulent years of Disney's struggle to survive as a company: how Walt was cheated by other studios and partners early in his career. How in World War II, Walt lost half of his film market, and having the studio lot be taken over by the military proved to be a blessing in disguise. For decades, The Walt Disney Company teetered on the brink of bankruptcy, and the famous 1941 strike proved to be a college course in and of itself.

As you can imagine, this Disney night course was a master class in animation. Those who took advantage of this opportunity were mentored by no less than the finest animation artists in the industry. In time, the pressures of completing *Sleeping Beauty* brought an end to Disney's night school. Then late nights at the studio meant you were probably working overtime. Those of us who attended night school at the Mouse House were a lucky bunch of kids. A day at Disney in the 1950s was pretty darn good. But sometimes the nights were even better.

© Disney

Something About Mary Poppins

6

Animation's Jolly Holiday

The tall, attractive redhead was quite pregnant when she walked past my office and down the hallway in Disney's Animation Building. Though she looked familiar, I didn't immediately recognize Julie Andrews as she headed down D-Wing to Frank Thomas's office. It appeared that Walt Disney had finally convinced the talented young actress to play the lead in his new feature film, *Mary Poppins*. He was a man who knew what he wanted, so even though Miss Andrews was having a baby, Walt Disney was prepared to wait.

Although the Walt Disney Studios was world famous for its animated cartoons, Walt had branched off into producing live-action films for theaters and televisiton as well. His *20,000 Leagues Under the Sea* was a masterpiece. It was directed by Richard Fleischer, the son of Walt's old competitor Max Fleischer, the Betty Boop guy. *Treasure Island* and *The Absent-Minded Professor* were big hits for the studio, and the TV episodes of *Davy Crockett* staring Fess Parker became a national sensation. Every little kid in America had to have a coonskin cap like Davy did. Some of the animation staff would move over to helping with the live-action work, like story man Roy Williams, and David Swift, who directed the Hayley Mills movies. The Disney TV series

(TOP RIGHT) PHOTOGRAPHS
OF THE CREW
Many talented artists
worked on the film. That's
animator John Ewing.

(BOTTOM RIGHT) BREAK
TIME ON THE SHOW
Animation artists Al
Stetter and Chuck
Williams chat during
break time in A-Wing.

Zorro with Guy Williams had become such a big hit that one whole corner of the studio lot was transformed into Zorro's Village. By the time *Mary Poppins* appeared on the production schedule, the studio had a well-established reputation as a live-action production company.

I was not familiar with the P. L. Travers novels, though I had heard stories of the exceptional English nanny. For the past year or so, I had been looking at a series of sketches and designs in the third-floor offices of Bill Walsh and Don DaGradi. I knew they had been developing this property over time, but I had no idea that Walt was ready to bring this story to the big screen and put the resources of the entire Walt Disney Studios behind it. In time, *Mary Poppins* would involve every artist, actor, musician, technician, and craftsman at Walt's magic factory.

After Julie Andrews had finally given birth to her daughter, Emma, the real work was ready to begin. Irwin Kostal had been chosen as musical director, and recording sessions began on Disney's recording stage, which was across the street from the Animation Building. Keep in mind that this was Disney in the 1960s, when we all worked together as one big family—a far cry from film work today, in which jobs are contracted out all over town, and several crews work on a movie and never even meet each other. On *Mary Poppins*, I got to know everybody, and that included attending the recording sessions where Julie Andrews and co-star Dick Van Dyke recorded the numbers they would lip-sync to once filming began. On that first day of recording, Dick Van Dyke was in a festive mood. He was already a famous star, with the most popular comedy show on TV at the time: *The Dick Van Dyke Show.* Yet he was very down to earth with all of us in the crew. He enjoyed cracking us up with his comic mannerisms. Soon, the stage was filled with the sounds of "Chim Chim Cher-ee." The composers of the score, Richard and Robert Sherman, had big smiles on their faces, as did we all. I think we knew we were going to be part of something very special.

While the score was being recorded, construction was under way on every soundstage on the Disney lot. Stage Two would house the exterior of the Banks's home, as well as the park where Bert would do his chalk drawings. Stage One contained the interior of the Banks's home, and the rooftops of London would find their home on Stage Three. Of course a film like *Mary Poppins* had many sets, so once a sequence was in the can, those sets were struck (i.e., disassembled) to make room for others. The sets for *Mary Poppins* were impressive. Like most musicals of the day, interiors as well as exteriors were all shot on stages, giving the art directors and lighting cameramen total control of the environment. Hollywood had a term for it back then— "Technicolor gloss"—something rarely seen in today's musicals, what few there are.

Because of a lack of rehearsal space, Disney's carpenters built a temporary stage platform on the studio backlot. Choreographers Marc Breaux and Dee Dee Wood put the dancers through their paces in this sunny outdoor location. They were preparing for the vigorous "Step in Time" rooftop number that would, no pun intended, bring the house down. As always, many of the animation artists were on hand for the rehearsals and, on occasion, the actual filming. We knew that once the actors had done their stuff, the scenes would be headed our way. As always, Disney filmed the live action using the sodium matte process. If the actors were to be placed in a shot with animation, all the elements were filmed separately. The actors against a blue screen (today it's green) or areas of the live-action set marked off for the animation. This process provided separation negatives that would eventually be composited with the animation by Ub Iwerks and his wizards in the process lab. Iwerks was Walt Disney's first animator in the 1920s and was responsible for the design of Mickey Mouse. After leaving the studio for awhile, he returned to head the technical end of production. Under his guidance, the Walt Disney Studios pioneered the use of sodium matte, or the blue-screen process. The animation done of the penguins dancing with Dick was some of the tightest choreography ever done with a live-action character. That kind of human-toon interaction would not be seen again until *Who Framed Roger Rabbit*—twenty-five years in the future.

Those familiar with matching animation with live action have heard of Rotoscopes. These are individual frames of live footage printed on sheets of paper punched to match the pegs on our animation disks. Though we often found working with the stacks of Rotoscopes cumbersome, they were necessary to make sure our drawings would composite perfectly with the live footage. Sometimes there were so many working levels in an animated scene that the "pencil tests" had to be printed on cels. An example of this process was the very involved dance number in which Dick Van Dyke danced with the penguins. Animation master Frank Thomas brought this fantastic number to life beautifully. Yet there were other equally daunting scenes. One was the singing and dancing "Pearlies": London Cockney street performers in distinctive costumes covered in little pearl and bells. But they were an animator's nightmare. And, should one ask, did we do all of those little pearls sewn onto the character's garments by hand, the answer is an emphatic *yes*. On the film *101 Dalmatians*, one animator had the unenviable task of doing all the spots on all the Dalmatian dogs, all moving in perfect alignment with the animals' muscles and skin. In hand-drawn animation, if even one pearl or spot strayed in a direction, it would kill the effect of the whole scene—especially when all your little drawings were blown up on a movie screen the size of a football field. We had a memo

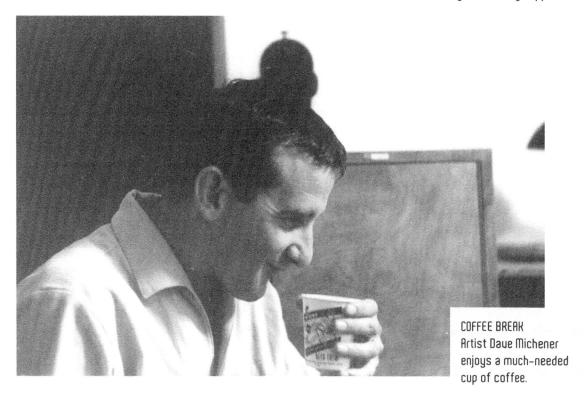

COFFEE BREAK
Artist Dave Michener
enjoys a much-needed
cup of coffee.

posted that reminded us that even a single dot the width of a pencil point, when enlarged up to the ratio of the movie projection, became the size of a basketball! So all this precision had to be done by eye. Where were the computers when you really needed one? The closest thing to a computer we used then were the slide rules employed by the scene planning department. They were the ones who calculated the motion-controlled camera moves for the animation.

Chances are you that didn't know about the change in art direction on the "Jolly Holiday" sequence, did you? In the story, the smartly attired chimney sweep sings to Mary Poppins as he escorts her through a London park. Originally, the animation was supposed to look like chalk drawings. After all, Dick Van Dyke's character, Bert, was a chalk artist, and wouldn't animated chalk sketches look really cool? After trying a number of tests, the Old Maestro gave us the thumbs-down. Though animated "chalk drawings" might have had a unique appeal, Walt decided to trust his instincts and go with what has become the "Disney House Style." The background artists modified their backgrounds to give them a chalk-like appearance, but you'll never see the sequence the way it was originally conceived.

Mary Poppins opened to rave reviews in 1964 and even garnered five Academy Awards. To the delight of all, Julie Andrews took home an Oscar for Best Actress. It was a special moment for her, because before accepting the role of Mary Poppins, she had been denied the chance to play Eliza Doolittle in the film adaptation of *My Fair Lady*, a role she originated on Broadway. Hollywood didn't consider Andrews a big enough star—yet. But that changed, because *Mary Poppins* catapulted her to the forefront of stardom. For Walt Disney, it was his crowning achievement, and the Old Maestro hadn't been that proud since the opening of *Snow White and the Seven Dwarfs*. As for myself, I got to put down my animation pencil for good as I moved upstairs to the story department. Yet I'll never forget my time spent on this very special movie and the talented people who brought it all to life. It was a lot of hard work, to be sure, but in a very special way, I'll always remember it as a "Jolly Holiday."

Taking My Best Shot

Learning to Be an Animator

Working on "The Saga of Windwagon Smith"

Chuck Williams and Floyd Norman

We all remember our first car, our first job, and certainly our first date. Like everyone else, I've got a "first" as well. However, mine is going to be a little different. I'm speaking of my first animated scene in a Disney cartoon and how that scene ushered me into the highly coveted position of "animator" at the Mouse House. We'll get to that scene in a bit, but first a little Disney history.

Let's go back to the 1960s and the completion of the feature film *101 Dalmatians*. Disney's animation department had already suffered a severe downsizing after *Sleeping Beauty*, but now the Animation Department was informed that it would have to tighten its belt even more. That meant even long-time Disney animators would be given their walking papers. A painful situation to be sure, but some animators took the bad news in stride. One such was animator Don Lusk. Don, a 20-year veteran, showed a sense of humor when informed he was being terminated. Standing before his boss, Don replied, "But I was under the impression this job was supposed to be steady."

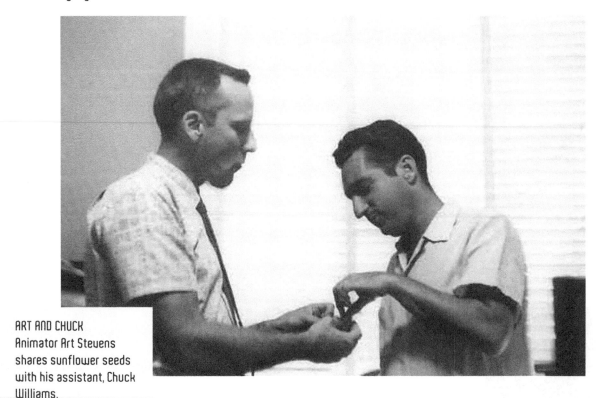

ART AND CHUCK
Animator Art Stevens
shares sunflower seeds
with his assistant, Chuck
Williams.

I confess that I felt guilty seeing many Disney veterans leaving the
company. Lowly assistants like myself were spared the ax because we
earned considerably less money and could be put to work assisting other
artists. Luckily, I found myself a position on a new animated short entitled
"The Saga of Windwagon Smith." Somehow, despite of all the cutbacks,
I had managed to survive. Yet I had to put my dream of being a Disney
animator on hold. Clearly, Disney had no need of new animators as they
had already sent a number of talented veterans out the door.

"The Saga of Windwagon Smith" was a delightful folksy short, much like
many of the Disney cartoons I saw as a kid. Rex Allen's easygoing drawl
provided the film's narration. With all the recent cutbacks at the Mouse
House, our crew was small, but not lacking in talent. Our director was C.
August Nichols, a veteran who had animated on *Pinocchio*. Nick used to
joke about animating his favorite character in the film: the evil "coachman"
who took the kids off to Pleasure Island where they would eventually be sold
as livestock. "He was a mean guy," laughed Nick. "A real fun character to
animate."

For layout and production design, we had the talented Ernie Nordli.
Walt Peregoy was the color stylist and, if I recall correctly, painted all the
backgrounds himself. Finally, Jack Boyd did the effects animation, and the

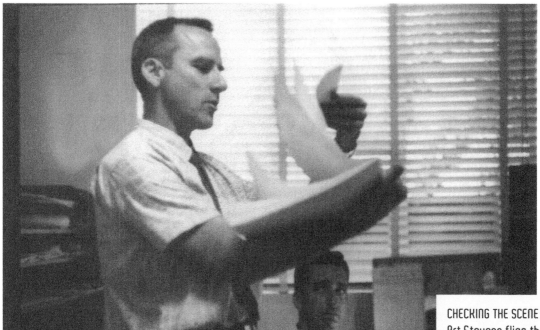

CHECKING THE SCENE
Art Stevens flips through
a finished animated
scene as Chuck Williams
looks on.

two character animators were Art Stevens and Julius Svendsen. Chuck
Williams and I worked as assistants. Our crew was small but more than
efficient enough to crank out a Disney cartoon on a budget.

The film tells the story of a former sea captain who "sails" his modified
covered wagon across the prairie, much like a schooner crossing the
ocean. The film was animated in the stylized technique effectively used by
Nick and Ward Kimball in such former films as "Melody" and "Toot, Whistle,
Plunk and Boom." Art and Sven had both worked for Ward Kimball on his
Tomorrowland space films as well, where they perfected this animation
technique. Though the animation was a little more limited than the average
Disney film, it was never short on imagination. The movement was stylized,
but even then it was how and when the characters moved that gave the
animation its punch. I had always admired the animation abilities of Art and
Sven. I had been watching their animation since I was a kid in art school.
Now, as luck would have it, I would be assisting my heroes. One morning,
I inquired about a particular scene and received an unexpected reply from
Art Stevens. "Go ahead and animate it yourself," he said. "You know what
to do." I was somewhat taken aback. I had never dared to even request
any animation assignments—here was an opportunity being handed to
me. Though somewhat intimidated, I went right to work.

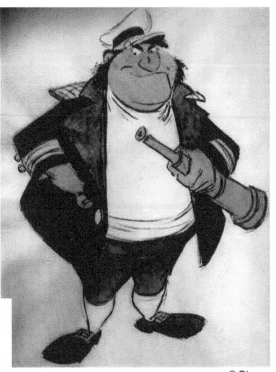

© Disney

CHARACTER SKETCH
A rough color sketch of
Captain Smith by one of
our talented animators,
Julius Suendsen.

An animation crew is basically a group of individual artists who all have
to draw as through the film were created by one hand. Of course, as in all
Disney films, the artists are bound to disagree on how things should be done.
For instance, the animators continually grumbled about the "foregrounds"
Walt Peregoy was painting for the film. They felt like their animation were
being upstaged by Walt's vibrant color palette. It brought back memories
of *Sleeping Beauty*, and the very same criticism of color stylist Eyvind Earle.
Meanwhile, we continued to churn out the footage, and my dream of
becoming an animator seemed closer than ever. Oddly enough, my cartoon
future would soon be changing, but I didn't know it at the time. In a few years,
I would be trading my animation disk for a pencil and sketchpad.

"The Saga of Windwagon Smith" turned out to be a pretty good little
film. Nothing to write home about, I suppose, but many people have told
me how much they enjoyed this little bit of Americana. In many ways, it felt
like the end of another era at the Mouse House. Many gifted animators
had already moved on, and now even our director, Nick Nichols, would be
saying goodbye to Disney, where he had worked since the 1940s. Nick
would begin a whole new career as a director at Hanna-Barbera, where he
would put in a least another 20 years before his career would come to an
end at—of all places—Walt Disney Studios.

I remember "The Saga of Windwagon Smith" because one of my favorite animators gave me the opportunity to be more than a clean-up artist. My dream of being a Disney animator seemed just a little bit closer because of my experience on the movie. Yet even with our tiny crew, there were still no screen credits for Chuck or myself. Animation assistants were not to be deemed worthy of credit until another decade had passed. No matter. I was delighted to have worked on a special Disney cartoon with a very special crew.

Finally, what was that first scene this tyro animator placed on his pegs back in the 1960s? If you remember the cartoon, Windwagon Smith has just roared into town, scaring the hell out of everyone, including an old codger sitting on a porch with his rifle. The frightened geezer jumps up and fires his rifle, and *ka-blam*! So you see, I got my first shot at Disney animation by having a cartoon character take—you guessed it—his best shot.

The Jungle Book

8

Working with the Old Maestro

Story Meeting

Working with Walt on the last film the Old Maestro personally supervised.

Wolfgang "Woolie" Reitherman and I were alone in the room. Woolie had started as an animator, well known for his work on Goofy in the shorts and Monstro the Whale in *Pinocchio*. This one of the Nine Old Men had lately been moving ahead of his peers and the other directors like Ben Sharpsteen and Clyde Geronimi to become the predominant feature animation director. As the Old Maestro (that's Walt) was turning his attention to the parks and TV production, responsibility for animation fell more on Woolie's shoulders. Woolie was a big, athletic man who reminded one of John Wayne in appearance and sported a big unlit cigar rammed in the corner of his mouth. Now here he was, in to look at a sequence being developed for the new project, *The Jungle Book*. However, this storyboard was not by one of the Disney masters—it was mine. We both knew what the stakes were. A few months ago, Marc Davis's team had shown Walt the "Chanticleer," an idea based on the medieval *Canterbury Tales*. The idea didn't go over well with the Old Man, and he killed the whole project. It was pretty devastating to all involved. A year's worth of work, thousands of dollars, and beautiful artwork all down the drain. After a few weeks, Walt

The Jungle Book 57

allowed development work to begin again on a new idea. This one was based on *The Jungle Book* by Rudyard Kipling. Our director had stopped in to look at a sequence being developed for *The Jungle Book*. After the devastating collapse of "Chanticleer", months earlier, Walt Disney had finally given the go ahead for boarding on a new film. As Woolie stared at my storyboard for what seemed an

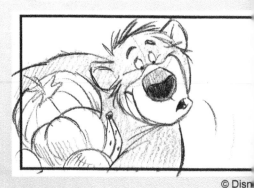

© Disn

STORY SKETCH
My rough sketch of Baloo the Bear. He was intent on keeping Mowgli in the jungle.

eternity, I stood with pad and pencil in hand, ready to take the volume of notes soon to come my way. The tall, imposing director suddenly turned and said, "Let's show the board to Walt." And with that, he turned and walked out of the office. The fact that my storyboard was going to be shown to Walt Disney sent a chill down my spine. What if Walt hated the sequence?

I honestly don't know how I made it into Disney's story department. I did know that story was a coveted position at the Walt Disney Studios. Walt and gag man Webb Smith had originated the idea of storyboards in the 1920s, putting all the gag ideas and staging ideas up on a large corkboard with pushpins. Since then, every movie had been done that way, and out in the rest of the business everything from the "Burning of Atlanta" scene in *Gone with the Wind* to the shower scene from Alfred Hitchcock's *Psycho* was first planned out on storyboards. Even Pixar and DreamWorks computer films were planned first with pushpins on the corkboards. The practice didn't change to digital tablets until the 2000s. Many friends and colleagues had attempted making the move upstairs, but all were eventually disappointed. So it was ironic that this plum job should suddenly and unexpectedly be dropped in my lap. I did know that story artist Al Wilson was leaving the studio. Al was living in nearby Santa Barbara and, being a golf buff, wanted to spend more time on the links. So the rather small story crew on Disney's *The Jungle Book* had an opening.

Of course, I was well aware of the film being in production. My office in 1D-1 was right down the hall from Milt Kahl, and I could hear the soundtrack as Milt ran his animation tests on the Moviola over and over again. I was enjoying a break from feature films and was content working on short projects on which I had the opportunity to assist guys like Ward Kimball. But then one Monday morning, my boss, Andy Engman, called me into his office with some rather startling news. I was being moved upstairs to the story department to work on *The Jungle Book*. News like this would have delighted most artists, but it left me puzzled. Why would they want me in story, I wondered?

So, less than elated, I moved my stuff upstairs to C-Wing on the second floor of the Animation Building. I was well aware of the location. This was Woolie's unit and the headquarters of Disney's newest feature film. My roommate was story veteran Vance Gerry, a talented, soft-spoken gentleman who had to be the most mellow man in the universe. In those days, the story artists often worked two to a room, with their desks facing each other. This setup gave the story artists opportunity for continual give-and-take as they went about their task of crafting a story sequence.

Still concerned that Disney management had made a blunder, I went about my duties hoping that I wouldn't prove too much of a disappointment. Vance told me I would start boarding from an outline by writer Larry Clemmons. Larry was an old guy who had worked in radio on the 1940s *Bing Crosby show*. In time, Larry found a home at Disney Animation, where he became the official writer for many years. Larry would provide the story artists with an outline of each sequence. This was not a script in the conventional sense but rather a rough outline describing the basic theme of the sequence. Working from this bare-bones outline, the story artist would flesh out the sequence. That meant developing the ideas and adding entertaining bits of business. You just can't write on a typewriter, "Pluto gets plumber's plunger stuck on his fanny ... Does funny things." You need to get it spelled out. Storyboard artists were given a lot of freedom at Disney to elaborate upon an idea. They could even delete and rewrite dialog as needed. Once completed, the sequence would be shown to Woolie, and if he approved, your next meeting would be with Walt Disney. This was done via a custom called "the pitch." The story artist took a pointer, and by pointing from drawing to drawing, they explain the action of the film at about the same speed it would run in the theater. This way you could see how the sequence was pacing. Only after the approvals from the pitch session would your storyboards be filmed and matched to the dialog and cut into the work reels.

Vance Gerry handed me a handful of grease pencils, also known as China markers. "Draw with these," he said. "Walt likes drawings that are bold and clear. Don't try and dazzle him with draftsmanship; that'll be provided later. For now, it's the ideas that are important." I think this was my first real story lesson. Vance taught me that the job of the story artist is to develop the story—not to design the movie or direct the movie. We tell the story. Vance liked to come up with a drawing that embodied the themed of the sequence and then "dream into it." Allowing the art to inspire the scene is what made Disney films so unique. With all due respect to my screenwriter colleagues, I think this is why the early Disney films were so brilliantly written.

It took me a while to adjust to the pace of working in story. Up to that time, I had spent my career in the animation department, where working fast was never fast enough. No matter how much footage you could plow through in a week, it seemed as if you always came up short. Animation artists were always under the gun. There was always a production manager brandishing a clipboard reminding you that you missed your quota. However, life on the second floor of Disney Animation was blissful. We were all off the clock, and we could stroll into work when we felt like it. There was little pressure, and all of us had ample time to complete our work. We met with Walt when he had the time, so that meant waiting for his availability—and that could take weeks. Should we want to view a movie, an assistant would call Warner Bros. or MGM and a print would be messengered to us. We would often sit and chat with guys such as Ken Anderson, Frank Thomas, and other Disney heavyweights. Life was sweet, and this kid was finally playing with the big boys.

I still hadn't fully adjusted to the story team after working many years in Disney Animation. There was no doubt that story had a different vibe, and in many ways I missed my animation drawing board. However, I was soon to discover that story came with a whole new set of challenges. Perhaps my old pal Rolly Crump said it best when I asked him about working with Walt Disney. "The closer you get to the sun," said Rolly, "your chances of getting burned increases." Of course, there are good things about it as well. Who wouldn't want to work with Walt Disney?

However, working with the Old Maestro was not always easy. Songwriter Terry Gylkenson found this out the hard way when Walt wanted him and his songs removed from *The Jungle Book*. I don't know the details concerning the split with Walt and the tunesmith, but it was enough to trash all of the material Terry had written. All—that is—except one. The Disney master animators loved one particular number, and pleaded with Walt to let the tune remain. Eventually, Walt relented, and that's why "The Bare Necessities" is the only Gylkenson song left in the movie.

(TOP LEFT) THE STORY PITCH
Story master Vance Gerry pitches a sequence.

(BOTTOM LEFT)
STORY ARTIST, FLOYD NORMAN
Hoping it would make me appear older, I decided to wear a tie.

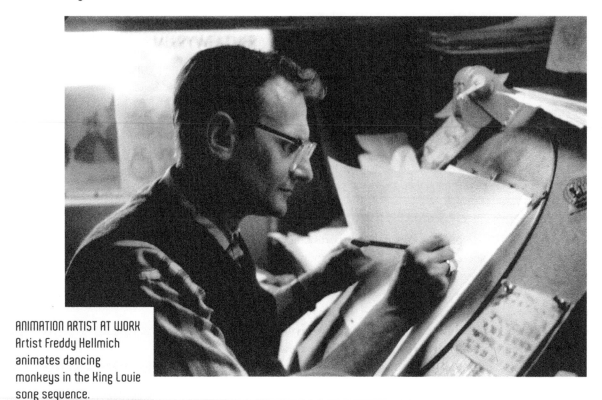

ANIMATION ARTIST AT WORK
Artist Freddy Hellmich
animates dancing
monkeys in the King Louie
song sequence.

Next the Old Maestro turned his attention to Walt Peregoy's background styling. There was no doubt that Peregoy was an incredible artist, and his knowledge of color was amazing. Peregoy had painted a series of color thumbnails that were on display in the hallway on the second floor of the Animation Building. Peregoy intended to use color to push the film in a bold new direction, and those lucky enough to see his incredible color thumbnails were privy to an animation breakthrough. Unfortunately, this was not the style Disney was looking for. Without hesitation, Peregoy was replaced by Disney veteran Al Dempster. Never a man to mince words, Walt Peregoy let his boss know how he felt about the decision. Peregoy was one of the few Disney artists who had no fear of getting into the Old Man's face. Though they often disagreed, I've always felt that Walt Disney truly respected Walt Peregoy for his outspokenness and total commitment to his art.

Walt Disney took great pride in his story men. (An outdated term, to be sure, but at this time in Disney history it was an accurate one. No woman had ever been given entrée to this famous of all Boys' Clubs.) Of all the story men, no one was more respected than Disney legend Bill Peet. Bill was always Walt's go-to guy whenever story problems arose. Peet was so trusted by Disney that he was one of the few story guys who could handle a film by himself. With this in mind, you can understand why this last disagreement was the most painful of all.

As I said earlier, Bill had been working on *The Jungle Book* for nearly a year before I joined the crew. Peet set the tone for the film; however, it was a tone unacceptable to the Old Maestro, and he made his feelings known to his ace story guy. This spat between Peet and the boss drew little attention. After all, Bill had been with Disney since the 1930s, and arguing with Walt had become commonplace. We knew that once the smoke had cleared, Bill and Walt would have found common ground and work would continue as always. Only this time it was different. Peet dug in his heels and refused to back down. Well, you don't challenge Walt Disney without him reminding you that his name, not yours, was on the building. At this point, Peet had had enough. Already a successful author of several children's books, he didn't have to be reminded that he wasn't needed. To the shock of every one of us, Walt included, Bill Peet packed up his stuff and headed out the door. Disney's master storyteller would never work on another Disney feature.

During these dark times, there were moments of lighthearted fun. If you were lucky enough to have been present on Recording Stage A back in the 1960s, you would have seen and heard singer and musician Louis Prima and his band tear up the place. Prima had been selected to be the voice of King Louie, the orangutan that Mowgli encounters in the jungle. However, Prima didn't show up alone for his recording session. He brought his band as well. And who could blame them? Las Vegas can be fun, but it can't hold a candle to Disney's cartoon factory. As Prima went through his number, the Vegas showman couldn't stand still. He was really into being King Louie. With all that energy being expended, the band couldn't help but join in. Of course, you'll never hear this music. Prima's voice was isolated on a separate track. Composer George Bruns would later record the final music. The original tracks recorded by Prima were deemed over the top. I don't exaggerate when I say Prima and his band totally freaked out. The final tracks you hear on the movie's soundtrack have been toned down. And, I mean way, way down. Louis Prima at full tilt was more than Disney moviegoers of the 1960s would have been able to handle.

© Disney

COLOR SKETCH OF BALOO THE BEAR
My sketch of Baloo the Bear.

The story crew of *The Jungle Book* had grown even smaller. Much smaller, considering the loss of a storytelling giant. However, the Old Maestro was undaunted and insisted that we push on. With the loss of Bill Peet, we couldn't help but ask the boss a very important question during an afternoon story meeting. "Walt," someone sputtered. "What about

the story?" Without hesitation, the Old Maestro puffed his ever-present cigarette and shot back his answer at all of us—and it's an answer I'll never forget. "Don't worry about the story!" Disney shouted in his gruff voice. "Let me worry about the story! Just give me some good stuff!"

The answer couldn't have been clearer. Walt wanted to be entertained. He knew that if he didn't find the movie entertaining, neither would the audience. Where were the fun, the laughs, and the gags? The charming bits of business that made a Disney film so distinctively Disney? True, I didn't know a lot about storytelling back then, but the Old Man certainly got through to me. From now on, I would approach my storytelling from a whole new perspective. Walt wanted to be entertained, and we darn well better come up with a way to do it.

A meeting with Walt Disney always guaranteed one thing. After it was over, there would be little doubt whether you had succeeded or failed. Luckily for me, my teammate was one of Disney's best. Vance Gerry pitched the Kaa sequence in his own casual manner. Pitching was a very delicate art. It was a mixture of salesmanship and storytelling. You could sabotage great ideas and great drawing with a bad pitch. Jack Kinney remembered one story artist who swore like a New York City cabdriver. During his pitch, he threw out so many expletives that Walt fired him on the spot. With Vance, there was none of the flashy showmanship and pizzazz that some story guys exhibit. Vance simply walked us through the sequence, letting the drawings speak for themselves. Vance knew that Walt hated being bamboozled. If the story wasn't working, he would know it soon enough. Our office was pretty crowded that day. Vance, me, Walt, Woolie, Larry Clemmons, Don Griffith, lead animator Frank Thomas, and a flurry of production people and assistants. You'll note that I said "our office" and not "the conference room." In those days, the meetings were held in the story man's office. No need to drag storyboards down hallways to a meeting room. I still wonder why this sensible system was abandoned!

The Old Maestro was not known for handing out compliments. I remember songwriter Richard Sherman speaking of an incident in which he and his brother played a new song for Walt some years ago. Disney listened for a bit, and then said, "That'll work." The brothers were delighted. That simple statement was a pretty good indication they had "hit one out of the park."

At the conclusion of Vance's pitch, Walt turned to our director Woolie Reitherman and said, "We could use a song here. I'll get the Sherman brothers to write something for you guys." This turned out to be the song "Trust in Me." And with that, the boss excused himself and moved on to other matters.

Woolie, Larry Clemmons, Don Griffith, Frank Thomas, and "the boys" shuffled out of the room delighted that the meeting had gone so well. Vance Gerry had a slight smile on his face. That was pretty much all the emotion my laid-back partner was going to show.

Many years ago, my mom took me to see Walt Disney's *Dumbo* at the Fox theater in Santa Barbara. Sterling Holloway voiced the stork that delivered little Dumbo to his mom, and it's a voice I'll never forget. Over the years, I would hear that same voice in numerous Disney features; Holloway also gave voice to Winnie the Pooh. Holloway was in his own way a Disney legend. So you can imagine how I felt one day in Recording Stage A as I watched and listened to Sterling Holloway record the song, "Trust in Me." The quirky actor sat on a tall stool in a pool of light. There was a music stand, and a boom microphone looming above the large recording stage.

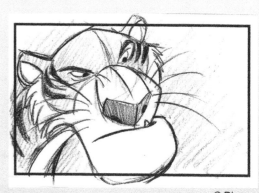
© Disney

STORY SKETCH
Our villain, Shere Kahn, the Tiger.

George Bruns scored the music for *The Jungle Book*. Disney, like most film studios of the day, kept creative sound people on staff. Bruns was now part of the Disney family. He also played in Ward Kimball's jazz band, the Firehouse Five plus Two, and I was lucky enough to jam with these talented musicians one Saturday afternoon. I was playing a borrowed saxophone that had seen better days. Whenever the battered horn squawked, Kimball would yell at me saying, "Play whole notes, just play whole notes!" Today, it was back to business: Bruns lifted his baton, and the music began. Holloway weaved on his stool as he sang. He was quite a sight with his red hair and wide eyes. Sterling Holloway suddenly became Kaa the Snake, and I watched him intently, eager to incorporate as much of his mannerisms into my boards. Yet time has a way of moving on, and I did not see the talented actor again until the early 1990s when he returned to the Walt Disney Studios to be honored as a Disney legend. Sterling Holloway passed away in the late 1990s. His distinctive voice was replaced by Jim Cummings in *The Tigger Movie*, a Winnie the Pooh feature directed by Jun Falkenstein. I did story on that film as well, and I'll always regret not getting to work with Sterling Holloway one last time.

© Disney

COLOR SKETCH OF MOWGLI
This cute kid needed a voice replacement halfway through the film. Kids have a habit of growing up, y'know.

© Disney

ROCKY THE RHINO
Hardly a big hit with Walt Disney, the wacky jungle critter was quickly cut from the film.

While we're on the subject of music, did you know we were going to do a rock and roll number in *The Jungle Book*? That's right, the song "That's What Friends are For" initially had a rock beat not unlike that of a popular singing group recently imported from the United Kingdom called the Beatles. As the popularity of this long-haired group continued to soar, we thought, why not incorporate this pop style into our film? However, Walt Disney was no fan of the Fab Four. He saw them as a flash in the pan, and said they would be forgotten in a few years. Walt suggested we stick with something that would never go out of style, such as a barbershop quartet. I didn't totally agree with Walt on this one, but I did get to take home a handful of Beatles albums that the studio had paid for. As for the singing group, I think Walt Disney might have been surprised. Rather than being forgotten, the Beatles went on to be the voice of their generation and one of the most influential bands of all time.

Finally, there remained that little matter of getting Mowgli back to the Man Village and the important scene that wraps up the film. And here we have another instance where the answer is right in front of your face, but you fail

THE JUNGLE BOOK POSTER
Decades later, I'm continually reminded of the work I did back in 1966 and what an impression the film made.

to see it. We had gone around and around trying to find a reason that would motivate Mowgli to leave the jungle, but nothing seemed to resonate. "It's simple," said the Old Maestro. "He sees the little girl and follows her." "But, Walt," we sputtered. "He's a little kid. He wouldn't have any interest in girls at that age." "Do it," said Disney. "It'll work!" If you've seen *The Jungle Book*, I think you'll agree with Walt Disney and totally buy the scene. By the way, that cute little girl at the film's end is the work of directing animator Ollie Johnston. It's just plain adorable. Is there any doubt the man is a genius?

I could go on and on with more stories. Frank Thomas animated most of the sequence Vance and I storyboarded, and boy, does he make us look good. On another note, one of the actors doing a vulture's voice in the movie turned out to be Digby Wolf, a producer I would later work for as a writer on television shows *Laugh-In* and *Turn On*. Although we didn't think that much of *The Jungle Book* at the time, Vance and I continue to be amazed at how much this film is loved by Disney fans. Many young artists tell me this movie inspired them to seek a career in animation.

Finally, I'll mention the screen credits. Did you notice that Disney story man Bill Peet doesn't have a credit on *The Jungle Book* even though he labored on the film for over a year? As a matter of fact, not one story artist—with the exception of Vance Gerry—has a credit on the film. Unlike today, screen credits were rare, and we often waited for years to finally

HALLWAY IN THE ANIMATION
BUILDING
After Walt Disney left our
last meeting, I never saw
him again.

see our names on the screen. Many artists never received a Disney screen credit. My first credit was garnered for *The Hunchback of Notre Dame* in 1994, even though I had started at Disney decades earlier. No matter. By caprice, I was given the opportunity to work with Walt Disney on his final film. That alone is all the reward this animation veteran will ever need.

I'm often asked, "What's your favorite animated film?" For a lot of reasons, it always comes back to *The Jungle Book*. Back in the old days, cartoon making was fun. Unlike today, where animated features represent an investment of millions of dollars, we were unimportant, and consequently we were left alone. And being left alone is what allows creators to do their best work. Even a boss like Walt Disney understood that. When something failed to work, he simply said, "Fix it," and left us alone to solve the problem.

When I watch *The Jungle Book* today, it's difficult to believe that I was ever part of this animation classic. It was so long ago, yet somehow it still feels like yesterday. Most of the Old Boys have since passed on and now we have a new generation of animation artists working to build their own legacy. As these new kids labor over their drawing boards and computer screens, I'm sure they're enjoying their work as much as we did. However, they'll never be able to say they worked with Walt Disney.

Your Host, Walt Disney

9

On Set with the Old Maestro

Walt Disney on the Set

As a regular visitor to Walt's set, I made this sketch to show what the filming process was like.

As winter approaches, I can't help but remember another December when things were less than cheery. It was December 1966, and we had lost the Old Maestro a few weeks earlier. I can't recall a drearier holiday season so many years ago.

However, I'm not mourning Walt's passing; rather, I'm remembering a very live and lively Walt Disney on the set of his television shows, *Disneyland* and *The Wonderful World of Color*. What was it like to see Walt Disney do his introductions for his television show? No research was done for this story on Walt's behavior on set. None was needed. I was there.

Like so many Americans back in 1955, I was introduced to Walt Disney on the television set in the living room. He appeared in glorious black and white on the ABC television network, and Wednesday evening suddenly became very special. As you can imagine, this Disney geek was entranced as Uncle Walt opened his magic factory to all of us. We were allowed to peek inside the animators' offices, the screening rooms, and even into Disney's private office, where Walt would let us in on some of the secret projects currently in development. Though still in school, I was already dreaming of a career at the Walt Disney Studios.

You can imagine how surprised I was when I arrived at the Walt Disney Studios some years later only to find my trip inside the fabled Animation Building to be a fabrication. The story rooms, workshops, and even Walt's office itself from TV were all studio sets on a sound stage. Still, it was magical being at the Walt Disney Studios back in the 1950s, and I wondered what it would be like to see the Old Maestro do his Disneyland spiel in person. Of course, this would mean a trip over to Stage Two and Walt's "closed set." However, that wasn't about to stop me.

If you've ever entered a sound stage during a film shoot, you know that you're immediately surprised how dark it is. Then your eye is drawn to one small area that's ablaze with light. The crew scurries about moving lights, pulling cables, and moving equipment. In the center of all this activity stood one lone individual behind a desk. It was Walt Disney himself.

The old guys told me Walt never wanted to do the introductions to the Disneyland program, but ABC had insisted on it. The network wanted to capitalize on the fame of the Old Maestro, and naturally they wanted him on camera. Disney needed the ABC deal to complete his theme park then

WALT ON SET
Walt was a natural actor and seemed—surprisingly, to me—at home in front of the camera.

(TOP LEFT) THE VERY PATIENT FILM CREW
Things could get a little tense when working with the boss.

under construction in Anaheim. Reluctantly, Walt agreed to do three or four openings a season, but that quickly changed, and he began appearing more frequently. Going before the cameras was not a first for Walt Disney. Some years earlier, he had appeared in a television special, and to the surprise of many, was good at being a television host.

I'm a little tired of Walt Disney lately being characterized by revisionist historians as a dour and angry person. Some of the criticisms range from Walt being a tyrant to an incredibly moody and morose individual, ever ready to lash out at subordinates. That may indeed be the Walt you read about, but it was not the Disney I observed. True, Walt Disney considered filming these introductions an obligation. As you can imagine, he had other things on his mind, and was eager to get back to business. There were scripts to read, storyboards to approve, and a myriad of things to check over at WED Enterprises, the theme park unit he had launched.

Still, Walt maintained his cool as he went through this task. Although it's true that he would often flub a take and fumble and stumble over script lines, he took it all in stride. He blamed himself, and his humor was more often than

not self-deprecating. On occasion, he would get flustered and grumble over having to do take after take. This of course made the director even more nervous, and I didn't envy the poor individual who had to ask the boss to do it "one more time." I've got to give special credit to Ron Miller, who often sat in the director's chair. Can you imagine directing the head of the studio, who also happens to be your father-in-law? Mr. Miller deserves my praise for having done one of the toughest jobs at the Walt Disney Studios.

Though these filming sessions often went longer than Walt expected, I never once saw him lash out at any individual or blame a crew member. One day in particular, Walt just couldn't get a line correct. As the director called for take after take, the Old Maestro was known to utter a few choice words in frustration. However, Walt's colorful language was nothing I hadn't already heard from my grandfather, who—like Walt—grew up on a farm.

Finally, do you remember the wonderful presentation Disney gave on his concept for EPCOT—the Experimental Prototype City of Tomorrow, which would have an impact on the future of this nation and maybe even other countries around the world? Did you realize that this filmed presentation was shot only weeks before Disney's passing? Yet as you watch the motion picture, Walt remarkably shows no sign of his illness. He delivers his presentation with the same youthful enthusiasm and optimism that characterized much of his life.

On this winter day, I can't help but think how lucky I was to have seen the Old Maestro in person—to not only watch Disney on the small screen, like many of you, but also to have been on set when Walt was filming those segments. The Disney you saw on camera was pretty much the same Disney you saw in person. There was little difference.

With filming completed, Walt, still in makeup, would rush off the set. He had a busy day ahead, and there was still much to do. Walt Disney would work very hard that day, but he loved every minute of it. Though time was quickly running out for the Old Maestro, he appeared content with his life . . . comforting thoughts for this Disney old-timer on a cold December day.

HOSTING THE SHOW
Although he pretended to not enjoy the task, Disney made an excellent host.

Spotted Puppies and a Bold New Direction

Technology Reshapes the Cartoon Business

A New Animated
Feature

Because of
increasing budget
concerns, animation
had to be reinvented
at the Walt Disney
Studios.

After six long years crafting the animated classic *Sleeping Beauty*, the Walt Disney Studios found itself at a crossroads. Walt's brother Roy, who oversaw the company's finances, presented an ultimatum to the studio boss: reduce cost, or the future of animation was questionable.

 Sleeping Beauty had taken a serious toll on the studio, with its lengthy production schedule and massive staff. Plus, a disappointing opening and the film's failure to make back its cost didn't bode well for the future. The market for Mickey, Donald, and Goofy shorts, once the bread and butter of the company, had dwindled as more and more kids watched cartoons on TV. Disney Animation needed to make some serious changes, and make them soon. Fortunately or unfortunately for all of us, the studio was prepared to do just that. First of all the sizable animation department was reduced to half its size. That still left hundreds of workers in Disney's Ink & Paint

PON GO

© Disney

department where the acetate sheets called "cels" were inked and painted by hand. However, that department would soon see a change.

Ub Iwerks was well known as Disney's technical wizard. Ub ran the process lab, where the optical work and photographic effects were created. Most of us looked at this Disney facility as a "secret research and development lab" where technicians crafted masterful solutions to the studio's technical challenges. The photocopier had emerged on the scene as an amazing new technology destined to revolutionize business. Could this device revolutionize putting animation drawings onto cels as well? Ub Iwerks decided it could. He deconstructed a Xerox photocopy machine and rebuilt his own. Animation tests were completed and photographed using the new process. When the time was right, the Disney technician screened the results for Walt and it appeared the experiment was successful. Animation cels would no longer be inked by hand. This meant considerable cost savings. Characteristically, Walt Disney gave his approval. "Look into it," he replied.

WALT DISNEY STUDIOS
The 1960s brought
changes and a new
technology to Disney
Animation.

However, the new Xerox process meant changes for art direction as well.
Disney's art directors would have to consider how this new production
process affected future motion pictures. The Xerox process lacked
the subtlety of hand inking. Characters could no longer be done in
"self-line"—meaning that the outline colors of the character were the same
colors of the characters—to increase their three-dimensionality. Because
the Xerox machines could not yet do color, they would have to go back
to a hard black outline, like they had in the 1930s. Could there be a way to
incorporate this new process in a film's design? Art director Ken Anderson
was convinced that he had a solution. Working with character designer
Tom Oreb and color stylist Walt Peregoy, the team crafted an exciting
new look that would move animation in an exciting new direction. Inspired
by the brilliant work of British cartoonist, Ronald Searle, Disney's new film
would feature a more linear design and a richly expressive "thick-thin"
outline for the characters. Because the animation drawings were being
photographed by the photocopier and not traced by an inker, you could
even let the outline be of a rougher, less smooth texture, with some hint
of construction lines. In addition, the color palette by Peregoy would be
bold and provocative. This motion picture represented a whole new design
approach for Disney.

(TOP LEFT) THE LEARNING
CONTINUES
A quick sketch of the
spotted doggie.

Downstairs in the Animation Department, things were no less revolutionary, as the studio artists struggled to adapt to the new way of producing animation. The sizable crews of the previous feature film were reduced to a handful of animation artists. The animators would more than double their output, and the clean-up process would slowly evolve into something we eventually called "touch up." The smaller units were clearly faster, cheaper, and more efficient. In almost no time, these new animation units functioned like a well-oiled machine cranking out reams of footage that would have been unimaginable on the previous feature, *Sleeping Beauty*.

With smaller crews and a greatly compressed production schedule, *101 Dalmatians* was completed in a fraction of the time it took to create *Sleeping Beauty*. That meant a huge cost savings and a new lease on life for Disney's Animation Department.

Looking back on this remarkable film, I'm reminded of the stories I've heard over the years. Many still believe that it was the Xerox process that enabled the creation of multiple spots on the dalmatians. Though the process did allow us to duplicate multiple drawings of the puppies, the spots on the dogs were still drawn by hand. Clever animation assistants worked out a system that allowed them to keep the multiple spots in the right doggie location. *101 Dalmatians* was still very much a hand-drawn feature animated film, although the elimination of the venerable Inking Department and the incredibly talented women who traced the drawings would change animation forever.

101 Dalmatians was a turning point at Disney Animation. Though it seems like ancient history today, the film's production represented technology's first impact on the animation process. It changed the way we worked in animation and pushed styling in a bold new direction. Of course, this was only the beginning of the technological shifts in cartoon making. Though digital techniques were still decades away, it was clear that they would one day affect Disney Animation as well.

However, this Disney film also taught us all the importance of remaining flexible and adaptable—open and willing to change and to accept any challenge as an opportunity to become even more inventive and creative. I have little doubt that Walt Disney would have encouraged that.

Transition

I didn't work on Disney's *The Black Cauldron*, so you'll gain no filmmaking insights from me this time around. Oddly enough, this was a very important film for The Walt Disney Company, and although it didn't exactly burn up the box office charts when it opened, it served an even greater purpose. However, we'll get to that later.

What I did find interesting back in the early 1980s was a change in attitude at Disney's animation department. Curious about the film, I thought I might stop in for a chat with animation boss Ed Hanson. I had known Ed for years while working at the studio. Ed had been director Wolfgang Reitherman's assistant for many years before taking on the position of animation manager. What I found odd was that Ed acted as though he hardly knew me and seemed reluctant to let me on the Disney lot for an interview. He told me to check back later because Disney CEO Ron Miller hadn't seen the movie.

Eventually, I was granted an interview and found myself back inside Walt's magic kingdom. The Walt Disney Studios felt weird because young artists now filled the animation building, and most had been recently hired. The young staffers displayed an odd arrogance and behaved as though they were "old Disney veterans." Some even preceded to lecture me concerning "how we

STORY CREW
Adapting the novel to
film proved to be more
difficult than anticipated.

make pictures." Were they clueless, I wondered? I was working at Disney
when most of them were still in middle school.

The Black Cauldron continued to garner a fair amount of media attention,
even though the movie struggled in development. The studio knew it
needed a refresh after a number of lackluster films failed to attract much
box office attention. The lure of pixie dust and Disney feature filmmaking
was compelling enough to warrant a return visit to the Mouse House. I
knew Disney was touting their new production and that they hoped their
animated experiment would be a breakthrough motion picture. I eagerly
headed upstairs to the second floor for a look at what I hoped would be
awesome artwork.

Having made my way to Animation's second floor, I wandered about
looking for what I knew would be a treasure trove of cool layouts and
backgrounds. Much to my surprise, there wasn't a thing in sight. I entered
one of the second floor wings only to find the inner door locked. Where
was I, I wondered? Was this the Walt Disney's Studios or Washington,
D.C.'s Pentagon? Eventually, I asked a passing artist about the film's
backgrounds. "We don't want the artwork in view," he replied. "It's

much too valuable." Too valuable to have on display? I couldn't help but remember when the awe-inspiring *Sleeping Beauty* backgrounds of Eyvind Earle were on view everywhere. Now, this Disney art was too precious to even have on display? I couldn't help thinking, "Give me a break!"

I was never accepted for a position on *The Black Cauldron*'s fledgling animation team, so I returned to my television gig making bad Saturday-morning cartoons. However, a few years later, I was asked to joined Disney's publishing department as an editor, and that turned out to be one of the best jobs I ever had.

Animation was still in my blood, and my new office on the third floor of the Roy O. Disney Building was only a short walk across the narrow street to the animation facility. I remained in touch with many of the animators and listened to their complaints and their dissatisfaction with the film and the way they were treated. The stories they told were more than familiar. Top animators were cherry-picking the good scenes and leaving the more lackluster stuff for others. And, of course, politics ran hot and heavy. I had heard these same stories more than a decade earlier, and I was reminded that things seldom change in the animation business. The situation began to grow even worse as the film continued to struggle. Director Art Stevens would eventually leave the movie and the Walt Disney Studios as well. I had assisted Art in my younger days, and I was sad to see such a talented animator end his Disney career on a sour note.

Being back in the Disney family meant I could attend screenings of the ill-fated animated feature, and each new screening grew successively worse. The directors began shifting the order of sequences, as if that would garner a more compelling narrative. Sadly, nothing appeared to help, and the arrival of new Disney management in 1984 only drove the nail deeper. The studio finally released the film with little fanfare, and audiences had zero interest in the dark, dreary Disney motion picture.

Cheer up, because this sad animated story has a silver lining. Remember all those green, young animation artists I mentioned early on? Many of them had never worked on a Disney feature film. *The Black Cauldron* provided an excellent training vehicle, and scores of young animators and assistants developed their chops while working on the movie. Of course, you already know what happened next. An animation renaissance was on the horizon, and a new series of motion pictures would garner critical acclaim and generate millions of dollars. Walt Disney's young revitalized Animation Department would never look back.

Roy's
Camera

The 16 mm Bolex

My very wise
purchase from Roy
Edward Disney.

A Non-Disney True-Life Adventure

Back in Disney's old days, life was simple. It was before corporate management laid down dozens of rules, protocols, and regulations that complicated the heck out of everything. When an employee wanted to sell something, he or she simply posted it on the company bulletin board. That meant any Disney employee could take advantage of the dozens or hundreds of potential buyers who walked the hallways each day. It was Craigslist before Craigslist and eBay before eBay. A slip of paper, a pushpin, and a bulletin board was about as high-tech as it got. However, this particular acquisition has an unexpected twist, but we'll get to that later.

As I made my way down the hallway of Walt's animation building one morning, I spotted a very special posting. Someone was selling a movie camera: a 16 mm Bolex that also shot single frames. I was an aspiring animator and filmmaker, and this was exactly the camera I needed. Plus, the seller wanted only a few hundred dollars for the used camera. In anybody's book, this was a bargain. And, who was the seller, you ask? It's a name I'm sure you know. He was the son of one of the founders of the company and the nephew of Walt Disney. Yes, I'm speaking of Roy Edward Disney.

At the time, young Roy had been active on a series of projects for The Walt Disney Company. He had worked in editorial on TV shows like *Dragnet* and even as a cameraman on the Disney True-Life Adventure series. Roy was earning his chops as a filmmaker and working his way up the ladder as a writer-producer. Even though Walt's nephew could hardly be considered a major player at The Walt Disney Company, he was still somewhat intimidating to guys like us. Consequently, I was reluctant to make the walk to the upstairs executives' offices to bargain with Roy Disney.

I was in danger of missing out on a great deal because I simply didn't know how to approach Roy Disney. Today, I look back on this incident and laugh, because Walt's nephew has always been approachable and a very nice guy. However, I was young and new to the company. Even the name "Disney" sent chills down the spine of this young animation assistant.

Lucky for me, animation artist John Kimball happened to be a friend, and we worked together in the first-floor Animation Department. The son of one of Walt's "Nine Old Men," John Kimball was quite comfortable dealing with the studio big shots. Supported by Ward Kimball's son, we headed upstairs with cash in hand, and in no time a deal was struck. Roy Edward Disney was $250 richer and I had my camera. However, the story doesn't end here.

As I mentioned earlier, Roy Disney had taken his camera into the field to photograph Walt Disney's True-Life Adventure series. Now, a totally different True-Life adventure was about to take place. My original reason for purchasing the movie camera was to photograph cartoon drawings on my homemade animation camera stand. Suddenly, my innocent cartoon world of fairies and bunny rabbits was interrupted by unexpected real-life events that would shake the nation. The city of Los Angeles erupted in chaos and flames as riots tore through the city.

My associate Leo Sullivan was a friend and a longtime colleague. Though trained as an animator, Leo was an even better producer. We founded a company in the 1960s called Vignette Films, Inc., with the intent of producing educational movies. Leo and our cameraman, Richard Allen, quickly grabbed our equipment, which consisted of two 16 mm Bolex cameras and armloads of film. This was 1965, and the mainstream media didn't have the stomach to enter the urban battlefield of south-central Los Angeles. It's difficult to explain an event such as an urban riot. It was terrifying, with an almost surreal quality. In many ways, it was not unlike assuming the role of a combat photographer. You move into the war zone determined to garner the best footage

possible. As motivated filmmakers, there's a need to document everything happening around you, so there's little sense of danger. Yet buildings are ablaze and you find yourself stepping on consumer products littering the streets—items dropped by looters making their way out of local shops and markets. The events of the evening were bizarre and memorable. One gang waited patiently for our cameraman to reload before torching a building. Clearly, the rioter was hoping for a spot on the evening news and a few seconds of fame. Another looter rummaged through racks of clothing in a burning department store, looking for items in his size. Though all these events were scary, they might have come out of a crazed Tex Avery animated cartoon. The hapless rioters thought they were "sticking it to the man." In reality, they were simply burning down their own neighborhood. After photographing the unnerving nighttime events, the footage was delivered to NBC in Burbank, where newsman Tom Pettit quickly edited a television special that went on the air nationwide.

I'm willing to bet you probably didn't know that all of this had a Disney connection, did you? That's right, boys and girls. The very same 16 mm Bolex camera that Roy Edward Disney used to photograph Walt Disney's True-Life Adventures was used to document another most unlikely True-Life Adventure: the historical event known as the 1965 Los Angeles Watts Riot.

THE 1965 WATTS RIOT
Filmed on location with a camera once owned by Roy Edward Disney.

Perfect Partnership

Floyd Norman and Leo Sullivan

Our long-time partnership began in the 1960s.

This book would not be complete without a look at my long-time friend and colleague, Leo Sullivan. Leo and I have a very animated history, and we've shared a good deal over the length of our careers. Oddly enough, it all began at the Walt Disney Studios in Burbank.

I first met Leo Sullivan in Andy Engman's office at the Walt Disney Studios, when he was applying for a position in Walt's animation department. While interviewing Sullivan, the jovial Engman remarked, "I've a black animation artist I want you to meet." The always-cheeky Sullivan replied, "I can meet a black guy any day. I came here looking for a job." However, that first meeting at Disney led to a partnership that has lasted over 50 years.

Like most successful partners, the two of us are pretty much opposites. I suppose my low-key personality was the perfect match for Leo's more expansive persona. Sullivan has always excelled as the perfect pitchman and has been effective in meetings. I preferred to sit quietly in the background and let my art speak for itself. In any case, the two of us hit it off immediately, and we've been working together ever since.

Leo decided not to go with Disney but choose to work instead with legendary animation director Bob Clampett. Located on Seward Street

THE FOUNDERS OF
VIGNETTE FILMS, INC.
The young film company
opened its doors in the
1960s; the founders
included Leo Sullivan,
Richard Allen, Norman
Edelen, and Floyd Norman.

in Hollywood, the Clampett Studio was the quintessential cartoonist madhouse. Presiding over the madness was no less than the boss himself, who was known to roam his studio with his puppets Beany and Cecil the Seasick Sea Serpent. It was a fun, free-wheeling environment in the heart of Tinsel Town, and returning to Disney in the Valley was like a visit to a nursing home.

Impatient with the time it took to become an animator or director, Leo and I were eager to make our own animated films. Over time, our rented apartments became film facilities, and we created a number of our own little productions. We moved from black and white to color, inking and painting all the cels with the help of geeks and girlfriends. Before long, we had graduated to sound cartoons and gained confidence that we could play the same game with the big boys. It was Leo Sullivan's confidence that took us to the next level.

With the passing of Walt Disney in 1966, I handed in my resignation and a group of us founded Vignette Films, Inc., in Los Angeles. Along with Norman Edelen and Richard Allen, Leo and I launched into a series of educational films on black history. School systems across the United States became our market, and we avoided the siren song of big-time Hollywood, where the

THE MENTOR WITH
HIS STUDENTS
Many of the kids who
worked with us went
on to have impressive
careers in the animation
industry. Pictured are
Pat Ventura, Leo Sullivan,
and Gary Trousdale,
co-director of Disney's
Beauty and the Beast.

doors were usually kept closed anyway. We did produce a television pilot starring former Disney Mousketeer Ginny Tyler. More than just an animator, Leo wore several hats in our little production company. He wrote, directed, and produced several films, all the while serving as studio manager. These were skills that would serve him well in the future.

In a way, our little company became a combination film and business school, and we learned our chops on the job. Big-time Hollywood talent contributed to our small films and we worked with such names as Steve Allen and *Twilight Zone* creator Rod Serling. It was during this time that Leo began to focus on such things as distribution and marketing—subjects seldom taught in film or animation schools. Yet these things are often crucial to success in this rollercoaster business. It was also during this time that I learned that my partner Leo was an excellent movie producer. Actually, it would not be exaggerating to say he's better than most. During this time, it was highly unlikely that a black man would ever be given such a position in a major studio. That would change, of course, but that time was still decades away.

The 1960s brought new opportunities, as Leo and I worked with Bill Cosby on the first *Fat Albert Special* for NBC. Plus, we were part of the writing team on ABC's ill-fated sketch comedy show *Turn On*. We found work on

LEO SULLIVAN AT WORK
One of the finest producers I've ever worked with, Leo managed studios around the globe as well as here in Hollywood.

its producers' other, more successful show, called *Rowan and Martin's Laugh-In*. If not for our love of cartoon animation, we might have considered another career and become television gag writers. After all, guys like Bud Swift and Frank Tashlin gave up animation for more high-profile careers in television and movies.

In the 1970s, I received another call from Leo. This time my pal was running the animation division of a commercial production house in Beverly Hills called the Spungbuggy Works. The company produced live action and animated spots for national clients, and Leo Sullivan once again was demonstrating his skills as a studio manager. I was content to work at my animation desk while Leo haggled with clients.

Setbacks are to be expected in this crazy business, but you have to keep going. Our movie deal with Doubleday exploded when the airplane carrying the executives crashed during a rainstorm, killing all aboard. Our potential feature film with Universal went into turnaround when our producer-director keeled over on his tennis court, dead of a heart attack.

In spite of all this, Leo and I maintain our frantic moviemaking partnership. Leo continues to pitch and produce, and I keep doing whatever else is necessary. Over the years, we've done darn near every kind of film or TV show you can imagine, from the most insipid kiddy show to the Los Angeles Watts Riot. Leo Sullivan—the consummate producer—has pretty much done it all.

Finally, Leo accepted an animation assignment in Shenzhen, located on China's mainland, where inefficient state-owned enterprises were restructured by the introduction of western-style management systems, probably the most daunting task of his career. Leo Sullivan managed an animation studio that employed thousands, and the poor guy didn't even speak Chinese. Yet because of his exceptional management skills, all the televisions shows under his charge were delivered on time and on budget, and Leo even won the respect of his Chinese colleagues.

My old partner and I began this filmmaking journey while we were still young men in our early 20s. We both shared a love for this crazy cartoon business, but we were so impatient with the lack of progress that we launched our own studio. Looking back, it was a totally crazy idea—but it was the best idea we ever had.

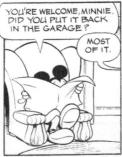

© Disney

The Other Floyd

Mr. Gottfredson and His Famous Mouse

The old battered drawing table sat in the corner of my office at the Walt Disney Studios. Though it occupied the corner for a number of years, I never worked on it. I considered it a priceless relic—a special piece of Disney history that had been rescued from the dumpster by a few hardy souls who knew the significance of this well-worn item. It was the drawing table used by Floyd Gottfredson.

If you're not up on your Disney history, you may not know the name Floyd Gottfredson. Floyd was the artist Walt Disney chose to write and draw the *Mickey Mouse* comic strip. Back in the 1930s, comic strips were as important as film in keeping your cartoon character popular. It encouraged people to go to the theaters and buy the toys. Today, we call this marketing concept "synergy." Walt Disney was an acknowledged master of it. As Mickey Mouse was beginning to grow in popularity, Disney borrowed Floyd from his animation department until he could find a permanent artist to draw and write the strip. This "temporary job" lasted 45 years. Guided by Gottfredson, *Mickey Mouse* became one of the most entrancing adventure strips of the era. While the animated cartoon Mickey

© Disney

FLOYD GOTTFREDSON
Floyd's career with Mickey began in the 1930s; he drew the famous mouse until his retirement in the 1970s.

became more of a wimp, Floyd's Mickey was put through every adventure imaginable. Whether it was detective stories, westerns, or science fiction, Mickey Mouse could always deliver the goods.

When my pals and I were young animation artists learning the ropes at the Walt Disney Studios back in the 1950s, we spent our breaks and lunch hours exploring our new place of employment. Every wing, hallway, or building provided a new learning experience. There was much to see and many talented people to meet. Keep in mind this was the Disney of the 1950s, and artists were everywhere.

One day, we wandered into a structure called the Production Building, located near Stage One on the Disney lot. As we explored the second floor of the building, we were pleasantly surprised to find a group of artists working away at their drawing boards. Without knowing it, we had stumbled into Walt Disney's Comic Strip department. I can't remember all the names of the artists we met, but two of them were special. Al Taliaferro was drawing Donald Duck, and the other gentleman was Floyd Gottfredson, the artist who drew the *Mickey Mouse* comic strip from its beginning in the 1930s to his retirement in the 1970s. It was a thrill for all of us to meet the guys who had been entertaining us since we were kids with these wonderful Disney strips.

Years passed, and I forgot about the special day when we met Disney's comic strip artists. My interest was animation, and there was little time for anything else. I never gave Disney comics another thought until the late 1970s, when I was pleased to have lunch at the Disney commissary with veteran Disney writer Cal Howard. Apparently, Cal had heard that I had a knack for writing funny gags, and he wondered why I was not working for Disney Comics. I was flattered to be considered as a writer in Disney's Comic Strip Department, but I was about to begin work as a story artist on another animated feature, and writing comics just didn't compare to working in film. As luck would have it, my feature animated project crashed and burned, leaving me unemployed, with the Disney offer still standing.

In December 1983, I found myself back at the Walt Disney Studios, working as a writer in the Comic Strip Department. The move from movies to comics had been surprisingly easy. I was still working with all the lovable Disney characters I had come to know over the years, and I was given free rein to write whatever stories I wanted. I soon realized that because of comics' low profile, the artists and writers had tremendous freedom to create all kinds of material unencumbered by Disney's management. Animation production was divided into a dozen regimented and stratified job classifications like an assembly line, but the comic strip guys were left pretty much alone to do what they wanted. It wasn't long before I realized this was probably the best job I'd ever had.

Besides writing comic stories, I was often called upon to fill in for the staff writers of the Disney comic strips when they were ill or were on vacation. I bounced from strip to strip as my services were needed. This could be anything from "Scamp," "Winnie the Pooh," or the venerable "Donald Duck" and "Mickey Mouse" comic strips. Probably the most fun during this time was the weekly writers' meeting with old-timers Cal Howard, Del Connell, and Bill Berg. These guys had seen or already written every gag there was, so they never laughed at anything. You knew you had scored a hit when Cal would casually remark, "That's funny." Cal Howard had been a gagman at a number of animation studios besides the Mouse House. His credits included *Gulliver's Travels* for Max Fleischer and MGM cartoons under the great director Tex Avery. He even did live-action gag writing for comedians like Red Skelton and Abbott and Costello. The other writers included veteran gagmen Don Ferguson, Tom Yakutis and Bob Foster. Our boss, Greg Crosby, had been a writer on the Disney strips himself before moving into management.

One day, Crosby called me into his office on the third floor of the Roy O. Disney Building. This was a more modern office building built on the lot next to the older 1930s-era structures. It was named for Walt's brother Roy, who was the financial brains of the operation. Once I was in Crosby's office, he told me that Del Connell had announced his retirement, leaving

the Mickey strip without a writer. The creator of the *Mickey Mouse* comic strip, Floyd Gottfredson, had already retired some years earlier, and Del had taken on the job until his retirement. Because I had already filled in on occasion for Del, I was the logical choice to take up the reins. I had my doubts. Filling in for Del meant a few days of writing, maybe a week at most. The thought of having to write six daily strips and a Sunday page every week was a daunting task, and I seriously wondered how long I would last before being totally drained of material. Finally, I would be following in the footsteps of Disney writers and artists like Bill Walsh, Del Connell, and the great Floyd Gottfredson. Filling the shoes of these Disney guys whose stuff I had read since I was a kid was not something I took lightly.

I honestly believed I would be out of ideas in a couple of weeks, but somehow I managed to write the *Mickey Mouse* comic strip for nearly six years before the contract with King Features Syndicate ran out in the early 1990s. Most of what I wrote was called "gag a day" because the comics

syndicate believed that kind of material sold best. However, I longed for the day when I could write the kind of Mickey Mouse adventures I had read as a kid. I hated the "gag a day" concept, because, quite frankly, Mickey Mouse is not really a funny guy. He is, however, a great character, and can be wonderful in stories. Writing *Mickey Mouse* was not always fun because I was well aware that I was no longer dealing with the feisty little character Walt had created. Mickey was now Disney's corporate symbol, with all the baggage that came with that image. I can't tell you how many times I found myself in hot water with Disney's legal people because of my gags. One organization thought The Walt Disney Company was taking a jab at satellite companies because I had Goofy using a satellite dish as a birdbath. The assumption was that Disney was taking a swipe at their industry. In reality, it was simply a stupid gag. Over time, I continued to be called before Disney's corporate attorneys for one screwup or another. Though I'm no fan of lawyers, I came to respect Disney's legal team for all I put them through.

The *Mickey* Comic Strip

A sample of my rough layouts on a Mickey comic story. © The Walt Disney Company

Disney had a long relationship with King Features and both prospered for many years. The comic syndicate is the link between the creator and his audience. It's their job to get the comic strip into as many newspapers as possible, and for years Mickey Mouse was a huge comic strip star. Perhaps I was a little naïve, but I hoped to return the mouse to his former glory.

After much pleading and begging, King Features Syndicate allowed me to change the gag format to an adventure format, as long as the continuity did not exceed four weeks. Finally, I was able to bring back the good old Mickey Mouse I loved as a kid. I wrote adventure stories and ghost stories. I sent Mickey to exotic locations around the world to fight new bad guys, as well as battle my old favorite, Black Pete. He was originally called Pegleg Pete, but then the legal department said we had to make it more politically correct. I saw Mickey Mouse as a cartoon version of George Lucas's Indiana Jones. Come to think of it—maybe that's where George got the idea in the first place. Mickey Mouse was always the scrappy little guy who never gives up. The Mickey adventure stories were a joy, and now I knew why Floyd Gottfredson must have loved his job so much.

Sadly, time was running out for both Mickey and me. It was now 1991 and King Features Syndicate had been home for Mickey Mouse since the 1930s, but now newer, trendier strips had caught the public's eye, and the contract between King and Disney was coming to an end. With *Mickey Mouse* in fewer than 30 newspapers, both companies realized that Mickey's time was nearing the end of a long and successful run. I thought long and hard about the final strip I would write. I couldn't help but wonder what Floyd Gottfredson might have written, were he still around. I was lucky enough to spend nearly six years with Walt's famous mouse. I only hope I was worthy of this stewardship. Guys like Gottfredson, Walsh, and others kept me entertained when I was a kid. I was hardly in the same class as these great Disney old timers; I only hope I didn't disappoint them.

What about Mickey? I continue to think that he must have retired and moved to Palm Springs. I can almost see him cooling it by the pool with Minnie and his pal, Goofy. As for myself, I was lucky enough to get a call to return to Disney Feature Animation, where I would enjoy another ten-year run working on animated films. This included moving north to the Bay Area to work on *Toy Story 2* and *Monsters, Inc.* at Pixar Animation Studios.

Finally, what happened to Floyd Gottfredson's old drawing board? I'm pleased to say that it occupies a corner in a special room at Disney's Publishing Department in Glendale, along with a treasure trove of original Disney art. Floyd Gottfredson's original *Mickey Mouse* comic strips adorn the well-worn desk, and visitors in the know are able to look at a genuine piece of Disney history.

(TOP LEFT) FLOYD GOTTFREDSON'S DRAWING BOARD
Gottfredson's drawing table remains on display at the Walt Disney Studios even today.

(BOTTOM LEFT) MICKEY REJECTS
In order to come up with six daily strips and one Sunday page each week, many, many gags were rejected.

Monster in the Bell Tower

15

Returning Home

Though not an overwhelming success, I think *The Hunchback of Notre Dame* was one of the most sophisticated animated films I've ever worked on. I actually went to my old pal, *Beauty and the Beast* director Gary Trousdale when I got word that he and his co-director Kirk Wise might be adapting this Victor Hugo novel for the screen. Frankly, I thought doing *The Hunchback* as an animated film was a totally crazy idea—and that's exactly why I wanted to be a part of it. Taking risks is what creativity is all about, and the thought of doing the Victor Hugo novel, with its darkness and sexuality, was a daunting challenge. Could such a story be translated into Disney animation, I wondered? So many fairy tales feature hideous creatures, and Walt's own *Snow White and the Seven Dwarfs* terrified me as a child. With its Gothic architecture, the Notre Dame cathedral could be as frightening as any Disney castle. Perhaps it was time for a new Disney monster.

The Hunchback of Notre Dame was my return to animation after a ten-year absence. In fact, I never thought that I'd return to animation, as I had found a new love. I was writing comics and children's books for Disney Publishing and

THE HUNCHBACK TEAM
It takes a lot of people to
create a hit Disney film.

DIRECTORS AND ME
That's me with our two
directors, Gary Trousdale
and Kirk Wise.

having a ball with my newfound freedom. This was a job I could do forever. However, the management of Michael Eisner decided otherwise. So I was booted out. In case you're counting, this was the second time I got the boot from Disney. Ouch!

No matter. I simply returned to Walt Disney Feature Animation, where I immediately doubled my salary. True story. You can't make this stuff up. In the animation business, you sometimes end up working for the kids you once hired. I remember a barefoot Gary Trousdale applying for a job a few years earlier. Now he was my boss. That was cool of course, because I considered this film a dream project. I loved the score by Stephen Schwartz (*Wicked*) and Alan Menken (*The Little Mermaid*). And I was given the opportunity to work with some of the greatest talents in the business.

For all its flaws, I still consider *The Hunchback of Notre Dame* a Disney masterpiece. Yeah, I know. We bit off more than we could chew. Still, I have to hand it to our talented crew for taking the risk. After all, isn't that what creativity is all about?

One chilly November afternoon in 1993, we had the opportunity to pitch this "masterpiece" to our Disney bosses. Yeah, everybody was there, including Peter Schneider, Tom Schumacher, Jeffrey Katzenberg,

THE TEAM
The *Hunchback* writers, producers, directors, and story crew.

Roy E. Disney, and Michael Eisner. Our CEO was in a jovial mood and even joked about the less-than-successful debut of what was then called Euro Disneyland. It's a pretty funny story, actually. Our art director David Goetz began his pitch with this description: "Fourteenth-century Europe. It was dark, dreary, and a time of hopelessness." Before Dave could finish his sentence, Michael Eisner blurted out "A time of Euro Disney!" Needless to say, the entire room broke out in wild laughter. Who says Michael Eisner lacks a sense of humor?

So began the dark tale of the disfigured Hunchback sequestered in the bell tower of Notre Dame. Composers Alan Menken and Stephen Schwartz were on hand to perform the songs that would grace this production. The music was well received, but Judge Claude Frollo's rendition of "Hellfire" clearly had the executives squirming nervously. Could this really play as a Disney film, they wondered?

In spite of the film's religious overtones, they bought it, and our animated motion picture was given a green light. Mind you, we were told to not make the movie too religious—a pretty daunting task when you consider how much of this story takes place inside of a big church. The entire "Hunchback" team moved out of development into a large warehouse facility on Airway Street in Glendale. This warehouse was

in an industrial park that was built on the site of Los Angeles's earliest airport from the 1930s. Where everyone from Amelia Earhart to Clark Gable had boarded aircraft. Airway Street was literally the site of the original runway. As the Disney story artists, layout crew, and animators moved into their new quarters, we decided that our building needed a name. So in the spirit of our new project, a new name was chosen. It was called "Sanctuary."

The start of 1994 was an amazing time for the production crew of Disney's *The Hunchback of Notre Dame*. We were all energized and couldn't wait to move our film into production. As the team moved into its new quarters, I made it a point to learn the names and talents of my colleagues. Because Disney Animation was knee deep in production on another film down the street, many of our crew was new to Disney. In past years, the studio had rarely gone through the government paperwork process to get foreign animators into the United States. But since the film *Who Framed Roger Rabbit* (1988), the studio had welcomed in more and more talented artists from around the world. Some had traveled from the United Kingdom, and some were from Spain, Germany, France, Ireland, and Canada. The studio had also created a satellite animation studio in Paris, and they would be shouldering part of the production.

One of our leads on Quasimodo was a new guy from the United Kingdom, and he was an awesome talent even back then. I knew James Baxter would be an animator to watch. He had led the animation crew doing Belle in *Beauty and the Beast*, and did much of Rafiki the mandrill in *The Lion King*. I had worked with some of the Canadian animators at other studios, and it was good to team up with them again. Like on most animated films, we struggled with story issues from the beginning. One example was the opening sequence that introduces our bad guy, Judge Claude Frollo. Story veteran Burny Mattinson had put together a very effective sequence that covered a lot of exposition. However, production boss Jeffrey Katzenberg felt that something was missing. In time, the sequence was eventually set to music and storyboarded by Paul and Gaetan Brizzi. The talented brothers joined our production and—unlike most of us—had actually lived in Paris. Set to the music of Alan Menken and Stephen Schwartz, this opening sequence remains, in my opinion, nothing less than brilliant.

One of the movie's highlights is the "Festival of Fools." The wild and raucous song sequence was storyboarded by the talented Kevin Harkey. Huge crowds fill the streets of Paris to enjoy the crazy celebration. Animating crowd scenes—once an animator's nightmare—now became possible because the multitudes of Paris could be generated digitally.

However, Esmeralda's dance number was another challenge altogether. The character was very sexually charged and moved in a very provocative manner. Lovingly drawn by Chris Sanders, the saucy gypsy girl was a cause for concern by Disney's female executives. Hey, this is Disney, not the Playboy Channel! More and more clothes were added to Esmeralda in the hopes of diminishing her sensuality. Another moment also caused concern. Claude Frollo sniffs the hair of the young Esmeralda and again the executives cringed. I should have reminded them that Kathy Zielinski was the animator, so don't blame the guys.

As you probably know, much is cut when a movie is in story development. Scenes and sequences are excised to improve story flow and character development. It's a process everybody in this business has learned to trust. However, I still regret the cool stuff that never made it into the movie. Brenda Chapman's inspired storyboards reveal the mysterious hunchback lurking in the shadows. Children in the streets of Paris tell scary stories of the "monster" in the bell tower, and the audience eagerly anticipates the first appearance of Quasimodo. I storyboarded a wacky pub sequence where Quasimodo, disguised as an "ugly woman," is hit on by a drunken patron. Eventually, the hunchback reveals himself, and the stunned drunk swears off booze forever.

Finally, I crafted a "rooftop chase" in which Quasimodo pursues the soldier Phoebus as he makes his way out of Paris. Climbing and sliding over the Paris rooftops, the very nimble hunchback demonstrates the abilities that will serve him well in the film's bell tower climax. Of course, every movie has its serious and silly questions. "How could stone gargoyles fly?" asked CEO Michael Eisner. Apparently, it never occurred to the boss to ask, "How can stone gargoyles talk?"

I attended a sneak preview of *The Hunchback of Notre Dame* in nearby Pasadena. The theater was only a 20-minute drive from the Walt Disney Studios in Burbank. The audience consisted of young adults and teenagers, and I knew they would have no mercy. If our film failed to resonate … well, we would know soon enough. After an hour or so, the end credits began to roll, and the usually jaded young audience began to applaud our efforts. Maybe we didn't knock it out of the park—but we didn't do half bad.

Finally, I have a special note concerning this motion picture. After having worked at the Walt Disney Studios for decades, I finally received a screen credit on a motion picture. Thanks to Don Hahn, Roy Conli, Kirk Wise, and Gary Trousdale for putting my name up on the big screen. And they even spelled it correctly.

Digital Dinosaurs

Technology in the Tar Pit

Early Ideas

Rough sketches
illustrate the world
of the dinosaur.

The Walt Disney Studios provided my first digital assignment. This was nearly a year before my move up north to Pixar Animation Studios. I spent a fair amount of time working on a project that was supposedly a breakthrough movie—a cutting-edge film guaranteed to knock the public's socks off. The film was called *Dinosaur*, and hopes were high that this would be Disney's crowning motion-picture achievement.

It was Walt Disney Studio's first attempt at an all-CGI (computer-generated imagery) movie. The Walt Disney Company had purchased computers and started a 3D unit way back in 1983 in the *Black Cauldron* days. Since that time, they had slowly been building and making digital contributions to each film, such as the Big Ben clockworks in *The Great Mouse Detective*, the Ballroom Scene in *Beauty and the Beast*, the Deep Canvas 3D background technique in *Tarzan* and more. They also created a movie visual effects unit called the Secret Lab to craft special effects for films like *Reign of Fire*. But this was going to be the first attempt at an all-CGI Pixar-type movie. It had been in production for a number of years even before we got hold of it. For a while, it was going to be a live-action movie with CG dinosaurs, much like *Jurassic Park*. Phil Tippett's visual effects (VFX) studio was considered for the production.

Because I have mixed feelings about this motion picture, I'll put it this way. Shortly after *Dinosaur* was released, I was having lunch with friends and their ten-year-old daughter. I was curious to learn what the ten-year-old thought about the film and asked for her impression. "Well," she replied, "It was kind of like *The Land Before Time*—only without the fun." This was the most concise review of Disney's *Dinosaur* I had heard.

So, how does a wacky cartoonist like myself get involved with a dinosaur movie? Well, the story begins while I was finishing up my chores on *Mulan* in the Hat Building in Burbank. My old pal George Scribner invited me over to Glendale to check out the new movie he was developing. I arrived at the Sorbus Building that evening. It was located directly across the street from Walt Disney Imagineering. Sorbus was not a clever Disney allusion; it's merely the name of the company that owned the building before Disney acquired it. Because of the long hours worked, some called it the Sore-Butt Building. I was impressed by what I saw that evening.

The building was filled with amazing artwork, and the filmmakers gave an effective demonstration on how they planned to bring these prehistoric creatures to life. A number of top computer graphics artists and engineers who had worked at Industrial Light & Magic (ILM) on the famous film *Jurassic Park* were wooed to come south to work on the project. The mandate was to create a film with ground-breaking computer animation. Because of this challenge, a special test was being created on a local sound stage that would combine miniature sets with digital dinosaurs. They even filmed live-action setups in Kauaii, Hawaii, like the original *Jurassic Park*. Once the powers that be had seen the results of this demo, funding would be provided and production would begin. However, once the Disney accountants ran the numbers, everyone realized that this approach to making the film would send production costs into the stratosphere. The 90-second test cost over $5.7 million dollars, more than the entire preproduction budget of contemporary movies like Warner Bros.' *The Iron Giant*. It was clear the filmmakers would have to find another approach to bring this movie to life. However, I'm getting ahead of myself.

Story Sketch

One of the many rough sketches done for the film.

So, back to the question: where does a cartoonist fit into all this? Well, it seems that the director George Scribner wanted his film to be more than just a struggle for survival. He wanted this dinosaur movie to have elements of fun and humor, and that's where I came in. Sure, dinosaurs can be scary. We all know the Tyrannosaurus Rex, the Carnosaur, and the Velociraptor can scare audiences out of their seats, but all dinosaurs are not scary; in fact, some are downright funny. Our director wanted to explore the fun elements of dinosaurs, such as their size, shape, and texture. George also knew that dinosaurs come in all sizes—what wacky relationships might I come up with? What funny situations might plague a critter of such massive weight? Well, I spent the next few months exploring these concepts, and filled several storyboards with dinosaur humor. Sadly, I didn't accomplish much in the way of laughs with my efforts. Eventually, Eric Leighton and Ralph Zondag replaced George Scribner as director.

MORE DEVELOPMENT ART
Creating the dinosaur
world on film.

© Disney

Not being a dinosaur expert, I gathered together every dinosaur book I could find. One of the first was the wonderful dinosaur book by artist William Stout. I started slowly, but eventually, as I got to know these fascinating creatures, the ideas began to flow and limitless situations presented themselves. I explored every wacky situation in which a dinosaur might find itself—being tangled in trees, wedged between rocks, or stuck in primordial sludge. Again, these were not life-threatening situations, but rather opportunities for physical humor that I hoped the animators could exploit. Needless to say, not one of my visual gags ever found its way into the movie. As was typical of Disney animated filmmaking at the time, visual humor had been replaced by "smart-ass" dialog from live-action screen writers. Instead of the film having its own sense of time and place, you felt like you were listening to two teenagers from the San Fernando Valley. Fortunately, I was in good company, among some great—if equally frustrated—story guys: Fred Lucky (who worked on the original *Rescuers*) Pete Von Scholly, Ricardo Delgado, Thom Enriquez, Olivier Thomas, and Tom Sito, who was waiting out his contract before moving on to DreamWorks. Most of Tom's satirical stuff wound up as gag drawings on our walls but failed to make it on to the screen.

That's the trouble with the movie, I guess. Simply making this film was an epic struggle for survival. The filmmakers had to abandon their original ideas, and the movie was produced by combining digital dinosaurs with live-action plates. After several viewings of the opening prologue, one has to admit the technique is still quite impressive. Yet even after several rewrites and hundreds of storyboards, the film story still comes across as less than compelling. This was a motion picture with enormous potential. It had input from the finest artists, scientists, technicians, and craftsmen in the business. For all the time, talent, and money spent making this movie, one would think it could have at least provided a measure of entertainment. I can only imagine what Walt Disney would have thought after viewing this film.

The dinosaurs didn't survive, and neither did I. Eventually I was pulled from the story crew and given another assignment. My departure was somewhat bittersweet. I truly wanted this to be a great movie, and in a strange way I felt I had let my crew down. Then again, it was all probably a problem of miscasting. It wasn't that I couldn't do *Dinosaurs*, I simply didn't have the right dinosaur. However, I was lucky enough to find a prehistoric critter that truly fit my style of humor. You probably know the large green Tyrannosaurus I'm talking about. His name is "Rex," and he's a member of the cast of Pixar's *Toy Story*—a more fitting assignment for an old Disney cartoonist like myself.

Playing
with Toys
Reinventing Animation

It was the early 1990s. I decided to stop in Pasadena's Old Town on my way home from the studio. I had just parked on Green Street when I noticed a car pull up directly behind me. A tall young man stepped out of the vehicle and called my name. Though I had not seen him in months, I immediately recognized my old friend Joe Ranft. "Floyd," he shouted. "You've got to come up north. We've got some great things going at our studio." I had just signed a contract with Disney Feature Animation and purchased a town home in Pasadena, so I reluctantly begged off. It was a decision I came to regret, because the project Joe Ranft was excited about was a little film called *Toy Story*.

Few of us get second chances in life—but this time, I lucked out. After the success of *Toy Story* in 1995, Pixar Animation Studios moved ahead on their second film. But The Walt Disney Company was anxious to capitalize on the success of their landmark digital film, so production of a direct-to-video sequel quickly moved into development.

"The sequel," as *Toy Story 2* was called at the time, began with a meeting in a third-floor conference room on a Friday afternoon in December 1996. Present at the meeting was Disney Vice President Thomas Schumacher, *Toy Story* producer Ralph Guggenheim, director Ash Brannon, and animator Jimmy Hayward. Disney and Pixar had decided to move ahead on the

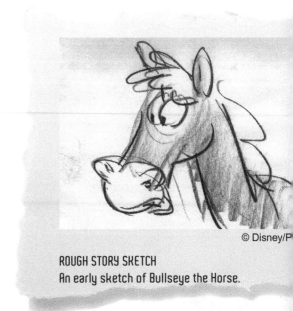

© Disney/P

ROUGH STORY SKETCH
An early sketch of Bullseye the Horse.

sequel to the hit film *Toy Story*. Because John Lasseter and his crew were still plugging away on *A Bug's Life*, it became apparent that an additional production team would be needed to create the film, which would be distributed as a direct-to-video motion picture. The film would also have the advantage of the digital assets already created for the first film. However, there was even more good news. The Pixar guys had come up with a dynamite storyline that opened up all kinds of possibilities. As a matter of fact, I hadn't heard a pitch this good in years. When asked if I wanted to be involved, it was hardly a question worth asking.

When work began on the sequel to *Toy Story*, Pixar's production facility in Richmond, California had already begun to feel the pinch. At the time, the studio housed nearly 300 people, all toiling away on the feature film *A Bug's Life*. Luckily, construction was going on across the street on a former piece of marsh land the Point Richmond locals called "Frog Town." One of the new facilities constructed on this site would eventually house the production crew of Pixar Animation Studio's third animated feature film.

Visiting Pixar Animation Studios in 1997 was much different than what you'd experience today. The studio was located in a nondescript industrial park in Point Richmond, California. The little town could easily have been a set for *The Twilight Zone*, because the town looked as though it had somehow been stuck in the 1950s and couldn't find its way out. I don't think the townspeople had any idea Pixar even existed, although some

might have wondered what the kids who wandered the streets did for a living. Each day, young people walked the quiet streets and frequented the restaurants and coffee shops at lunchtime. Then they made their way back across the railroad tracks and disappeared into a low-slung industrial facility, where they would not be seen until the next day.

In many ways, Pixar was the anti-Disney. The Mouse House employed thousands, while Pixar could count its staff in the hundreds. Legions of executives managed Disney Feature Animation, while Pixar's owner, multimillionaire Steve Jobs, worked out of an office no larger than that of most of his artists. The main facility was a creative patchwork of rooms and cubicles reflecting the artistic proclivities of its inhabitants. Unlike Disney's stylish, high-tech screening rooms, Pixar's main projection space was filled with cast-off furniture that looked like it had been picked up at a garage sale or flea market. Ideas were incubated in this crazy, haphazard environment, and some employees even brought their dogs to work.

I arrived at Pixar Animation Studios in early spring 1997. Oddly enough, it was the same day the ribbon was cut, champagne was poured, and the sequel crew moved into the new facility. Our producer Ralph Guggenheim raised a glass and gave the toast. "Pixar Animation Studios is now a campus," he proclaimed. Yet even though we had a brand new building, we were still the little guys across the tracks in what was known as "Frog Town."

What was I doing at Pixar Animation Studios that spring? Well, I had already been storyboarding on the sequel for about five months. Actually, story work began on the sequel in January 1997. We began working from a rough script by screenwriter Steve Boyette. The Disney story team of Don Dougherty, John Ramirez, Kirk Hanson, and myself began the process of storyboarding the first few sequences in the film. Our Disney group video conferenced three times a week with our colleagues up north in Point Richmond. Pixar's story team consisted of Ken Mitchroney, Matthew Luhn, Davey Crockett Feiten, Dave Fulp, and Charles Keagle.

Few of the team at Disney Feature Animation was even aware of the Pixar project. They were all working on the "important films" that were sure to be the upcoming blockbusters. At the time, Pixar was simply the "little brother" up north. Sure, they had come up with a hit film, but that was probably a fluke. Disney was still the undisputed master in the production of animated feature films. Because we had been banished to work on a Pixar direct-to-video movie we bore the stigma of not being qualified to work on the "good stuff."

One might imagine the story process was pretty much the same at both Disney and Pixar, right? Basically, yes, but there were differences. At Pixar, our sketch pads were half the size of the Disney pads, and we pinned our sketches to the storyboard with one pushpin. This process annoyed one visiting Disney story artist, who insisted that the sketches be pinned to the storyboard with two pins. However, this artist totally missed the point. Our story sketches were soon to be discarded. In fact, that's the whole point of the story development process. Story sketches are not beautiful drawings to be admired. Rather, much like a flow of ideas, story sketches are temporary. They're meant to be ripped off the board and replaced by a better idea. Pinning the story sketches with one pushpin helped us keep that in mind. A visit to a Disney story room in the 1990s would impress you with its organization and neatness. Our Pixar story room was a mess. Sketches littered the floor, a drum set occupied a corner of the room, and toys were strewn everywhere. This organized chaos proved to be the perfect incubator for great ideas; Disney's corporate story development style was already beginning to show signs of stalling.

Things appeared to be going well until our producer, Ralph Guggenheim, cancelled a Friday lunch meeting. In the next few days, we would understand why. It seemed that Ralph was not only stepping down from his assignment as producer of the movie, but leaving Pixar Animation Studios altogether. Ralph was not just some empty suit—he was one of the founders of Pixar. He had been working with Ed Catmull since his days at the George Lucas Graphics Lab and NY Tech. So his leaving was a big deal. Somewhat taken aback, we were about to be given two new producers and a new co-director. There was some good news, however. Our movie finally had a name. The sequel would be called *Toy Story 2*.

Steve Jobs and John Lasseter announced other upcoming changes as work on the film continued. Colin Brady would join Ash Brannon as co-director, and our new bosses would be two lovely young women, Helene Plotkin and Karen Robert Jackson. A lot had changed at Disney since the 1960s, when women could not expect to be promoted much further than the Ink & Paint Department. Since the 1970s, many women had moved into the upper echelons. Nancy Beiman, Linda Miller, and Kathy Zielinski were excellent animators; Brenda Chapman and Lorna Cook were doing story and directing; and Pam Coates, Bonnie Arnold, and Kathleen Gavin were producers. So, despite the disruption, we were making progress, but there were many challenges still ahead.

In early 1997, we had been storyboarding on the sequel to *Toy Story* at the Walt Disney Studios in Burbank. Occasionally, our small crew would fly north to meet with our Pixar colleagues. Our meetings were always high-spirited and energetic because things were wide open at this stage

(TOP LEFT) DEVELOPMENT CONTINUES
Story artist Matthew Luhn at work.

(BOTTOM LEFT) ARRIVAL AT PIXAR
I meet two old friends on my way down the hall.

of development. We sat in a circle in the Pixar story room and ideas were thrown back and forth so quickly that our director, Ash Brannon, struggled to referee what often seemed like a group of maniacs. The creative energy reminded me of my arrival at Disney back in the 1950s and 1960s, when the story development process was controlled by artists, not executives. Coming to Pixar was like going back in time. Working in story was suddenly fun again.

One day, Kirk Hanson brought in a pile of old videotapes of a television program called *The Howdy Doody Show*. This popular children's television show was a big hit in the 1950s. The show was presided over by Buffalo Bob Smith, but the star was really a cartoonish marionette named "Howdy Doody." We hadn't seen this kid show in years, and to be sure, it looked pretty primitive and tacky by today's standards. However, it was a jumping-off point for a television show that would play an important part in our story. Woody the Cowboy would eventually be the star of his own television show, called *Woody's Roundup*.

In the story development process, characters and ideas come and go. Originally, Woody was being sought after by a group of New York City toy collectors who would make an appearance in the film. However, additional human characters would only be a chore to pull off effectively. The toy kidnapper, Al McWhiggen, would be tough enough to animate, because at the time digital humans were never as engaging as their toy counterparts. Having the buyers reside in Japan and never seen was a more effective storytelling device.

I'll bet most of you didn't know that included in our cast of toy characters was a cute cactus toy named Senorita Cactus. This lovely Latina was in cahoots with the prospector as they connived to convince Woody to come with them to the Tokyo Toy Museum in Japan. I storyboarded a number of scenes with this cactus cutie until director Ash Brannon called to tell us that a feisty young cowgirl had replaced the lovely lady cactus. We all thought the addition of this character was a brilliant idea, and we couldn't wait to get started doing drawings of Jessie the Cowgirl.

In spite of all these good times, it soon became clear that our little group was breaking up. John Ramirez had accepted a position at Warner Bros., and Don Dougherty would be moving on to do story work on *Tarzan*. Kirk Hanson and I were the last two remaining Disney story artists on the sequel. In addition, the bosses at Pixar requested that the two of us move north to work with the rest of the crew.

A week later, Kirk Hanson and I grabbed a Southwest flight to Oakland. Kirk headed for his hotel, but I drove straight to Pixar Animation Studios in Point Richmond and checked in at the front desk. A nice young man named A. J. Riebli escorted me across the train tracks to Frog Town, Pixar's new production facility. As I walked down the hallway, one of our

new producers, Karen Robert Jackson, spotted me. This attractive young woman walked up to me and ripped the visitor's pass off my shirt. "You're no visitor," she said. "You work for Pixar now!"

And work, I was about to learn, was just beginning. Our producers, Helene Plotkin and Karen Robert Jackson, informed us of an upcoming screening of the film. New storyboards were needed, so the story crew would be working late that evening. Even before I could check into my hotel room, I was on the drawing board preparing for my first all-nighter. My story colleagues couldn't help but laugh and say, "Welcome to Pixar."

I lived in a condo in nearby San Rafael. Each morning, I would rise early and head down to a nearby coffee shop for a hot latte. As I sat on the patio enjoying my coffee, I could feel the morning sun on my face and the cool breeze blowing in off the bay. Finishing my coffee, I would enjoy a pleasant drive across the San Rafael Bridge to Point Richmond for another day of work. As I drove through the light morning fog, I could see the ferry crossing the San Francisco Bay down below. The air was fresh, the traffic was light, and another exciting day was beginning. I couldn't help but think to myself, "Man, it doesn't get much better than this."

Working at Pixar had an aura of coolness and being on the cutting edge. On Friday mornings, the Pixar bosses would invite the staff to brunch and speak of the studio's growth and upcoming plans. Usually, these pep talks were presided over by John Lasseter and Pixar's owner, Steve Jobs. When the session was over, the employees mingled together over sandwiches and coffee, and I took the opportunity to hook up with several old friends from the Los Angeles area. At times, I found myself standing next to the boss, Steve Jobs, and I could overhear him grumble about the way Apple Computer was being run. As early as 1997, I had no doubt that Jobs would soon be leaving his day job at Pixar and returning to Apple. Jobs and his partner, Steve Wozniak, forever changed the way we look at personal computing, and they had more work to do. Because Pixar Animation Studios was now considered a successful studio, Steve Jobs could focus on more important matters.

The story artists in the Frog Town facility had individual offices, but we spent a good deal of our time in the main story room hashing out the movie. I remember days when the crew would engage in a "story jam" that would last for hours. During these madcap sessions, there would be laughing and yelling as sketches were pinned, ripped down, and redrawn on the spot. When we completed a sequence, the floor was littered with sketches and the storyboard was a haphazard mishmash of sketches done by different guys in different styles. Then the chaotic mess would be pitched to our co-director, Ash Brannon, for his take on the sequence. Once again, this insane way of working was in direct contrast to that of our colleagues down south, where the process went according to the "efficient system" the creative executives had put in place.

(TOP LEFT) MORE STORY REVISIONS
A meeting with co-head of story Dan Jeup.

(BOTTOM LEFT) FILLING THE HALLWAYS
The multiple storyboards extended out into the hallways.

"Senorita Cactus"

John Ramirez

Of course, there were also disappointments along the way. I remember the day that producer Helene Plotkin told us there was no way we could include the "Barbie" sequence in the movie. What was that sequence? While searching for Woody in the toy store, the group happens upon a Barbie display where the toy cuties are having a party. We knew every little girl would respond to the toys and even boys would have a laugh. After all, what little girl didn't have a Barbie collection? However, the cost was too high, and we simply didn't have the time or the money to pull it off. I confess, many of us were in love with that wacky sequence, and to see it suddenly cut from the film was a major setback. However, this was only a little direct-to-video movie, and we had to deal with reality. But what if this movie were a theatrical feature film? We would have more time and money, and so much more could be done. Could such a change be possible, I wondered? Clearly, it was too much to hope for.

On occasion, the Pixar "brain trust" from across the tracks would storm into the main story room to see how we were doing. However, these visits from Andrew, Joe, and Pete were brief because they were still hard at work trying to wrap story on *A Bug's Life*. We also had visits from writers Ted Elliott and Terry Rossio, who would one day give us the blockbuster movie *Pirates of the Caribbean*. However, we would soon have a more important visitor from Pixar's main facility across the tracks. There was someone else who wanted to check on our progress, and this guy's opinion truly mattered. No doubt, you can probably guess who I'm talking about: Pixar's creative leader, John Lasseter. What did Lasseter think of the movie? We were about to find out.

As usual, I decided to sit in the rear of the theater at Pixar Animation Studios. It was the day of the John Lasseter screening of *Toy Story 2*, and I decided that it was best to remain out of sight. This was nothing new for me. I learned this back in the 1960s at the Walt Disney Studios when attending meetings with the Old Maestro. All the "important" people had to sit up front with John, much the same way the old guys had to face Walt. On days like this, I figured that it's good to not be important.

The movie, still mainly in story reel, was pretty much complete, except for the wrap-up. That meant you saw story drawings standing in for animation that would be done one day, and some scratch voice track and stock music once the track was complete. But there was enough there to give you the idea of how the movie would pace and flow. When the film ended, and the lights came up, everyone in the room waited for Lasseter's reaction to the screening. And, if I recall correctly, it was a long time coming. We waited patiently as John pondered the movie's problems—and then he went right to the issues in the story.

I would probably be correct in saying I was the only person in the room that had attended story meetings with both Walt Disney and John Lasseter.

(TOP LEFT) A CHARACTER DISCARDED
Senorita Cactus was ultimately rejected as a character in the film.

(BOTTOM LEFT) ANOTHER LONG NIGHT
New revisions might keep the crew up all night. Sounds like fun.

WORK CONTINUES
Story artist Jim
Capobianco.

And Lasseter, like Walt, was able to pinpoint the problems in the film. Being older, I was never part of the 1970s Cal Arts gang, the group that included Bruce Morris, John Musker, Brad Bird, Nancy Beiman, Darrell Van Citters, Chris Buck, and John Lasseter. Perhaps this gave me a different perspective. However, it was on this day that I realized John Lasseter was the real deal, and his story instincts were solid. Could Lasseter have been channeling Walt, I wondered? I'm not one to gush over leaders, but I must say that I was impressed.

Armed with Lasseter's notes, (I still have them, by the way), the writers and board crew went back to work fixing the story problems. New people had come on board as *Toy Story 2* began to pick up momentum. Dan Jeup was our new head of story, and David Salter joined Edie Bleiman in editorial. Over time, more artists and animators would join the crew as they spun off of *A Bug's Life*.

Co-director Ash Brannon asked me to put together a story reel of Jessie the Cowgirl using the voice track of actress Holly Hunter. I thought this was a perfect casting choice. Who better than Holly Hunter to play a rough-and-tumble cowgirl? I admit I was somewhat taken aback when Ash told me he had cast another actress, Joan Cusack, instead of Holly Hunter for the role. Was this a mistake, I wondered? My fears were abated once I heard Joan Cusack's voice tracks. Her performance was wonderful, as she pushed Jessie in a whole new direction. Jessie the Cowgirl is a real nutcase, as well as

being totally warm and lovable. My office at Pixar was near editorial, so I could hear Joan's tracks throughout the day as I worked. The animators did a terrific job, but it was Joan Cusack who brought Jessie the Cowgirl to life.

I forgot to mention that all this time I was shuttling back and forth between Burbank and Point Richmond on weekends. I still had a life to maintain down south, and I often needed to grab stuff from my office at Disney. One Saturday while in the Walt Disney Animation Building, I saw my old friend Chris Sanders working on a presentation for a new film. It looked really cool, and I hoped that somebody would be smart enough to let him make it. He called the movie *Lilo and Stitch*.

Back up in Richmond, the storyboarding on the movie continued hot and heavy, and we begin to wonder how we would wrap up this exciting story. Somebody suggested a locomotive chase through the toy store. After all, Nick Park had already done a nifty train chase in one of the Wallace and Grommet films (*A Close Shave*), and it was hilarious. Eventually, that idea was scrapped, but we did manage to pull off a "train chase" at the airport with the luggage carts as the "train." Speaking of airports, did you know that we sent a video camera through the luggage system at San Francisco International airport to get a "toy point of view" as the toys searched for Woody and Jessie? I still can't believe the airport authorities allowed us to do that. Such a request today would probably land all of us in jail.

ROUGH IDEAS
Buzz Lightyear plans his escape.

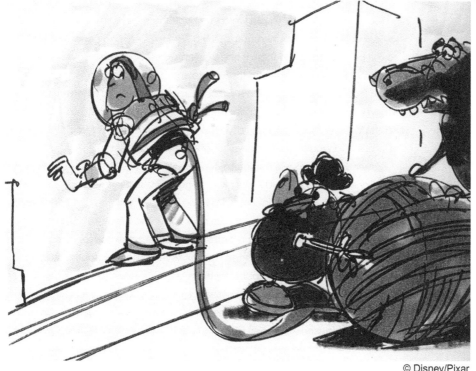

IT'S BEEN ANOTHER LONG DAY
Story artist Dave Fulp continues to smile.

Because *Toy Story 2* would welcome back the original voice cast, we had to cast only a few new characters. David Ogden Stiers had been cast earlier as the prospector, and I thought he was an excellent choice. However, Kelsey Grammer eventually replaced the very talented Stiers. Known for his role as a pompous snob on television's *Frasier*, Grammer seemed a better fit for the scheming, self-important prospector, Stinky Pete. At one point, comedian Don Knotts was considered for Bullseye the Horse, but Ash decided that Woody's faithful steed would play better as a nonspeaking character.

Remember, this movie had been conceived and greenlit as a direct-to-video cheapie. We still had a long way to go, but I couldn't help feel a sense of validation when Disney announced in February 1998 that they had changed their minds and that *Toy Story 2* was now a theatrical feature. I had been annoying poor Jane Healy for months about our little direct-to-video movie getting an upgrade. Jane was the Disney development executive attached to our film, and I sincerely doubt anything I said changed Disney's mind. However, I continued to make a nuisance of myself each time I saw her. We had screenings on a regular basis at the Burbank studio, and in time, the Mouse House executives began to see the movie's potential. One afternoon, we showed what we had to the Disney chiefs at the Northside facility near Burbank's Bob Hope airport. When the lights came up,

I overheard one executive remark, "That film is going to make us a lot of money," which we all know is the nicest compliment an executive can make.

In spite of the good news, things still had a way to go. As any film school writing teacher will tell you, a good movie has to break down into three acts. The second act of our film was still wonky and unfocused. Jessie's backstory was still unclear, and Buzz Lightyear's dealings with his alter ego needed to be addressed. We were working with an excellent premise, but the second act of our story still left a lot to be desired.

One evening, local elementary school children were given a tour of Pixar. The kids seemed to like our drawings, and all were fans of the original movie. However, they caught us off guard when they asked a very important question. "Where's the dog?" they inquired. If you recall the first film, it wraps up at holiday time with Woody and Buzz finally the best of buddies. Our two heroes had proven themselves able to deal with anything that might come their way. Then, we hear a dog bark—they look at each other—and the movie ends. Sounds perfect, right? So, where was the dog? We suddenly realized that in our effort to make a great little film, we had totally overlooked a very important character in our story. And it took a bunch of kids to bring it to our attention. Once the story was reworked, the doggie would play an important role in the yard sale rescue of the little penguin, Wheezy.

STORY SKETCH
The T-Rex is reflected in the rear-view mirror. Look familiar?

objects in mirror are closer than they appear

© Disney/Pixar

By the summer of 1998, I was back at Disney in Burbank doing visual development for a new animated film. *Toy Story 2*'s co-director Ash Brannon and co-producer Helene Plotkin were in Studio B on the Disney lot. They were recording new dialog with Tom Hanks, Tim Allen, and Jodie Benson. I received a call from my former bosses to get over to Stage B. I arrived in time to watch Jodie Benson record the dialog for the "Barbie" sequence. Though seven months pregnant, the lovely Ms. Benson was great, as she did her ever-so-cute shtick as Barbie. While recording her tour guide spiel (something we've all experienced at Disneyland), someone had the bright idea that Jodie repeat her dialog in Spanish. All of a sudden there were disagreements over how the line should be read from those who spoke Spanish. One guy even stopped the recording session to call his mother because she spoke fluent Spanish. Finally, someone retrieved a recording of the actual Disneyland spiel from Disney artist Scott Tilley.

Now that we had Barbie speaking Spanish correctly, we asked Jodie to give us a series of syrupy-sweet "goodbye lines" we could use in the movie. You can hear all the "buh-byes" she recorded for us on the *Toy Story 2* DVD. Finally, the session was wrapped, and I looked over to see my exhausted producer with her head down and her dark hair spilling over the desk. It had been a long day for all of us. Those recording sessions look like fun when seen on TV, but they can be grueling eight- to ten-hour marathons requiring intense concentration from all involved. As we headed out of the stage and onto the Disney lot, my former bosses finally told me

THE OLD MAN
Pitching my storyboard with a walking cane. Yes, the Pixar staff was pretty youthful in those days.

the reason they had sent for me. The movie, although making progress, still had a lot of rough spots that needed fixing. Would I consider coming back to Pixar?

Things were a little bit different when I returned to Pixar Animation Studios in 1998. This was the second year in the development of *Toy Story 2*, and it's not unexpected for a few snags to pop up in this wacky process of crafting an animated feature film. Things had started out great, but now the crew was feeling weary as we tried to iron out the kinks in the movie. Jessie the Cowgirl wasn't coming across as a very sympathetic character, and Woody was becoming a little self-absorbed—problems that immediately caught John Lasseter's watchful eye at the last screening. We knew we couldn't move forward until these issues were addressed.

It was smooth sailing during the first few months on the film. Even the new characters seem to fall into place. Our new toys included Wheezy the Penguin, Bullseye the Horse, Jesse the Cowgirl, and Stinky Pete the Prospector. Our villain, Al McWhiggen, was a terrific character, and the guy who sets our story in motion. We couldn't help but be reminded of another toy collector we knew. Our colleague and friend Scott Shaw! (yes, that's how he spells it—he legally had the exclamation point added to his name) could easily have been the model for Al. We even joked that Al might have

STORY SKETCHES
All feature animated films require loads and loads of story sketches.

tried to hawk the collectable Woody at the San Diego Comic Convention. Actor Wayne Knight was the obvious choice to voice Big Al, and I don't think we ever seriously considered anyone else.

As usual, there were a lot of late nights, and one evening I sat having dinner with story man Ken Mitchroney and technical director Oren Jacob. We discussed how down everyone felt because of the lack of progress on the movie. Our co-director Ash Brannon had taken off for a much-needed vacation, and the crew was beginning to approach burnout. While taking a break around the pool table one evening, our pal Joe Ranft ambled into the room. Now the tables were turned as I begged Joe to come help us on our film. Joe was well respected as the ace story guy at Pixar, even in those early years. Having just completed *A Bug's Life*, the last thing Joe wanted was to inherit the problems of another movie. However, the generous story guru provided advice and encouragement during those dark days and continually reminded us to "trust the process."

Our screenings were beginning to look more sophisticated as we incorporated Adobe After Effects into our story reels. Today, we're familiar with what has become known as previsualization. The computer allows us to incorporate effects into static drawings, giving a feeling of depth and heightening impact. We could add smoke or pull focus from the foreground to the background. These tricks were not possible before

TODAY'S PIXAR CAMPUS
Things have truly changed
since the early days in
Point Richmond, California.

computers. Of course, this meant breaking down all the elements so that the drawings could be scanned. Naturally, this meant even more work as our days lengthened into evenings. The appearance of a production assistant brandishing a dinner menu meant we wouldn't be going home anytime soon.

Our editors finalized another cut of the movie, and we screened it at the Walt Disney Studios in late 1998. In recent years, I've read that our movie was a horrible disaster and had to be rescued at the last minute. I beg to differ with those assessments. I attended the last meeting with the Disney executives, and they didn't feel they were viewing a lost cause. Most were enthusiastic about having made the right choice in moving *Toy Story 2* from a direct-to-video to theatrical feature. I think some were already counting the money the film was sure to make.

However, I did have concerns about the rescue of Jessie at the climax of the airport chase. In this cut, Woody and Jessie manage to escape from the jetliner that's already airborne and float down to earth. They come to a soft landing on a stream of "foam" (shaving cream grabbed from the luggage) on the airport's runway. Kirk Hanson and I felt this was way too *Air Force One* and that it stretched credibility, even for an animated cartoon. We wanted to keep the rescue on the ground and let Woody and Jessie escape just before the plane takes off. Thankfully, this is what happens in the final film.

It was the holiday season of 1998, and everyone took a much-needed break. We would return first of the year, hopefully reinvigorated and refreshed. However, I had no idea the surprise that January 1999 would hold for all of us. John Lasseter decided to hold an off-site meeting to reveal his plans for *Toy Story 2*. Usually a quiet location away from the company facility, the off-site meeting attempts to provide a fresh perspective for the staff. And it was indeed a fresh perspective. "We're starting over," said Pixar's creative chief. "We've already got a good movie. Now, we're going to make a great movie." Naturally, the initially reaction to John's decision was shock. However, the exhausted crew had been revitalized by the holiday break. All were now refreshed and ready to jump back in. Adding to that was John Lasseter's emergence as a creative leader. A lesser director might not have rocked the boat, but John made a gut-instinct decision that was worthy of Walt Disney.

It was January 1999, the same year the movie was scheduled for release. Though it was due in theaters in November, *Toy Story 2* was about to undergo its third complete story pass, starting with scene 1. A daunting task to be sure, but with *A Bug's Life* out of the way, Pixar Animation Studios could throw all of its resources onto the movie. Every artist who could storyboard became a story artist. Current boards would need extensive revisions, and new ones would have to be generated. Andrew Stanton and Pete Docter now fortified

the story team, and Joe Ranft had taken over as head of story. Now the story became more focused and character-driven. Woody fortifies his leadership role as he risks danger to save Wheezy from the garage sale. We finally bond with Jesse once we learn her backstory, and we learn that the friendly prospector has a hidden agenda.

Despite all our misgivings about attempting a complete redo so late in the schedule, after a lot of sweat, pencil stubs, cold pizza, and late nights, we made the changes. I remember walking the hallway of our Frog Town facility in the summer of 1999. It was difficult to believe, but the job was practically done, and composer Randy Newman was already recording the score for the movie down in Los Angeles. I had just taken a look at the movie's new opening, in which Buzz Lightyear encounters the evil emperor Zurg. Because of the advancements in technology, the movie had taken a quantum leap forward. Considering what we had initially envisioned back in 1997, this opening sequence was totally mind-blowing. We all had to admit that John's instincts were right.

When a film is wrapped, you forget about all the pain it took to get to the finish line. You forget the countless revisions, the shuttling back and forth on Southwest Airlines, and all the nights you drove home at 3:00 in the morning. When you see the finished film up on the screen and hear the reaction of the theater audience, you know it's all been worth it.

THE NEW PIXAR
Working away on my laptop at Pixar's new facility in Emeryville, California.

Unlike most of my Pixar colleagues, I had already worked on a dozen or more animated feature films. Yet, of all the movies, *Toy Story 2* remains a favorite. Walt Disney often said that he loved WED Enterprises because it reminded him of his studio in the 1930s. "There was something new happening all the time," he gushed. Like Walt, I found that same energy and enthusiasm when I arrived at Pixar Animation Studios back in 1997. Not yet corporate-driven or leaden with management, the creative staff was able to thrive.

Toy Story 2 has delighted audiences since its opening in November 1999 and will continue to do so for decades. It remains in the opinion of many an animated masterpiece. It was the perfect blend of gee-whiz technology, gifted storytelling, and delightful characters. I've worked on a lot of films in my career, but few can boast a storyline this solid. It remains one of my favorites to this day and probably always will.

Monster's Brawl

Monster Sketches

Scary and funny monsters. What could be more fun?

Welcome to the Scare Floor

By the summer of 1999, story had finally wrapped on *Toy Story 2*, and things were back to normal in my animated life. I was back at my desk at the Walt Disney Studios in Burbank when I received a surprise telephone call. It was from the office of Pixar producer Darla K. Anderson. Darla, a Pixar veteran, had been with the company since its early days as a software developer and was the producer of the new film to be directed by Pete Docter. It was Pete's first chance at directing a film. Darla's assistant had a question: would I be willing to meet with the producer next Monday afternoon?

My Southwest flight arrived in Oakland Monday morning, and I drove my rented car to Point Richmond, California. Though construction was finally underway at the new Emeryville studio, Richmond remained the home of Pixar Animation Studios. Not much had changed since my last visit to the studio.

My meeting with Ms. Anderson seemed to go well, and before I knew it, I was ushered into a small conference room, where I was given my first look at the movie. Oddly enough, I hadn't seen anything previously, even though the film

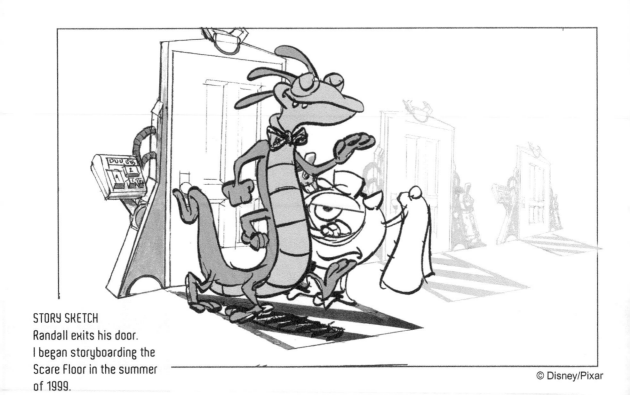

STORY SKETCH
Randall exits his door.
I began storyboarding the
Scare Floor in the summer
of 1999.

© Disney/Pixar

**(RIGHT) EAVESDROPPING
MONSTER**
A curious Sully wants to
know what I'm drawing.
(Photo by Jean Paul
Orpinãs.)

was being developed right next door while we were working on Buzz,
Woody, and the gang. We were so focused on our film the development
work on "Monsters, Inc" seemed like a blur.

Now I was getting my first look at the new Pete Docter movie. The
filmmakers had come up with an amazing conceit: a monster world
powered by the screams of frightened children. Monsters, Inc. wasn't just
a clever title. It was actually a factory that harvested screams from the
human world. Of course, you couldn't help but embrace the wacky and
fun characters and the adorable little girl, Boo, who's not frightened but
calls the big blue Sulley (voiced by John Goodman) her "kitty." Originally
called *Scarey Monsters*, it had received the name *Monsters, Inc.* from
Joe Grant, an 88-year-old veteran Disney story man. I immediately knew I
wanted to be a part of it. I found the premise charming and delightful. After
completing work on a classic movie, it would appear that Pixar had another
hit up its sleeve. Meanwhile, back in Burbank, Disney and its muddled
management continued to struggle. By 1999, the bloom was off the rose of
the big Disney musical classics, and the audience seemed like it wanted to
move on. Jeffrey Katzenberg had left to form DreamWorks and had taken
a number of key artists with him, and competing studios like Warner Bros.
and Fox were piling on their own animated films.

© Disney/Pixar

However, I couldn't fret about the studio down south. By caprice, I had been selected to do another Pixar motion picture. I eagerly accepted the opportunity to put more Disney-like entertainment on the screen—even if it didn't come from Disney.

I began storyboarding the "Scare Floor," a large industrial area lined with special doors. The monsters were given access to the real world through these portals, and naturally competition was stiff. Each monster was intent on ramping up his output and being heralded as a company favorite—a wacky, pointed metaphor for today's corporate environment.

Storyboarding on *Monsters, Inc.* was surprisingly smooth compared to my last assignment. This was a new story that didn't have to compete with a prior classic. I think this took some of the pressure off the filmmakers, even though they were well aware that they still needed to deliver a hit film.

I was introduced to Bob Peterson, a bearded, jolly giant who was our head of story. Though I didn't know it at the time, Bob would provide the gritty voice for Roz, the no-nonsense factory supervisor.

Another surprise was meeting co-director David Silverman. I had met David some years earlier at an animation festival in Ojai, California. Though best known for his work on *The Simpsons*, David had left television to try his

JOE RANFT AND DAVID
SILVERMAN
The late story guru with our
co-director of *Monsters,
Inc.* This was the last
photograph I took of Joe
before we tragically lost
him in an accident.

hand at co-directing a feature film. My first storyboards featured a character
we called "Switch"—a chameleon-like shape-shifter who would be our bad
guy in the movie. However, when I had barely started, there was a problem.
It seems that Disney director Chris Sanders was hard at work on a movie
called *Lilo and Stitch*. It was decided that our villain needed a new name. I'm
not sure why, but we eventually settled on "Randall."

 I didn't have an office when I returned to Pixar in the summer of 1999.
I set up shop in one of the conference rooms because it wasn't used that
often. Soon, screenwriter Daniel Gerson moved in, and about two weeks
later, Joe Ranft found a space there as well. Initially, I was surprised that
Joe—Pixar's story guru—didn't have an office. Then I realized that Joe
had taken a sabbatical after the completion of *Toy Story 2*. In his absence,
his office was probably taken over by other Pixar employees. The studio
was already bulging at the seams, and the new Emeryville facility couldn't
be ready soon enough.

 It was fun sharing an office with Joe Ranft again. We hadn't worked
together since our Disney days, and I still remembered that evening in
Pasadena when Joe spoke about a new studio in the San Francisco area.
Now, that same little studio had completed three hit films and was starting
work on the fourth.

(TOP LEFT) MONSTER
SKETCH
It was fun working with
such great animated
characters.

SCARY PHOTO
Posing for a picture with
Mike and Sulley.

Joe Ranft was a very gentle guy, and I don't ever recall seeing him lose his temper. Storytelling came naturally to Joe, and he never seemed at a loss for ideas. However, something about the sequence he was boarding bothered him, and he complained out loud about getting it to work. I was somewhat taken aback. Joe was probably one of the best story guys in the business, but I guess on occasion even he had difficulty.

I began my sketching on the Scare Floor sequence. This is the hangar-like facility where the monsters move in and out of the human world to gather "screams." This large industrial structure had been thoughtfully designed. It was as though this fantasy world had a counterpart in reality. Things had really been thought through, and everything in this monster factory truly worked.

One sequence that wasn't used in the final film involved a wacky tangle of movable doors. The doors moved back and fourth on a track system, each door sliding into place as needed. You can imagine the chaos that would result should a door move in the wrong direction or stop in the wrong place. Such a mistake would totally screw up the works. I storyboarded such a situation, and though it was funny, it really didn't advance the story, so the idea was discarded.

However, things came together and Pixar's fourth animated feature opened November 2, 2001, to rave reviews, even though another monster named Shrek managed to steal our thunder at the Academy Awards. This was the first time that animated features would have their own category at the Oscars, and *Monsters, Inc.* was among the first nominations. Over the years, Pixar has won a bushel of Oscars, but this one particular year, the big-screen ogre pinched our statue. People still tell me how much they enjoyed our wonderful characters Sulley and Mike. Plus, women found our little girl "Boo" simply adorable. To top things off, composer Randy Newman finally took home an Oscar for his song "If I Didn't Have You." After picking up his Oscar, Newman chided his colleagues in the orchestra pit. Having lost multiple times, he got back at them. "I don't need your pity," he joked.

As for myself, I had already been away from home too long. Though I truly loved working at Pixar Animation Studios, some things have to come to an end. I returned to the Walt Disney Studios in Burbank, curious what my next animated assignment would be. Little did I know that The Walt Disney Company had a digital card up its sleeve and was ready to challenge Pixar.

Elephant in the Room

Reinventing Disney

Because of a quirky accident, an elephant from a local zoo is transformed into a singing, dancing diva. The appearance of this pop icon kicks off an incredible story of love, revenge, and intrigue. Better yet, it's a new animated digital motion picture from Walt Disney Feature Animation.

Wait a minute! Did you say "Disney"?

I was surprised and delighted when I heard that Disney had decided to give the okay to an exciting new book that would examine the animated movies the company never made, titled, "The Disney That Never Was" and describing projects that for one reason or another ended up on the Disney shelf. Noted animation historian Charles Solomon authored this new tome, providing images and insight into a number of Disney projects that never made their way to the silver screen or that were radically revised along the way—an animated feature about Don Quixote, *The Emperor's Nightingale*, a Fantasia sequence set to Wagner's *Ride of the Valkyries*, and Marc Davis's story for the "Chanticleer" (a story taken from Geoffrey Chaucer's *Canterbury Tales*.) Master artists had worked on these ideas for months, and they had generated superb artwork and

© Disney

© Disney

ideas. Yet for one reason or another, each project was cancelled, deep-sixed, shot down in flames, bought the farm, given the thumbs down, and other clichés—sealed up in a box and placed in storage. Quote the Raven, "Nevermore."

My involvement with one of these type of projects began on my return from Pixar Animation Studios, where I had worked on, *Monsters, Inc*. Early in the year 2000, I was requested to join the story team of a film then in development entitled *Wild Life*. The assignment to storyboard a song sequence would require my services for only a few weeks.

I was well aware of the *Wild Life* project, having seen it move into development at Walt Disney Studios before I had left in the late 1990s. The original idea seemed pretty cool as the film had a narrative that appeared to be a send-up of American pop culture. Howard Baker and Roger Gould created this project, which chronicled the creation of an American pop idol—a hip Eliza Doolittle who eventually self-destructs. I recalled the characters being wacky representations of pop icon Andy Warhol and fashion mavens Anna Wintour and Diana Vreeland. The pop magazine *Magazizzi* represented the many glitzy and glamorous publications one continually saw on the local newsstands. Think *The Devil Wears Prada* on steroids.

Innovative and ground-breaking, *Wild Life* was the animated digital motion picture that, in the words of Disney's own executives, "was going to knock the socks off the competition." *Wild Life* would be the last thing they ever expected to come from the Walt Disney Studios.

You've got to admit that on the surface, this seemed like a good idea. After all, what could be funnier than a satirical motion picture that poked fun at the shallow, superficial conventions of popular culture—laughing at the current contrived trends involving music, fashion, and style? However, the filmmakers made one very deadly mistake. They took it all seriously.

Don't get me wrong. The filmmakers were well intended, and the movie could certainly boast some of the finest art direction and production design to ever come out of the Walt Disney Studios. The talent was top-tier, and Disney spared no expense in bringing this very unique motion picture to the big screen.

My one month on the project became two, and I continued to create the storyboard assignments sent my way. Having completed the song sequence, I would continue on the show until its eventual shutdown.

By the summer of 2000, the motion picture *Wild Life* had two sequences greenlit for production. I enjoyed seeing the digital characters come to life on the computer screens, and we were all dazzled by a fully

(TOP LEFT) *COLOR BEAT BOARD BY HOWARD BAKER* The film was unlike anything Disney had attempted before.

(BOTTOM LEFT) ANOTHER SKETCH BY HOWARD BAKER The film's story line was roughed out in a series of color sketches by the co-director.

KITTY AND ELLA
Kitty Glitter and Ella
the Elephant enjoy their
newfound fame and
glamour.

© Disney

rendered scene showing the color imagery in all its digital glory. Wow! The effect was jaw-dropping. Maybe Disney had something here after all. Or did they?

By late summer, my directors had me tweaking certain scenes as the crew prepared for an upcoming screening of the new motion picture. The entire film would be "up on reels." That means all three acts in storyboard form could be viewed in their entirety. Eventually, word got around that we were going to have an important visitor take a look at our film—oddly enough, the same person who performed another rescue mission some years earlier. Roy Disney would be viewing *Wild Life*.

Wild Life had been in development for nearly two years, and now it was finally moving toward production. The crew was delighted when word got out that two sequences had been given the green light for production.

In spite of some obvious story and theme issues, our production team was totally energized and blazed ahead with full artistic intensity. Even our large story room was filled with the booming sounds of techno rock as the artists continued to crank out reams of storyboards. Like it or not, no one could escape this driving heartbeat, and it provided a special energy that seemed to push us all forward.

Oddly enough, few seemed concerned about the adult themes threaded through the film's narrative or the risqué dialog spoken by the characters. "Let me in that manhole," shouted characters heading for a secret

underground club. Alternative lifestyle jokes were hardly material suitable for Disney family entertainment.

As I mentioned earlier, this production was not short on talent. In fact, this was one of the few animated movies that included a costume designer. Visually, the motion picture would have been stunning. On board were designers such as H. B. (Buck) Lewis and Craig Kellman. Premiere production designer Hans Bacher had recently joined the team, and I still remember the worried look on his face when he stopped me in the hallway. "The movie is in serious trouble," said Bacher. "We've got to do something about the story." I fully understood what troubled the designer, but I also knew there was little I could do about it. Disney story artists had long since been marginalized by Hollywood screenwriters, and things were not about to change anytime soon.

Despite the reservations of the veteran Disney artists about the tone of the humor, the project pushed ahead and spent a lot more money. Professional voice actors began to replace the scratch track, and our film could now boast of big name talent. Noted character actor Alan Cumming had been pegged for the voice of Red Pittstain, and Academy Award winner Kathy Bates would create the voice of media maven Magda. Finally, television star Debra Messing was being considered for the voice of pop diva Kitty Glitter.

In spite of the story issues, I continued to have fun on the project. Our directors requested that I create color storyboards for the screening. I was able to add glitz and polish to the usually simple storyboards using the computer applications Adobe Photoshop and Illustrator. I couldn't help but be amused by the fact that I was doing all this on my tiny Apple laptop while surrounded by millions of dollars worth of high-end computer workstations.

Suddenly, the day of the screening was upon us. I wasn't invited to the Roy Disney screening in the Northside facility, but there was really no need. I already knew the verdict before the first act was over. "We can't release this movie," said the disgusted vice chairman as he stormed out of the building.

© Disney

LOGO DESIGN
The production designer created a bold new logo for the production.

If you've been in the business as long as I have, you already know what happens next. Executives scramble to cover their butts, and everybody blames everybody else. Hey, what would you expect? This is Hollywood. Finally, there are the inevitable questions. How did this happen, and who was to blame? Why were certain decisions made, and who made them? Everybody, it seems, wants the inside scoop.

Sorry, boys and girls, you'll not find them here. Grunts working in the trenches are not privy to top executive decisions. However, you can bet there is plenty we'll never know. *Wild Life* was hardly a stealth project, and studio managers would do well not to paraphrase Louie in *Casablanca*, who might have said, "I'm shocked! Shocked! To learn such a movie was being produced here at Disney!"

Wild Life was not necessarily a bad idea. A mix of Studio 54 and *Pygmalion*, it was hip, cool, and edgy. Maybe even a little ahead of its time. After all, the Mouse House is currently cashing in on projects like *Hannah Montana* and *High School Musical*. In many ways, this innovative film could have been an incredible blockbuster that attracted the growing teen markets the company so eagerly courts.

With its sophisticated themes and provocative story line, it was clear to all who had a brain that *Wild Life* was hardly a Disney movie. One could only imagine the howls and shrieks that would have come from conventional Middle America once little Jenny and Jeff got introduced to the "club scene." It was, as one story artist put it, "too hip for the room."

Ella the Elephant was a fascinating character and the central focus of *Wild Life*. She could sing, dance, and captivate an audience. She was an incredible animated wonder. But she was still a huge, lumbering creature. She was the elephant in the room that nobody ever saw.

Inside Man

The Studio Custodian

The most informed
man in the studio
might surprise you.

In order to make sense of what happened to me next, I need to jump back and talk about someone from the past whose memory helped me a lot at this time.

I never knew Claude's last name, but he performed a service at the Walt Disney Studios that was not unimportant. It was Claude who kept the men's rooms on all three floors of Walt's Animation Building sparkling clean.

Claude was an older gentleman about the age of my parents. It was notable that his was the first black face I saw at the Walt Disney Studios. Always cheerful, he greeted me with a smile as he made his daily rounds through the many wings of the creative facility. I often wondered what Claude thought of my arrival at Disney that summer of 1956. Was he proud that an eager young black kid had finally entered Walt's creative enterprise? I certainly hope so.

I suppose one might consider a custodian the lowliest position one could have at the Walt Disney Studios. Over time, I came to understand just how important Claude could be. When it came to information, this old gentleman could easily be described as the "inside man." The topics being discussed in the story rooms on the second floor or the boardrooms of the third were known only to a few. The exception was Claude. He knew everything.

DISNEY'S ANIMATION
BUILDING
The company custodian
kept the cartoon factory
neat and tidy for decades.

If you're familiar with British dramas often set in English country houses, you'll know what I mean. There was a physical separation of the lords and ladies and the downstairs workers who served them. As always, the gentry knew little about their servants. The men and women who did the cooking, laundry, and cleaning were essentially invisible. This was also true of the Disney custodian who slowly pushed his cart down the hallways of the Animation Building and was privy to everything that was going on. No executive or board member was as knowledgeable as Claude when it came to the internal workings of the Walt Disney Studios.

It was notable that I received my first impression of Walt Disney from the custodian. Who better than an older black gentleman to provide this insight. You see, besides his day job, Claude often worked for the Old Maestro as a bartender at Disney parties. Claude revealed his second job one day as we chatted about the boss. Walt was often regarded as a tough taskmaster at work, and I wondered what he would be like in his own home. Walt Disney scored high marks from Claude when it came to respect, fairness, and generosity.

After Walt's untimely passing in 1966, I left the studio for a time. However, I missed Walt's creative facility, and returned to work on *Robin Hood*. This would be my first animated feature without the Old Maestro, but

I hoped for the best. Once again, I confided in my inside man concerning Disney's internal management situation. Claude warned me that things did not look good inside the Animation Department, where factions were already developing. Suddenly, The Walt Disney Company was struck another blow with the loss of Walt's brother Roy in December 1971. Once again, Claude and I spoke privately concerning the power struggle inside the company. I was continually amazed how much the studio custodian knew. It wouldn't be too much of a stretch to imagine Claude taking a seat on the Disney board of directors.

Disney Executive Producer Ron Miller tried to move the company in a bold new direction but met with increasing resistance from the old guard, who had become calcified in their perception of entertainment. It may have been the 1970s, but the mindset of the Disney board remained in the 1940s. Meanwhile, the eager young kids in the retooled Animation Department continued their jousting match for leadership. Sadly, there was a fair amount of treachery and skullduggery between the warring factions, but we'll not deal with that here.

It wasn't the best of times at the studio, and in the midst of all this turmoil, things began to look grim for me. Eventually, for reasons more business than personal, I was sacked a few months later. However, it was not without a warning from my inside man.

By the time I returned to the Walt Disney Studios in 1983, Claude had already retired. I honestly don't know how many years he worked for the studio, but I'm sure it could be numbered in decades. Though he wasn't around to see it, I'm sure Claude would have been privy to the Green Mail takeover attempt in the early 1980s and the move by Roy Edward Disney to bring new management to The Walt Disney Company.

Many years have passed since Claude pushed his little cart through the three floors of the Animation Building. I can still see the smile on his face as he emptied the trash, cleaned the toilets, and polished the sinks. I'll never forget the wise words the old custodian gave me one sad day in the winter of 1972. "The old men are gone now," he said softly. "Things will never be the same."

Wise words from my inside man, and as usual they turned out to be correct.

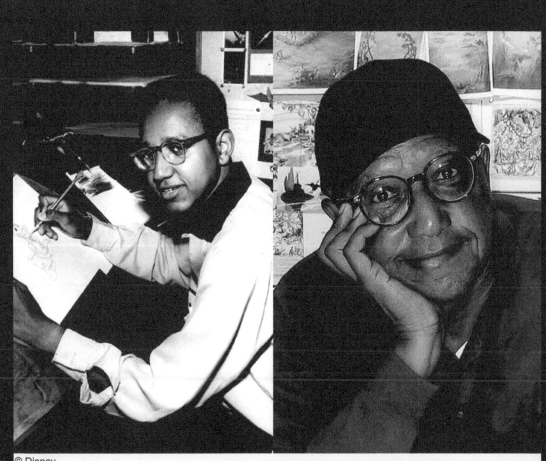

Life After Disney

The Challenge of
Retirement

Hopefully, creativity
never ends.

One quiet summer afternoon in June, I received a call to report to the office of a young executive at the Walt Disney Studios. I didn't consider this meeting anything unusual because I had just spent several months working on the film *Wild Life*. I was well aware that this unusual movie was now in meltdown, and it was probably time to move on.

The executive was the go-to guy for information on your next project, and I was actually looking forward to my next assignment. However, I was about to find out that this meeting would not be like the others. I could scarcely believe my ears when I was informed there was no next assignment. As a matter of fact, there was no work for me, period. I left the office with glazed eyes. How could I have been so dumb? June was the month of my 65th birthday. I should have seen this coming.

(TOP RIGHT) THE ARTIST
IN RETIREMENT
After leaving Disney,
I continued to work
on other animated
assignments.

As luck would have it, our union business representative, Steve Hulett, was visiting the Walt Disney Studios that afternoon. Sensing my distress, Steve reminded me of something that had totally slipped my mind. I immediately saw myself as being unemployed, and things looked pretty hopeless. Steve reminded me that I wasn't exactly unemployed—I was retired. And being retired is not necessarily a bad thing. I suppose Steve was probably correct in evaluating my situation. With the upcoming layoffs, I was already in a better position than the hundred or more people who would soon be losing their jobs.

For the next six weeks or so, I was difficult to live with. After getting up and going to work every morning all my life, I suddenly found myself sitting in my backyard with nothing to do. Clearly, retirement wasn't for me. I was miserable, and everybody around me knew it. Suddenly, my life changed when I received a telephone call from Scott Tilley at Disney Publishing. They were doing a series of books featuring the characters from *Toy Story* and *Monsters, Inc.* Would I be willing to take on some freelance work? The opportunity to return to work was a godsend. I eagerly accepted the assignment, and I've been grabbing jobs ever since. No matter how big or small, I'm ready to come on board.

Many people my age spend their declining years reminiscing about youthful accomplishments and recalling past glories. I've never wanted to take that attitude or to view my life in retrospect only. The future is what truly matters, and there's nothing more exciting to me than an upcoming assignment.

Since walking out of the Walt Disney Studios back door some eight years ago, I'm pleased to say that I've done development on two feature films, storyboarded a television series, and worked as production designer on a puppet show. In my spare time, I pen my own daily blog and write a monthly online column about animation history. I've declined offers to teach because I honestly think that I lack the skills necessary for being a good instructor. I do enjoy speaking with students on occasion, and sharing my experiences in the animation business can be a joy.

I remember being terrified of public speaking. Whenever this was necessary, I trembled in my boots backstage with my stomach doing flip-flops. I've become more at ease in the classroom, lecture hall, and on stage. It's as though I've been given something special to pass on. So, rather than focus on myself, I focus on the message.

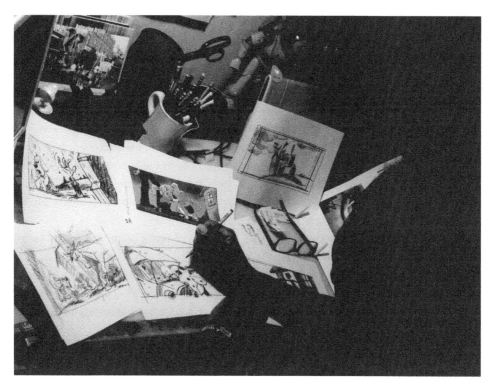

(TOP RIGHT) THE ANIMATION INSTRUCTOR
It's been fun sharing the things I've learned with young animation artists.

(BOTTOM RIGHT) YOU CAN'T BE SERIOUS
Somebody mistakenly put my handprint on the wall with the real Disney Legends.

I'd be less than honest if I didn't say I miss my animated life. I miss the big feature films in the mainstream studios. I miss the magical yet strenuous process of seeing a story begin to gel. I miss watching a compelling narrative evolve from a few rough sketches. I miss the collaboration of talented people working together to create something special. I miss hearing the audience's laughter at a prerelease screening of a feature film. Finally, I miss going to work every day.

In a strange kind of way, I doubted this day would ever come. I had this naïve notion that once accepted into this very odd enterprise, I would be allowed to work until I dropped. Unlike insurance salesmen and bus drivers, an artist never looks forward to the day they can stop creating. Unlike most people in life, we actually love what we do.

I really shouldn't gripe, because I've had it better than most. I was fortunate to work with many of the creators of this crazy business before they shuffled off this mortal coil. I was lucky enough to be mentored by many of the greatest talents in the profession, and I managed to stick around through four successive Disney management teams while doing so.

After a score of feature films, short subjects, and television shows, this animation veteran continues to look for another assignment. I know there's something out there that I've not yet experienced, and I'm eager to get started. I believe all this as much as I believed I would one day walk through the gates of the Walt Disney Studios some 50 years ago. I had no doubts about any of this because, as goofy as it sounds, it seemed like my destiny.

That's my animated life. The dictionary defines animation as "to give life." Throughout my Disney career, I've been engaged in "giving life" to a collection of silly, strange, and wonderful animated characters. It was a fair trade, of course. After all, they've given life to me.

objects in mirror are close[r]
than they appear

PART 2

TIPS, TECHNIQUES AND ANIMATED OBSERVATIONS

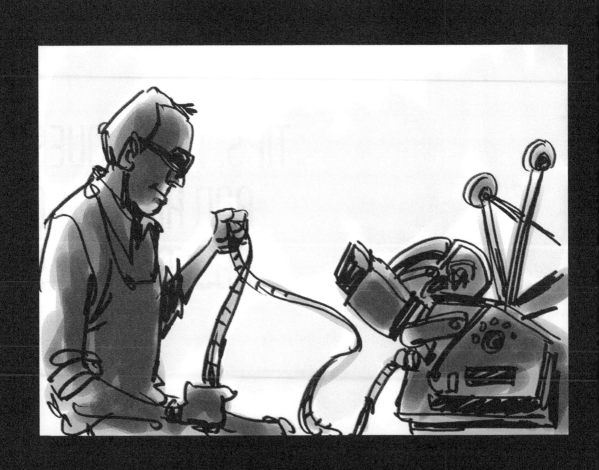

Attending Your Own Film School

You don't necessarily need school to make a movie.

"The best way to learn film is to make one." Those are the words of my favorite filmmaker and personal hero, Stanley Kubrick. When I was a kid, I was eager to create my own movies, but there was no way a studio would indulge an inexperienced kid (although it appears they do today) with his own motion picture. The answer was easy. My partner, Leo Sullivan, and I decided to make our own movies.

Yes, that means we would have to do everything: write the script and create the storyboard, layouts, and animation. Finally, we would have to edit our project and do all the postproduction. How does one accomplish all this without ever attending film school? The answer is easy. You simply do it.

Because my film partner and I both worked in the animation industry, we had access to experienced cartoon veterans who were generous enough to share their considerable expertise with us. Leo and I took advantage of our unofficial mentors and began to craft our own films. We started with simple, short cartoons that lasted a few minutes before graduating to longer, more challenging productions. Even back in the 1950s, you didn't need tons of money to produce animation. Pencil and paper was cheap, although you would have to spring for film stock, processing, and maybe even a Moviola (a hand-operated editing machine). Hollywood in the 1950s and 1960s wasn't just large movie studios. The boulevards of Tinseltown were dotted with small shops that rented equipment and processed

(TOP RIGHT) THE ART
CENTER COLLEGE OF DESIGN
There were no classes in
film when I attended Art
Centerback in the 1950s

(BOTTOM RIGHT) THE USC
FILM SCHOOL
This impressive structure
had not yet been
constructed when we
edited film on the campus
back in the 1960s.

film for smaller independent producers. Professional equipment was available to young filmmakers who were serious to cough up the extra cash.

I honestly can't think of a better way for a young filmmaker to learn his or her craft. Because we had to do everything ourselves, we learned why each step in the process is important. It's critical to learn how all the components fit together and how each relates to each other. Animators should know story, and story artists should know animation. Every artist should know what the other is doing and how it all relates. I've been discouraged by the sometimes-insular nature of today's modern studios, where too many people work in isolation. Film is about collaboration, and I'm sometimes surprised and saddened by the lack of it.

One of our early steps into long-form filmmaking involved the production of a 14-minute film on the life of African American writer and poet Paul Laurence Dunbar. The short documentary was in postproduction when an educational film distributor saw a rough cut of the movie. Without even seeing the finished motion picture, the distributor offered to buy our film, and we suddenly found ourselves running our own production company. None of us, with the exception of our cameraman/film editor Richard Allen, had ever been to film school. Allen, a retired Los Angeles police officer, had been attending some film classes at the University of Southern California (USC).

Don't think I'm knocking film schools, because that's not my intention. A lot of talented filmmakers have come out of USC, Cal Arts, Sheridan, SVA, NYU, and other fine schools. I'm just saying that a film school education is not necessarily required to become a professional filmmaker. Plus, with the incredible new technology practically at everyone's fingertips, there's simply no longer any excuse to not produce your own films. The new cinema tools that exist today were only fanciful dreams when we were young cartoon moviemakers. Hollywood Boulevard may no longer be festooned with 16–35 mm equipment rental stores, but the amazing computer software and hardware that is increasingly affordable today takes away any excuse a budding young movie maker might have to not create their own projects.

I still remember sitting in our bullpen at Walt Disney Studios and hearing a number of my young colleagues grumble and gripe about not being allowed to develop their own personal projects. Apparently, they had forgotten that another name—not theirs—was on the outside of the building. The studio's production and development slate belonged to a person named Walt Disney.

What these kids failed to recognize was there was nothing stopping them from developing their own movie ideas outside the studio. The completed animated motion picture would make an excellent portfolio piece. If you failed to impress Disney, there are always plenty of other studios that might have a possible interest in your idea. Probably the most important thing is that it would be time well spent, because in the process of making a finished motion picture, I guarantee that you'll become a better filmmaker along the way.

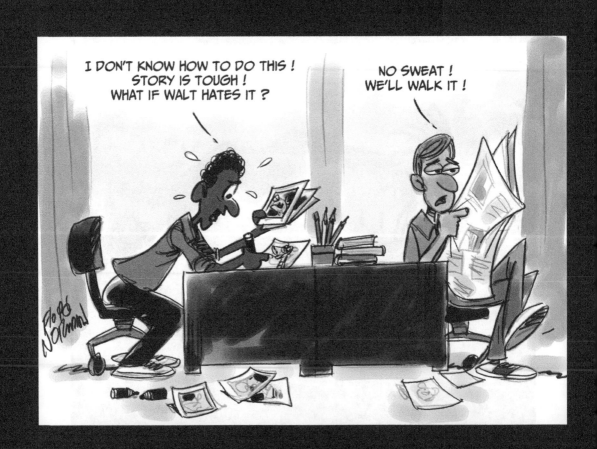

The Vance Advantage

Things I Learned from an Exceptional Story Man

The Perfect Mentor

Never let stress
influence the story
process: a valuable
lesson learned from
Vance Gerry.

I've been an incredibly lucky guy throughout my animation career. I've been able to sit, talk with, and even work with many a Disney legend during my days at Walt's magic factory. Never one to waste an opportunity, I was eager to learn what made them tick and gain whatever insights they had to offer. Some of my mentors were well up in years, and others were younger. All of them had knowledge that they were willing to share, and this geeky kid was ready to drink it all in.

My life changed in 1966, all because story legend Bill Peet got into an argument with the Boss. Of course, Peet and the Old Mousetro had crossed swords often in the past, without any following repercussions. That was because both men knew the underlying cause was their mutual passion to make the best picture possible. But I guess after decades of arguing, by the time *The Jungle Book* was underway, both men had had enough. This time, neither Walt nor Peet was willing to compromise. So Walt Disney Studios's premiere story man walked off the picture and out of the studio. Without missing a beat, Uncle Walt demanded that a new story crew be formed to rewrite the movie. Included in the little group was

VANCE GERRY AT WORK
Laid back and
unassuming, Gerry was
an exceptional Disney
storyteller.

a 20-something kid who had never done it before. However, I was lucky enough to be seated across from a man who was knowledgeable, and that guy became my mentor. His name was Vance Gerry.

The things Vance Gerry taught me about the storyboarding process has served me well throughout my career as a story artist. His tips and techniques have not only helped me make many a deadline, but have also helped me maintain my sanity in what could sometimes be called a pretty insane business. Some of these ideas you might embrace, or perhaps you'll choose to disagree. However, I offer them freely as Vance offered them to me.

No Big Deal

Naturally, I was somewhat apprehensive when moving into story for the first time in my professional life, but Vance taught me that storytelling is neither rocket science or brain surgery. It's important to begin with this thought because it will affect everything you'll do in your career. Although we have a responsibility as entertainers, what we do will not change the world. We're simply entertainers, offering no profound insights that will affect humankind. Far too many storytellers take themselves way too seriously, but Vance had none of that.

Visual Is Better

Vance Gerry embraced Disney visual storytelling and often saw it as more important than the written word. "Scripts tell you too much," he often said. "I prefer to create an interesting visual and then dream into it." I'm in agreement because I find visuals extremely stimulating. I remember visiting the home of my grandparents when I was a kid. My grandmother filled the walls of her home with artwork, and I loved to sit and dream into a painting. Suddenly, I'd find myself inside the oil or watercolor, and I wandered the lush fields, swam the streams, and climbed the mountain tops. What better way to start an animated sequence than to create a fascinating image and allow that image to animate in your head? Written scripts are all too often cold and lifeless and offer little opportunity for exploration. Artwork is alive and vibrant. Walt Disney responded to art and instructed his artists to do the same.

You're Not the Director

"Don't direct the movie," warned Vance. "The story artists' job is to develop the story." Another point well taken, especially when I look at today's storytelling process. Eager young storytellers cannot wait to add "director" to their title, and it's easy to forget our job and be seduced into trying to make the film. Vance reminded me that my job was to develop the story—not direct the movie. The film's director will be given that job in due time. Hopefully, the director will have storyboards that will effectively communicate the story and maybe even inspire. The storyboard is only the blueprint of the movie—not the finished film.

Over the years, I've watched storyboards become more and more sophisticated. Once you add the new technology, story reels now resemble the completed film. Of course, much of this is done to aid the "visually impaired"—film executives who are seldom able to visualize the finished film. Back in the day, the storyboard and the story reel were simply ways to try out ideas before moving on. Now, the storyboard seems to have become an end in itself. Crafting a solid story is difficult enough, and the wise story artist would do well to focus on that task and leave the filmmaking to someone else.

Of course, Vance realized that story is never done. Eventually, time and money run out and you move on to a new movie and a new challenge. I collaborated with Vance Gerry on only one movie, but our friendship lasted for years. In time, Vance retired from full-time work at Disney and came in just one day a week. I always made it a point to stop in Vance's office every Wednesday. As usual, Vance was at his desk creating remarkable visual and story development with the tiny watercolor set he always used. As always, I had questions for my mentor because I still had much to learn. Low-key and soft-spoken, Vance Gerry was always willing to share.

A Mistaken Notion

A Woman's Touch in the Cartoon World

Artist Retta Davidson

Women artists could hold their own in animation's "boys' club."

There's a mistaken notion that back in the 1950s, the Walt Disney Studios was strictly a man's world and that women were not even allowed in the Animation Building. It was believed that women employees were restricted to the "women's work" over in the Ink & Paint Department, where they dutifully traced the pencil drawings onto sheets of acetate or painted in the colors.

Such was not entirely true. Although male artists certainly outnumbered the women, it might surprise you to know that Disney had its fair share of talented female artists working away at the drawing tables on the Disney classic feature film *Sleeping Beauty*.

Should you stroll into D-Wing on the first floor of the Animation Building, you would find a fair-sized room with three or four young women doing beautiful clean-up animation on the film's lead character, Briar Rose. The young women turning out the exquisite drawings were Doris Collins, Fran Marr, and Mary Anderson. The drawings were delicate yet masterful, and they certainly seem to benefit from a woman's touch.

Of course, there were other young women who labored in the Animation Building back in the 1950s. There were so many that I can't even recall their names, but I do remember the names Lois Blumquist, Elizabeth Case, Eva Schneider, Jane Shattuck, Marlene Robinson, and Sylvia Frye. Though no

ARTIST CHARLOTTE HUFFINE
Women were no longer
restricted to the Ink &
Paint Department, and
many sought jobs as
animation assistants.

woman had yet to crack the animation "glass ceiling" and become an
animator, they were clearly making their presence known. However,
women were also represented in Disney's coveted background
department, and talented painters such as Thelma Whitmer and Barbara
Begg proved they could wield a paintbrush as well as any guy.

I don't recall women's issues being a big deal back in the 1950s,
although there were certainly incidents that might be a cause for concern.
Some artists regularly featured *Playboy* pinup calendars in their offices,
and secretaries were often referred to as "girls." However, the women
I talked to took it all in stride and maintained an attitude of "boys will
be boys." I remember sitting on a studio park bench and chatting with
animation artist Kay Silva about the situation. Unlike most women today,
she simply laughed it off.

On the other hand, some of the veteran women artists could be as tough
as any guy at the studio. Should you be foolish enough to turn in a poorly
drawn scene, one rather tough, chain-smoking female artist could provide
a "chewing out" that would make Milt Kahl proud. Disney artists back in
the day were known for their noontime "thirst," and one attractive brunette
was known for her ability to drink many a man under the table.

By the 1960s, women were finally moving into Disney's once all-male
layout department and working alongside the men. Talented layout artists

ARTIST LOIS BLUMQUIST
Lois became one of our
instructors back in the
1950s.

such as Sylvia Roemer and Sammie June Lanham began creating layouts
for *101 Dalmatians* and *The Sword in the Stone*.

Veteran animation assistants Retta Davidson, Grace Stanzell, Sylvia Niday, and
Charlotte Huffine were eventually joined by newbies Joan Drake and Kimi Tashima.
Times were changing, and their male superiors did not as easily intimidate this new
generation of young woman. I still gleefully remember a confrontation between
Joan Drake and Milt Kahl. The bombastic directing animator, intent on bawling out
his young assistant, was reading her the Riot Act. The young woman looked at
him and laughed in his face. The fearsome animator simply wilted on the spot. He
turned and stomped back to his office, clearly defeated.

As the years passed, Disney Animation moved through several
transitions as fresh young talent came on board. The old guard that once
dominated animated filmmaking was moving on, and more opportunities
for young artists were becoming available. Unlike years past, many of the
women would now become animators, story artists, and even directors.

However, let's not kid ourselves. We know that men still dominate motion
picture film production, and that includes animation. However, it might be worth
a reminder that even back in the 1950s, women were not exclusively consigned
to duties in the Ink & Paint Department. Among the hundreds that labored at the
Walt Disney Studios, a fair percentage of the artists were women. This is a very
real fact that any serious student of Disney animation history should not forget.

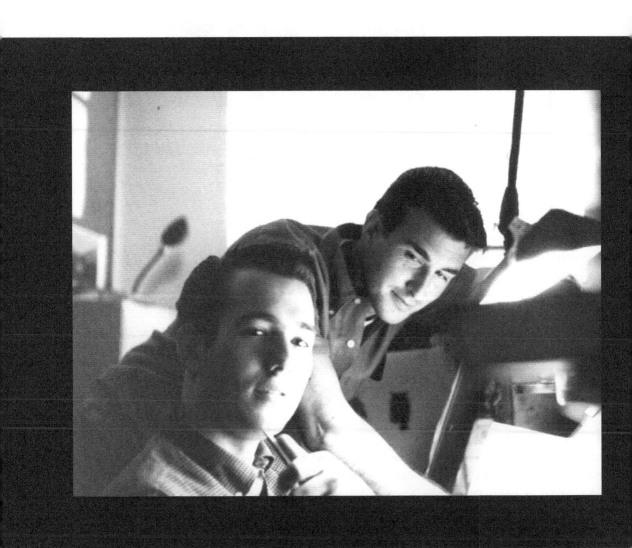

Stay Hungry
The Dangers of Success

Several years ago, a group of young artists was griping about things at their studio. Their behavior amused and annoyed me. I scolded the kids and informed them that one day they would look back and remember this time as the good old days and wonder why they ever complained about anything.

Every studio goes through this very special period. It's the beginning. It's the honeymoon. It's the start of a brave new adventure—and, to be sure, it's always extremely exciting. I know—I've been there numerous times myself.

Let's go back in time and take a look at a brand new enterprise just beginning in the Silverlake district of a town called Hollywood. A group of young men and women were engaged in a brave new experiment, and few thought the group of young artists even had a chance of survival. However, survive they did, and the face of animation was changed forever by a man named Walt Disney.

Of course, few young companies even manage to survive. However, if success were to be their destiny, such firms face obstacles other than mere survival. They are challenged with the possible loss of their heart and soul. Success has a way of doing that. In my lifetime, I've seen more than one enterprising young company succeed its way to failure. I'll give you an example—only this time, it won't be Disney.

YUSAKU "STEVE" NAKAGAWA
The young artist retained
his enthusiasm for
animation when he
returned to Japan to
become a director.

Many years ago, I had the opportunity to work with a vibrant young company in Southern California. The staff was energized, hard-working, and diligent. However, that wasn't what impressed me about the company. It was their shared interest and their concern for each other. Perhaps this was best expressed at lunchtime, when the president of the company and his staffers sat at a large table to chat while having their noon meal. Writers, designers, and accountants sat and ate together while discussing their shared goals. Call it "Camelot" if you will, but it honestly felt exactly like that inside the company. There was no hierarchy and no top dogs. Staffers were not motivated by money or self-interest, but all pitched in to create and market the best product possible.

In time, the company not only survived—it thrived. Soon, a larger company with millions of investment dollars came calling. A deal was made, and the company was soon acquired. There were talks of expansion, growth, and even more production. We were all very excited.

Sadly, that's not what happened. With the acquisition came corporate structure and every negative that goes with it. Now there were endless, pointless meetings with inept vice presidents whose jobs were expressly

to do nothing. The former president was long gone, and those left behind scrambled for a better position within the company. It wasn't long before this scrappy, enterprising little establishment became another bloated corporate dinosaur. Nothing could get done because no one dared to make a decision. The employees who once looked out for each other now worked in their own self-interest. In time, I grew disenchanted and walked away. It was just as well, because the company was eventually shut down. A promising enterprise became the victim of its own success.

As I said, the studio I'm referring to no longer exists. However, the twin dangers of complacency and hubris continue to stalk the successful. It would appear that success saps even creativity. Once an artist is no longer hungry, he or she is no longer creative.

Early on, I mentioned Walt Disney and his little experiment over in the Silverlake district of Hollywood. You can't help but get the impression that Walt was always "betting the farm." Every time it appeared that the company could cool its heels and let the money pour in, Walt would be off on another wild and risky adventure. It was almost as though Disney dared not allow himself to become complacent. He had built his business on risk—and he needed to keep it that way. For a guy who started with nothing, it was a pretty audacious plan.

I know it sounds crazy, but I think success is the greatest risk every company faces. Once you've built an enterprise, there's a danger of losing it. Therefore, you tend to hedge your bets. Minimize risks. Do the opposite of everything that made you successful in the first place. When that time comes, a company needs to be more vigilant than ever, lest they end up on the trash heap of business failures.

That initial animation company I mentioned in my introduction is still around today, and a few of the grumbling kids (now a whole lot older) remain employed. However, there's one thing I know they'll admit. All of them are beginning to miss the old days—the good old days when they were still hungry and foolish.

The Price of Success
All too often, it can wreck a truly great company.

Sacked

It's never fun to lose your job. Getting your dismissal papers can be downright traumatic or just plain odd. Let me tell you about the unique way Walt Disney said "bye-bye" to the artists and writers whose ideas failed to impress him. This was a time when there was no Human Resources Department to act as a buffer, and getting sacked was an art in itself.

When we were kids back in the day, it was not unusual to see a number of animation veterans arrive at Walt Disney Studios charged with a task. They were there to develop a new cartoon property for the Old Maestro himself. The artists were usually given office space on the second or third floor of the Animation Building. If you've ever had the opportunity to visit the studio, you'll remember that the writers and story artists worked in large spacious rooms with ample room for storyboards and such.

Sometimes the creators were industry legends such as T. Hee or Robert (Bobe) Cannon and even Chuck Jones. They and many other talented veterans worked on film ideas for the boss that sometimes and sometimes not moved into production. Walt knew that ideas had to be developed and natured to keep his Animation Department chugging along. However, that didn't necessarily

mean that your brilliant idea would move into production. Walt Disney had a way of quickly making up his mind, and should your idea fail to inspire him, you knew pretty quickly the party was over.

Here's how the process worked. An industry professional would move into an upstairs office and would spend the first few days visiting and chatting with old friends and colleagues. Then the pro would knuckle down and get to work creating script pages, storyboards, and character designs. After a few weeks had passed, the presentation would be ready, and a pitch with Walt Disney would be set up.

Because Walt Disney was a busy man, it might have been another two weeks or so before the Old Maestro would have room on his calendar. Eventually, the day would arrive, and Walt's distinctive loud cough could be heard in the hallway. The day of reckoning was at hand, and Walt and a number of "big shots" would gather around a series of storyboards as the creator made his pitch.

An hour or two later, Walt Disney would get up from his chair and thank the artist for all his fine work and quickly exit the room. Did the pitch go well, or was it a bust? Will I continue, or am I sacked? In a few days, the answer would be provided.

Phone calls, visits by production personnel, and maybe even a move to another office was a pretty good indication that your project was being tracked for further development and maybe even production. However, should your phone sit silently on your desk and visitors avoid your office, you might have cause for concern.

Having seen this scenario played out several times, I realized that this was Walt's method of saying goodbye. It was a way of telling the artist or writer that it was time to move on. No junior executive brought the bad news. No envelope with a pink slip was shoved under your door, nor were you ever told to vacate your space. Nope! You continued to receive your paycheck week after week while you sat in your empty office with nothing to do.

You might say, a paycheck is a paycheck—so what's the harm in taking a free ride? Well, men and women have their pride, and sitting in a room with absolutely nothing to do eventually takes its toll. Unable to take it any longer, the artist would gather up his personal belongings, say his goodbyes, and walk out the door to the parking lot. After a number of lonely weeks, the artist has essentially "fired himself."

Finally, there were a few employees whom Walt Disney actually did fire. However, the sacking they received was for indiscretions other than creating a lackluster story. The Old Maestro had little patience with prima

donnas or those who exhibited poor public behavior. Many of the young actors in present-day Disney would have long since been shown the door had Walt been around.

Of course, times have changed, and when I look back on the 1960s, I still feel sorry for that unfired artist or writer. Because he's sitting all alone in his huge office and he's staring at the telephone. The worried writer is waiting for a call from Walt Disney. However, it's a telephone call that sadly will probably never come.

The Crazy Young Kids

Initially, the old veterans were annoyed by the new kids with their fresh approach to color, design, and styling.

You probably already know the story. A group of crazy young guys moves into the establishment and begins to shake things up. The old guard naturally has issues with the "young punks," and they begin to push back. It's a story we've all heard before, and I find it amazing that it never seems to end.

You know the location well. It's the Walt Disney Studios in Burbank, where the Old Maestro, Walt Disney, has been creating animated masterpieces for decades. Disney's creative team was always the cream of the crop, and for years they defined cartoon filmmaking for the rest of the animation universe.

Suddenly, the little creative sanctuary is invaded by a gang of young turks, most of them just out of school and getting their feet wet in the cartoon business. They bring with them radical new ideas and a fresh approach to animated filmmaking. Sure, they maintain respect for the "old school," but now it is a new decade and things are rapidly changing in the fields of painting, architecture, and music. Clearly, it was time that animation saw some changes as well, and this new team of animation artists was determined to lead the way.

As you can imagine, Walt's established veterans were not all that pleased with the kids encroaching on their turf, and I regret to say some even turned on the eager young guys. "Who do they think they are?" grumbled the Disney

old-timers. "We don't need any snot-nosed kids telling us how it's done!" However, the youngsters persisted. They even had the audacity to come in on weekends and quickly turn out storyboards and other development art. Their approach to layout was unique, and the bold color palette suggested by the new background artist puzzled many.

However, not all the Disney veterans were resistant to change. Forward thinkers like Ward Kimball, Tom Oreb, Bill Peet, and Don DaGradi refused to close their minds. They encouraged the young guys and talked them up. They even looked forward to working with them because even though they were new to the business, they still had much to offer. I've always especially admired Ward Kimball for his approach. His unit was a mix of old Disney veterans and eager young kids. Ward was smart enough to know that new ideas and approaches were needed but they had to be built on a solid foundation.

In time, the "new kids" proved their worth, and in no small measure they helped launch a revolution at Disney. Today, they're highly regarded as Disney veterans and masters in their chosen field. Most have profoundly influenced this amazing medium, and I'm proud to have worked with many of them.

Several names are already coming to mind, right? You're thinking of John Lasseter, Brad Bird, Tim Burton, John Musker, and Henry Selick. Sorry, but you'd be wrong. You see, these things happened long before the 1970s. This talented group of "crazy young kids" arrived at the Walt Disney Studios in the 1950s. You can see their influence in many of Walt Disney's midcentury animated shorts and feature films such as "Melody," "Toot Whistle Plunk and Boom," "Paul Bunyan," *Sleeping Beauty*, and *101 Dalmatians*: a brash, bold use of color and design that stood the Disney animation community on its ear.

That's right, boys and girls, the kids I've been talking about include Eyvind Earle, Walt Peregoy, Victor Haboush, Tony Rizzo, Ray Aragon, and a number of other talented artists who upset the status quo. This is something studio managers would do well to remember, should they plan to keep the animation business alive, vital, and out of a creative rut.

Perfect Combination

Best of Both Worlds

It never occurred to me at the moment. I guess I was too busy being enthralled by all the amazing artwork on the walls. Yet there was something different about the animation unit, and it took me a while before I realized what it was. It turns out that the entire unit was unique. It was composed of animation veterans and green young kids beginning their move up the animation ladder. Why is this important, you ask? Read on, and you'll find out why.

The entire second floor space of D-Wing was occupied by Ward Kimball's unit, and they seemed to exist in a world all their own. I do not exaggerate when I say they were probably Disney's most creative and innovative Animation Department. They did things that other animation units would never dare, and they got away with most of it, even though their boss, Walt Disney, was known to be a micromanager. How did this happen, you might wonder? Two things, really. Disney knew that his directing animator, now turned producer, could deliver the goods. Second, the Old Maestro was preoccupied with his theme park and other matters that left him distracted. This meant Ward Kimball could run things his way because a lot of it was being done "under the radar."

However, I digress. I began speaking of the incredible mix of talented individuals Ward Kimball assembled for his "Super Science Unit." And I think the makeup of that unique mix is significant. Veteran writers worked alongside novice storytellers, and young animators worked with masters. Ken O'Connor had worked on *Fantasia*, yet most of his layout team were new to Disney. Conceptual artists such as Con Pederson would go on to work with Stanley Kubrick on *2001: A Space Odyssey*. Such was the makeup of Kimball's artistic team.

It took a guy as insightful as Ward Kimball to see the need for this dynamic in his creative unit. He could have built a team of Disney veterans, but they would be lacking in new approaches and fresh new ideas—ideas that would be invaluable in this bold new adventure that would take Disney and animation to the threshold of space and beyond. However, a team of talented youngsters would not have been a wise choice either, because they would have been lacking the depth and experience of the Disney masters. No, Ward Kimball wisely assembled a team of kids and codgers into a unit that would draw on the best assets of each group of artists. It would be breaking with the restrictions of the past while retaining the solid foundation constructed by the Disney masters.

With his team of young and old, Kimball began by breaking away from the strictures of Disney past and used his creative team to rethink animation and filmmaking in bold new ways. He gave his writers leeway to pioneer fresh approaches to storytelling using scripting, storyboards, and whatever else would serve the storytelling process. Animators were not restricted to their drawing boards but were invited to share in the writing of the film, character design, and even painting their own backgrounds. Disney's tightly structured production process was deconstructed by Kimball as he pushed his creative team to explore fresh new approaches to filmmaking.

Of course, the glue that held these unconventional ideas together was the combination of young and old. Should the veterans lean too heavily on past solutions, the kids would press them to explore new ways of accomplishing a task. And should the kids find themselves in a pinch, they could rely on the wealth of experience provided by the old professionals. Clearly, it was the best of both worlds.

Naturally, the finished film would eventually be screened for the Old Maestro, and the boss was clearly impressed by what he saw on the screen. However, nothing got past Walt Disney, and Kimball caught some serious heat after the screening for pushing things just a little bit too far. The *Disneyland* episode "Mars and Beyond" features a parade of horrifying monsters in one zany sequence. However, Donald Duck makes an unexpected appearance. The audience howled with laughter, but Walt was

not pleased having one of his favorite cartoon characters be the butt of a joke. He read Kimball the Riot Act after the screening, yet Ward's cheeky gag remained in the film. Lest you think this is hearsay or something I read on a geeky blog, let me remind you that I was there.

Ward Kimball's creative unit created some impressive work throughout the 1950s, and it's difficult to believe these innovative films were done so long ago. The impressive list included "Man in Space," Man and the Moon," "Mars and Beyond," and "Magic Highway USA." The films were very successful, and the optical effects and compositing techniques were first-rate and required a brilliant team that could think outside the box. Of course, the clever animation demonstrated that Disney could do a good deal more than the conventional "house style."

Bringing it all together required a team of clever, irreverent young kids and sage, gray-haired old codgers—a pretty odd combination, one might think. Yet this approach generated a creative, innovative powerhouse that enriched the Walt Disney Studios. Just a small thought that one might consider in today's youth-obsessed filmmaking culture.

Endless Development

Getting Things Done Is a Good Thing

I don't suppose
the process could
moue a little faster,
could it?

It's been a personal gripe of mine that animation studios need to display some degree of impatience when it comes to animated filmmaking. This is critical because feature film development burns through goodly sums of money. If you're serious about getting the most from your investment, a little impatience might be in order.

Yep, I know what you're thinking. In recent years, production schedules have contracted, and many find themselves doing nine months' work in six. If you work in television, you've seen what used to be an almost leisurely pace turn into a nightmare of scrambling to meet impossible deadlines. However, we'll leave the discussion of television schedules for another time.

The craziness of television is not my focus here. I'm talking about feature animated film languishing in development hell—the high-profile motion picture that appears to go nowhere while constantly gobbling up huge sums of money. Looking back on my career, I've been involved in more than one of these nightmarish enterprises, and I can't help wonder whether this was a master plan by the powers that be—or simply just incompetent upper management? Take your choice.

First of all, I'm not coming at this with a skewed perspective. I've had the opportunity to see both sides of this serious issue. I've labored in the trenches as a regular worker, and I've pulled the plug on projects while in management. This is something that concerns me as a worker and a manager, so I've no agenda here.

As I'm less than impressed with animation management today, I'll take my examples from the past. Of course, I'm speaking of the Old Maestro, Walt Disney, who launched and shut down a fair number of projects himself. You see, Walt knew that a good idea doesn't necessarily translate into a feature animated film without some work. That work, known as the development process, would in time reveal a potentially great movie ... or a dead end. In the old days, these calls were made by the old man himself, and the decisions were made according to his judgment. Walt appeared to know what would sell and what wouldn't. And more often than not, his instincts proved to be correct.

While working at a small production company some years ago, I had the opportunity to experience the approval process firsthand. There were always a number of terrific ideas that refused to gel into a workable script. Several writers contributed drafts, and story artists worked away to help visualize the movie. It quickly became evident that we didn't have anything, so the project was pulled and we moved on.

I'll admit that like the current administration, I'm pretty darn impatient as well. I've spent endless months in "development hell" on a number of projects, and more often than not, we ended up with nothing. I've worked on shows where the writers, directors, and producers were replaced on a regular basis. And I've completed boards where the finished story bore no resemblance to the one we started.

Over the years, these experiences have taught me three important lessons, and I would have thought they'd be obvious by now. However, I continually notice that nothing about the development process has changed. For what they're worth, here's what I've learned.

- Start with a solid idea. You should know how your story begins and how it ends. If you can't answer these questions, you're simply wasting time and money.
- Limit development time. If your ideas aren't coming together in six months, then six years probably won't make any difference.
- Kill the darn thing and move on. There are dozens of good ideas out there waiting to be developed. It's pointless to get bogged down with one that doesn't work.

There's a long list that includes "The Emperor's Nightingale," "Don Quixote," and "Chanticleer." I've watched Walt Disney pull the plug on more than one idea during my time at the studio. Some of the projects in development were amazing and it broke my heart to see them die.

However, I quickly learned that animation remains a business, and the Old Maestro was not about to squander time and resources on ideas that were going nowhere. A shelved project didn't necessarily mean the movie was dead. There was always a chance the troubled film might be resuscitated at a later date. For instance, Walt Disney kept *Peter Pan* on the shelf for most of the 1940s, but when work on it was resumed and finished in 1953, it became a classic.

I know I'll probably be taken to task for my opinions, but I still contend that a lengthy development time does not necessarily guarantee a great movie. After all, Walt's master story artist Bill Peet adapted, wrote, and storyboarded *101 Dalmatians* in six months. Plus, he pretty much did the whole damn thing by himself.

Finally, I'll admit that keeping a project in development for an extended time does have one positive advantage. Hopefully, you can get the kids in and out of college before the money runs out.

Nothing to Lose

Nothing Like a Fresh
Start

The new film can't be
any worse than the
last one.

If you're a fan of Pixar Animation Studios (as I am), you're probably familiar with the evolution of their first animated feature film effort called *Toy Story*. You see, the motion picture concept that the boys from up north showed Disney back in the 1990s was hardly greeted with warm enthusiasm. As a matter of fact, some Disney executives wanted the movie shut down. Confronted by this dire situation, the Pixar brain trust—which included Joe Ranft, Pete Docter, and Andrew Stanton—decided to regroup and rethink the entire movie. I saw earlier versions of the film, and Woody the Cowboy was hardly an engaging character. Snarky and wise-ass, he just felt wrong. A pile of notes from Disney's executive bosses wasn't helping, so the Pixar story team decided to tell the story their own way. What they eventually came up with was an animated classic that was destined to change animation forever.

The lesson we should learn from this serious situation is that we're often at our most creative when we're backed against the wall—when we, as filmmakers, have totally screwed up and have nothing to lose. Oddly enough, it's times like this when we do our finest work. It provided success for Pixar, and it can provide opportunities for you as well.

Some years ago, when I was a young film producer, our team reluctantly delivered a finished film to one of our valued clients. Let's just say that our

THAT WAS YOUR MOVIE WE JUST SCREENED ?!
BOY ! IT REALLY SUCKED !

BAD MOVIE
We can only go uphill
from here.

motion picture failed to meet expectations, and we were about to be
booted out on our butts. Instead of making excuses, we agreed with our
client's misgivings. We suggested a quick rewrite and reshooting a few
new scenes. The script remained solid, and this was hardly a lost cause.
With a little luck, perhaps we could even save the film. I wouldn't have
blamed the client had he fired us on the spot. Instead, he listened to our
ideas and inquired about how much more time and money it would take to
rework the movie. We asked for a little more cash and a month to turn the
film around. We were going out on a limb, but it was the only limb we had.

When you've already screwed up, you've got nothing to lose. I honestly
think this made our entire team more creative. We scrambled into high gear
and began to rewrite the script. New scenes would have to be reshot, and a
few hundred feet of animation would have to be produced. Plus, all this would
have to be accomplished in under a month's time. I remember meeting for
breakfast at a Hollywood coffee shop on the corner of Sunset and LaBrea,
where new scenes were written over breakfast. We shot on several locations
around town, including the front of Hanna-Barbera's animation facility on
Cahuenga Boulevard. Luckily, they had no idea what we were doing.

Because additional actors would have to be cast, my partner Leo
Sullivan paid a visit to a local Hollywood acting school. Eager for a part in a

movie—any movie that paid real money—the young acting students were immediately on board. However, we managed to fill out our cast with pals from local animation studios in the San Fernando Valley. We had learned one important lesson when it comes to casting: if your "actor" looks the part, you're already halfway there. Animator Bob Maxfield was neither a judge or an actor, but he sure looked like a stuffy, grumpy judge on screen, and that was really all that mattered. Once we put a black suit on Disney animator Bud Hester, he came across as a firm defense attorney. Our courthouse shoot had to be accomplished in one Friday afternoon, and there was nothing in the budget for retakes. Even though we had to go into overtime, our film crew managed to shoot all the pages in that one day.

Because animation sequences had to be produced quickly and cheaply, we bypassed the inking and Xerox process and drew directly on sheets of acetate with grease pencils. We had no choice but to be creative and innovative in order to meet the impossible deadline. Our production process was chaotic yet decisive. We pushed ourselves because we had no recourse. It was make or break. Do or die. And the great part about all this is that we had nothing to lose. The worst had already happened. We had already made a movie that sucked. The only alternative was to actually make a film that was good.

I guess the lesson in all this is to take advantage of failure. It's often the very thing that forces you to be creative. Having once failed, risks don't seem all that big of a deal. You've already blown it, so why not push yourself to do the unthinkable? Why not risk the impossible? Something brilliant just might happen.

In spite of our filmmaking setbacks, we were in good company. Walt Disney's early career was not without its shortcomings and missteps. Mistakes are a part of the process; it's what pushes you to learn. That's how you become a better filmmaker or anything else you want to do in life. Walt often said he embraced failure because that's how he learned his stuff. A number of animated filmmakers have said, "We want to make our mistakes and make them as soon as possible. Once we get our blunders out of the way, we can go on to make a successful movie." This kind of thinking may seem foolhardy, but it's smart. You've got to leap over the cliff or rush into the machine-gun fire. That risk may just eventually lead to success.

Pixar Animation Studios stumbled badly back in the 1990s. Yet they recovered and went back to work with increased resolve. It must have been a time of pressure and pain, but look at the result when they presented the new story reels to Disney and knocked their socks off. Sometimes it appears we're about to lose everything, yet more often than not, that's when we do our best work.

The Wow Factor

31

Impressing the Boss

You had to work
pretty hard if you
planned on wowing
Walt Disney.

I've often been asked this goofy question: "How would you run an animation studio if you were in charge?" Questions like this come from young people who assume that I have answers. The truth is, I'm not in that position, and I don't expect to be. However, I once ran my own business many years ago, and I learned a few things from that experience.

When you run your own business, you gain the equivalent of a Stanford business degree—and I'm not joking when I say this. Those who have taken this wild ride know what I mean, and those who have never tried it don't. There are a few successes out there, but they are few. More often than not, businesses fail, and there are a number of reasons why. Among them are lack of business savvy and being undercapitalized, along with producing and marketing a less-than-stellar product. However, this experience taught me a few things about the road to success, and I'll share one of them with you.

Many years ago, before studios had security guards and electronic gates, we animation artists often visited each other. In those days, animation art was not hidden away but proudly displayed on the studio walls for all to see. Every now and then, we would come across storyboards and development art that would cause everyone in our little group to say, "Wow! Look at that!" I'm talking about

AWESOME PITCH
Pretty impressive stuff ...
too bad the boss didn't
see it.

concepts that caused our jaws to hit the floor. I'm talking about artwork
that inspired awe and inspiration. This is the movie you wanted to work on.
This was the movie you had to work on. I'm talking about the "wow factor."

Some years ago, I received a call from a producer friend of mine. He was
a hard-as-nails Hollywood type who spent most of his day barking orders
on the phone. "You're in animation, right?" he began. "I want you to find me
some animation artists! I want you to find the baddest dudes in town, because
I want stuff that will [his words, not mine] kick ass!" This guy knew what
he wanted, and was willing to pay whatever was necessary. His message
may have been coarse, but it was clear. He wanted to see some "bad-ass"
development art up on the walls, and he wanted stuff that would, as he put it,
blow people away. Once again, we're talking about the wow factor.

These are the lessons I've learned in my many years in the business.
And should the unlikely opportunity be laid at my feet, I know exactly what
I would do. First of all, I would scour the studios and schools for the finest
talent available, whether young or old. Veteran or novice, I would be on
the lookout for the boldest and the baddest talent I could find. I would be
like the obsessive computer boss who called in his finest hardware and
software designers and gave them a task. This was a task that could be
stated in two words: "Astound me."

Much like the crazed computer boss, I would tell them to not look to the past for inspiration. What's been done has been done, so move on. Don't look to your competitors and try to duplicate what they're doing. Imitation is not the sincerest form of flattery. Imitation is pathetic. And, most important of all, don't expect your public to tell you what they want to see, because by the time you finish your movie, they will have moved on and will probably want to see something else.

So, how do you achieve the wow factor? It's very simple—and very scary, but here goes anyway. When there's a choice of following the safe and well-trod path or the dangerous road, choose the dangerous road. When your director is the old, reliable veteran or the studio "crazy man," choose the crazy man. When you're faced with following or breaking the rules, break them. Sure, these choices can land you on your butt if you should fail. But what the heck. You were probably going to fail anyway. However, should you succeed—wow!

There was a guy who exemplified this kind of leadership. He didn't look to others to see what they were doing, and he didn't need focus groups to tell him what would work. Finally, he was willing to commit incredible resources to accomplish his goals even when his financial advisors didn't agree. They all said he was nuts, but he proved that a creative vision was something worth fighting for. So, each time he did something bold and amazing, his audience said, "Wow!"

Not an easy job being a leader, is it? Because in order to achieve the wow factor, a leader must be creative, innovative, and—most of all—fearless. Walt Disney had those qualities, but sadly, he passed away in 1966.

Maybe I'm nuts, but I think the wow factor is still obtainable. We've no shortage of talented young kids eager to show their stuff. Hell, there's no shortage of talented old veterans ready to get back in the game. All we need is a bold dynamic innovator who's ready to lead.

Any takers?

Telling Stories

Storytelling 101

A few sessions with
Walt Disney could
teach you a lot about
storytelling.

Looking back on my school days, I'm reminded of our media room in Santa Barbara Junior High School. This was ordinary space that contained no computers, digital projectors, or elaborate sound equipment. What we had instead were storytellers. They were fascinating men and women who processed a special gift. They could tell a story that totally engaged every person in the room. For an hour, the young students hung on every word and were on the edge of our seats. On occasion, the stories were historical; sometimes they were simply fanciful tales. The characters were real, and the images in our heads were vivid. What was it, I wondered, that made these stories so compelling?

People far more talented than myself have written eloquently on the subject of storytelling in motion pictures. I'm often surprised when people ask for story advice. I've never pretended to be an expert. I remain fascinated and baffled by the storytelling process even though I've been working at it for years.

If I remember correctly, my storytelling began when I created my own comic books as a kid. Because I needed something to draw, I simply made up my own stories. Some were funny animal stories in the tradition of Carl Barks's Donald

Duck adventures, and others were based on the stuff we did as high school kids growing up in Santa Barbara. Stupid yarns to be sure, but what the heck—I was just a kid and simply having fun. In high school, I teamed up with my classmate Bill Tuning. Bill and I sat next to each other in English Literature, and he was an aspiring writer. As Bill had already developed pretty good writing chops, I followed his lead. We collaborated on classroom assignments and even produced a student documentary film. Bill and I worked on *The Forge*, our Santa Barbara High School newspaper, for editor Richard Richards. We gave him the nickname "R2" long before Lucas named his funny little robot. However, I digress.

When we met some 25 years later, I was working in Disney animation's story department and Bill Tuning was still pursuing his writing career. Neither of us had yet figured out the elusive storytelling process, but I wasn't worried. My plan was to become a Disney animator. I had no idea that my animation career would suddenly move in a new direction. Some years later, I accepted a position in the comic strip department of Disney Publishing and worked on several of the famous Disney characters, including Mickey and Donald. I felt embarrassed when given the title of story editor. What did I know about story, I wondered? However, I had my assignment, so I sat down and began to write. I penned several Mickey Mouse Detective stories and I allowed Goofy to take on the role of American historical characters in a number of stories. Plus, getting the irascible Donald Duck in trouble didn't take too much thought. Before long, I had written a dozen or more stories, so I thought I might as well continue. Perhaps, in the process, I might even learn to write.

Expect no profound insights here. What I will do, however, is share a few of the things I've learned while struggling to develop animated films. Below are a series of questions I've often been asked and I've tried to answer. However, keep in mind after fifty plus years this story apprentice is still learning his craft, so all bets are off.

What's the difference between animation and live action?

There's no difference between animation and live action when it comes to crafting a story. Of course, each medium has its own demands, but telling an effective story requires the same storytelling skills. The audience is impressed with the technique for about a minute, then they start to watch the story. Without those necessary elements, the film will fail, regardless of the medium. I've often enjoyed working in live action because the process moves more quickly. Animation tends to move at the speed of a glacier. The late story artist Denis Rich worked on many of the James Bond films as well as *Superman* and *Aliens* in the United Kingdom. We often joked that the advantage of live action is you can make your bad movie faster.

(TOP LEFT) THE STORY PROCESS
Piles of sketches are generated and discarded during the development of an animated feature film.

(BOTTOM LEFT) COMIC STORIES
Comics provided incredible storytelling opportunities. Writing for film can be cool, but I'm sure I learned a good deal more writing for print.

Are there great plot lines?

There are no great plots, just effective ones. A great film can be crafted from a very simple plot line. This was a lesson I learned from the brilliant Don Ferguson, a talented writer in Disney's comic book department. Fergie was a comic genius and one of the few writers who could actually make you laugh out loud. Fergie scolded me for my overly complex plot lines because I simply had too much going on. "You've left no room for character or business. Keep it simple," he advised. I was initially pleased with myself because I had developed this convoluted plot structure. The veteran writer ripped my plot to shreds and in its place I was given a lean narrative that not only worked but also gave me sufficient room to make my story entertaining as well. In story, as in life, sometimes less is more.

How do you create great characters?

Good characters have to live. They have to be believable, especially to the writer and story artist, if they're going to be believable to the audience. How do you create a memorable character? Get to know the character. Having done that, simply "watch" what they do and "listen" to what they say. If you know your character, so will the audience. If you've successfully created a great character, the plot will shape that character. Let the character drive the story. I've found that this approach usually works.

What makes a great animated film?

I'm often asked, "What's a great animated film?" My first thought would be wonderful, timeless stories well told. This would include delightful, memorable characters who are imbued with charm and appeal. And, of course, beautiful art that nourishes the soul. However, an animated film need not be all sweetness and light. Some stories may have dark themes that can be just as compelling. As creator of an animated film, you can make your own rules.

What's the hardest part of making a film?

There is no hard or easy part. You simply continue to do it until you get it right or until the money and time run out. Another lesson learned from Vance Gerry. My job becomes difficult when the director has no clear vision or is unable to articulate that vision. Life is easier when I know what the director expects of me. Tough as he was, Walt Disney was probably the easiest boss I worked for. The answer is obvious. Walt always knew what he wanted and provided a clear sense of the story's direction. Nobody had Disney's unique ability to edit a story.

How do you create a great villain?

Hopefully, you'll give your bad guy depth and dimension. You don't want a cardboard cutout, so strive to make your villain live and sympathize with their point of view. I honestly think you should sometimes like your villain and be ashamed that you do.

Finally, a good writer or storyteller has to trust him or herself. Luckily, I had managed to please Walt Disney back in the 1960s, but once I returned to Feature Animation in the 1990s, I found myself overwhelmed by creative executives enamored of Hollywood storytelling gurus. Taking a class and becoming an award-winning screenwriter seemed to be the norm. Encumbered by a list of storytelling "rules," I found myself a less effective storyteller. Luckily, at Pixar Animation Studios, I felt less restrained by "pages" and felt free to develop ideas much in the way I had for Walt. This is no knock against screenwriters, mind you, because I've worked with some great ones. Sadly, most don't understand the medium and think writing for "cartoons" is a breeze. Obviously, it's much more difficult than it appears, and the smug novice screenwriter is in for a surprise.

In a live-action film, you can put Al Pacino and Robert De Niro at a table in a diner and simply listen to them talk. The scene is brilliant because these talented actors can deliver a nuanced performance. A tilt of the head and the blink of an eye can convey so much information, as well as character. The animation director has to get a performance out of a drawing, and it's a good deal more difficult. Character, warmth, and empathy requires "business" in order to convey those feelings to the audience. However, an animated character must resonate with the audience, and the animator's only key tools are his or her pencil and paper.

In Defense of Mavericks

Wild Ride

Would you prefer a
spirited steed
or a nag?

If you know anything about the Walt Disney Studios, you know that the Old
Maestro exercised total control over his animated kingdom. From the studio's
humble beginnings in the 1930s to his passing in 1966, nothing,—and I do mean
nothing—ever escaped the careful gaze of Walt Disney.

Maybe Walt Disney wasn't the first control freak in history, but he was certainly
worthy of that dubious title. Every story idea, art style, and casting choice in a
Disney motion picture had to go through Walt. When you worked for Walt Disney,
you either became Walt Disney, or you went somewhere else. Your story ideas had
to be acceptable to Walt. Your art styling had to match Disney's artistic sensibility.
The studio was the perfect reflection of its founder.

Knowing these things, would it surprise you to know that the Old Maestro
actually encouraged dissent in the ranks? Would you be shocked to know Walt
Disney allowed his artists and writers to pursue their own vision even though it
might be in total opposition to the accepted Disney style?

To be sure, Walt Disney was an enigma. On one hand, he wanted things done his way, and he was not tolerant of opposition. Having said that, how does one explain the latitude he often gave those who traveled a different path? Some might say he was only giving those "radicals" enough rope to hang themselves so he could be done with them. Such was not the case. The Old Maestro may have ultimately rejected their ideas, but he was perfectly willing to allow those ideas to be pursued.

IT WAS WALT'S STUDIO, AFTER ALL
On occasion, the Old Maestro even allowed dissent in the ranks.

Even in a studio as tightly controlled as Disney's, it would appear that the Old Maestro recognized the need for new, untried ideas to have a platform. So Walt allowed projects that did not reflect his personal vision to continue. If you were to wander the story rooms in the Animation Building in the 1950s and 1960s, you might have been surprised to see what was in development. Walt was no curmudgeon, stuck in the past. He was perfectly willing to take risks with story and art direction if he felt something might be gained from these experiments.

Remember the Ward Kimball space unit in the 1950s? Walt was willing to let Kimball run with his often wacky ideas in this new and unusual Disney department, even though he sometimes seriously objected to what Ward was doing with the Disney characters. What about Nick's commercial unit on the second floor of the Animation Building where the Disney characters were radically stylized for television ads? How many of you remember Tom Oreb's restyling of Mickey Mouse, with squared-off ears? Think the Old Man was unaware of what was going on in his own studio? Think again.

As much as he wanted things his way, Walt Disney recognized that he needed people on his staff who would challenge, disagree with, and go against him in his own Animation Department. This is the stuff that breeds and nourishes creativity and keeps the medium alive and vital. To be sure, there were those who would toe the company line and do exactly what the Old Maestro expected. However, there were also those who chose to move in

I'VE GOT A BRILLIANT IDEA !
SETH MACFARLANE WILL DIRECT
OUR NEXT PRINCESS MOVIE !

A BRILLIANT THOUGHT
A totally dumb idea. Wait
a minute … it just might
work !

a different direction, even though that move might incur the wrath of the Old Man himself. Guys like Ward Kimball, Walt Peregoy, Tom Oreb, and others knew that in order to keep animation alive and thriving, there was a need to move forward—even over the objections of the boss.

Today, I see The Walt Disney Company making some of the same mistakes that were made in the 1970s. Back then, there were artists with strange drawing styles. Some had odd and quirky ideas. There were those who wanted to break new ground with technology. However, these guys just weren't Disney. They simply didn't fit. The talented individuals who failed to conform to the company line were allowed to walk out the door— only to be brought back years later at considerable cost.

Walt Disney Feature Animation has had a name change, and along with that, I think they could use a new attitude. This studio could use a roomful of mavericks and crazy people to challenge the status quo. All too often, the people the studio decides they don't need are the very people they should embrace—the artists who refuse to "play by the rules" and make the movies that are acceptable to the corporate establishment.

Walt Disney was the ultimate control freak who wanted things done his way. Yet even the Old Maestro realized that sometimes the most

important people in the organization are not necessarily the employees who toe the company line and follow the rules. What keeps any studio creatively vital are the mavericks and the crazy people. These are the nut cases who come up with the ideas that don't fit. Keep in mind that these troublemakers will eagerly be snapped up by your competitors, and their goofy ideas will be making money for them—not you.

Get rid of the mavericks if you choose, but be advised that you've also compromised your future.

The Reluctant Partnership

The Standoff

I've watched this battle for decades, and it won't be going away anytime soon.

I couldn't conclude this foray into the wonderful world of animation without a brief discussion of the testy relationship between art and commerce. Of course, this tension has always existed between creative and business departments. Each has its own agenda, and we travel the same path toward different goals. However, we needn't be adversaries, because—like it or not—we need each other.

I learned these valuable lessons when working for my own company many years ago. One of my films was in production and extensive editing was taking place. Lines of dialog and whole scenes were being cut. Naturally, as a filmmaker, I felt like the producers had taken a meat ax to my masterpiece. One morning as we sat looking at our storyboards, another critical line of dialog was excised from the script. This was the last straw, and I shouted angrily and hurled my script at the storyboard. My producer was unmoved by my sudden loss of temper and sat silent until I cooled down. After a few moments, he finally spoke. "I'm sorry you're an artist," he replied. "But I have to deliver a product I can sell."

SINCE I DO NOTHING ALL DAY...
HOW DO I KNOW WHEN I'M DONE ?

THE HOPELESS MANAGER
I often beat up on
managers because I've
been one as well.

I've never forgotten that day and how foolish I must have appeared. Being a young filmmaker, I was filled with indignation because my artistic vision had been compromised. What had totally escaped me was the fact that I was now a part of a business enterprise and that earning income was a priority. This was not a film school project or a contender in an arts festival. We were now commercial filmmakers and—like it or not—our goal was to deliver content that would survive in a very competitive marketplace.

Young filmmakers should be aware that compromise is not just an option—it's a requirement. Although filmmaking is an artistic enterprise, it is also a capitalistic venture that sustains itself through money. The movie business is ideal if it can provide creative management. Good management is essential if the business is to survive. Part of that job is to keep a watchful eye on eccentric filmmakers who, if left unchecked, can bankrupt a company. I've been lucky enough to work with stellar talent throughout my career. Yet these brilliant artists often lacked a grasp on reality and had little concern for budget or schedules. When you're a small company without the resources of a major film company, you learn to work lean and mean out of necessity. The studio should be the antithesis of the dated, baroque Hollywood studio and its filmmaking process. Staying in business means balancing these opposites.

TOUGH MANAGERS GET THE JOB DONE
Beating up on our "mean bosses" has become an animation tradition.

Once an artist leaves school and takes his or her first job, the artist will be doing a good deal more than joining an artistic community—he or she will be part of a business enterprise. This doesn't mean you can't create art and accomplish amazing things. After all, motion picture production is a capitalistic venture that sustains itself as well as provides artistic freedom, because money makes that freedom possible.

Welcome to the animation business. And remember it's called that because it is a business.

Working Without a Net

A High-Wire Act

You won't have the benefit of a net if you're directing an animated feature.

When the new *Mission Impossible* movie finally opened, I couldn't help looking for the screen credit "Directed by Brad Bird." Jumping from the cartoon business to big–time live action with the likes of Tom Cruise has got to be a fairly daunting task. However, I've always considered Brad Bird to be a risk taker, and I remember him saying a creative person has to be willing to "leap off the cliff" if necessary.

In today's less-than-creative environment,it's cool to hear such sentiments expressed so openly. When Brad Bird journeyed to Pixar Animation Studios some years ago to "shake things up," he was new to the company already known as the "hit maker." Instead of playing it safe, the writer/director pushed further and harder and the result was *The Incredibles*—a film that changed the rules and broke new ground—but all this didn't come easily.

I guess that's why I've always been fascinated by risk takers. Others fear failure, but the risk takers are ready to make the jump and land flat on their butts, should fate decree. You're already well aware that this business is full of such people, and this lucky guy has had the good fortune to have worked with some of them.

I would imagine Walt Disney to be the ultimate risk taker—always attempting something new and untried and betting the farm on each venture. Undaunted by naysayers and skeptics, Disney plunged ahead, focused only on his vision. You can be sure there were failures along the way, but such setbacks seemed to only make him stronger. Perhaps Walt had his share of sleepless nights, but no one

OFF THE CLIFF
The director and his crew have to be willing to take a risk.

appeared to notice. Disney always came across as confident and fearless. It's no wonder so many followed his lead.

The lackluster entertainment we experience today is the result of a risk-averse environment. Naturally, media producers want financial success, but they seem to want it all risk-free. This means nervous executives continually micromanage creativity, and you already know where that leads. The breakthrough film, novel, or television show happens only when the artist is allowed to create. The innovator can't be managed, second-guessed, or guided by creative executives. He or she needs to take chances, but more important, to have the freedom to do so. If this is too much pressure for the top-level executives, they're probably in the wrong business. These bosses should have chosen a more mundane career such as selling insurance or manufacturing widgets.

I feel that taking risks is what creativity is all about. It's doing a daring high-wire act not unlike that of the trapeze artists "The Flying Wallendas." This is a job in which failure is public. When you're writing and directing a movie, you're working 12 stories above the ground and you're doing it all without the benefit of a net. Yes, boys and girls, that's the rush and the risk of being an innovator. Clearly, it's a job not for the faint of heart.

Personally, I've always felt that true creativity is somewhat organic in nature. Unpredictable and surprising, it's a process seldom understood. This risky process keeps our work from becoming pedantic and

mundane, and it's something I've applied when working on a writing assignment. Back in the 1980s, I wrote dozens of Disney comic stories. Rather than constrain myself with structure, I kept my writing loose and let the story take me where it wanted to go. Of course, there's always the danger of painting yourself into a corner, but it kept things fresh and exciting for this storyteller. If the story is going to compel the reader, it had darn well better interest the author.

Further, I apply this same technique to my cartoon gags, and I tend to let my drawings decide what the gag should be. While sketching characters on a page, I'll notice a dialog beginning to take place in the drawing, and I decide to see where it leads. In a strange way, I like not knowing where the whole thing is going. I like leaping off the cliff, and I like working without a net.

Bottom line: this is what keeps things fresh and exciting. We work in a business in which the mantra continues to be "do what works." Don't take a risk or try anything not proven to be successful. Companies now "manage risk" because they fear failure. The sad thing is that by fearing failure, they pretty much guarantee they'll eventually fail.

I guess that's why I applaud the fearless people I've had the pleasure of working with over the course of my career. Guys like the Old Maestro, Walt Disney, and the brilliant Apple CEO Steve Jobs. I'll also include young filmmakers like Brad Bird, Brenda Chapman, Chris Sanders, and Dean DeBlois. These artists were willing to defy convention, and their creative passion often broke the rules. In this current atmosphere of pasteurized corporate entertainment in which movies amount to little more than flashy commercials for consumer products, it would be nice to see someone—anyone—with the courage and resolve to willingly leap off the cliff. Of course, there's no guarantee, but I'm willing to bet they soar.

Marketing Animation

The Bold New
Marketing Plan

Sometimes they'll do
whatever it takes to
garner an audience
for their new
animated feature.

Executives need reasons for success or failure. After all, it's all about survival, isn't it? It's how you cover your butt when things go wrong. If you can provide a plausible reason for success or failure, then there's a chance you've kept yourself off the firing line when your movie dies at the box office.

I've often joked about the business of marketing and the people who sell motion pictures. This includes our crazy animation business as well, because making the movie is only half the job. Granted, it's a tough task and not for the faint of heart. I guess that's why we leave the marketing of our movies to the experts. Sometimes I'm not sure that's a good idea, because what makes us think the "experts" have all the answers?

I remember reading about the late Stanley Kubrick and how controlling he could be when it came to his films. Kubrick wanted control over every aspect of his movies, including the marketing. Not a bad idea, if you ask me. Who better to sell a film than the person who conceived it in the first place?

Still, I'm sure I'd catch a lot of flack from marketing people, because they would insist that they—and only they—know best. Of course, these are the same people who are wrong half the time. I can't tell you how many times I've heard marketing people take credit for a film's huge box office opening. Naturally, it

OUR CARTOON FEATURE IS A HUGE HIT !
QUICK ! HIRE SOME MORE EXECUTIVES !

THE HUGE HIT
Your new film is a huge blockbuster. Now who gets the credit for that success?

was because of the brilliant marketing campaign. Should the film open to less than spectacular expectations, you can be sure the filmmakers will be the ones to blame for their unimpressive efforts.

Clearly, I'm no expert in film marketing, and my opinions are just that. However, I do know that if people are unaware of a film's existence, don't expect them to turn up at the box office on opening weekend. After all, how many times have you talked to someone about a great film you saw, only to have the person say they'd never even heard of it. Marketing has to first make people aware of a film. Getting them to actually go see the film is an even tougher challenge.

Some motion pictures—and this includes some pretty good ones—have no marketing budget at all. It's not surprising that such a movie would fair poorly at the box office. However, film studios pour millions into their marketing campaigns and often come up with little to show for it. Film marketing is not an exact science, and though studio executives would love it to be so, there really is no way to guarantee results.

Producing an animated feature film is pretty labor-intensive, and it's an arduous process that often takes years. Do people actually think this all comes down to a marketing campaign? Forgive me if I bluntly say that I don't think so.

Some truly good motion pictures are allowed to die in release because—for one reason or another—the studio decided to give up on the film. Others are given a disingenuous marketing blitz that unfortunately totally misrepresents the motion picture. Sometimes I'm not sure which is worse.

A solid marketing campaign can help a good film reach unexpected heights. However, a real stinker is not going to be saved by tons of marketing dollars. You can hoodwink the public on opening weekend, but the truth will ultimately catch up with you. It spite of this, it would appear that everyone still wants easy answers.

As an old Disney guy, I can remind you of our deep disappointment when *Sleeping Beauty* failed to find an audience back in 1959. However, its failure was not due to a flawed marketing campaign. Nor was *101 Dalmatians'* success due to a brilliant marketing strategy. The public will ultimately choose the film they want to see, and if we're lucky, that film will be ours.

For filmmakers, our obligation is to produce the best motion picture we can. If we've done that, then we've done our job. There's not a whole lot we can do once our film opens on Friday afternoon, except pray.

Still, producers continue to speak about better marketing as if that's the answer to all their problems. It isn't—hasn't been—and never will be.

Racial Politics from a Cartoony Perspective

A Bold New Palette

The cartoon business has always benefited from a diverse palette, both on screen and off.

I've can't help confess my delight at the wonderful Toontown conceit in the Disney motion picture *Who Framed Roger Rabbit*. The special area of Hollywood where tinseltown cartoon characters were segregated was called "Toontown."

I've been given a unique perspective as a cartoonist and person of color. I've always enjoyed mocking human behavior in my gags. Adding racial and ethnic prejudice to this potent mix really helps stir things up. Yet humor has always served an important function when it comes to revealing truth. It's something I've often used as a tool. Although I must confess that I've sometimes used it as a weapon.

Recently, a fellow at the Walt Disney Studios asked me if a comedian's tirade at a local comedy club had offended me. I told him that I felt bad for the comic because his unfortunate rant said more about himself than it did about the hecklers in his audience. After all is said and done, I consider such incidents small potatoes compared to the stuff I've experienced over the years. Most people live in their own little world, and it's difficult to relate to those who might not share their personal experience. Back in the 1950s,

I was continually asked why I made the long drive from Los Angeles to the Walt Disney Studios each day. Why didn't I simply find an apartment in Burbank or nearby Glendale? It never occurred to my friends and colleagues at Disney that it was nearly impossible for a person of color to rent an apartment in Burbank. Today, people find this story incredulous. However, keep in mind that this was the 1950s and years before the Civil Rights Movement of the 1960s. Nearly a decade would pass before most of America would even become aware of racial inequities. On another occasion, I was walking to the Walt Disney Studios on a quiet Burbank street, when a group of school children began to yell and shout. They were just little kids, and I doubt they had full understanding of their offensive behavior. I didn't think that much about the childish outburst. Kids are often guilty of bratty behavior because they're just that—kids. However, this unfortunate incident spoke volumes about their parents.

Like many Disney artists, I put down my drawing pencil to do my duty and serve my country in the armed forces. This was during the 1950s, and the draft still required service to one's country. Although it seems like ancient history now, the incident we were dealing with then was the so-called "Korean Conflict." Eventually, my tour of duty ended, and I returned to the United States after 14 months in Korea. My return home was made even better by a letter I received from the Walt Disney Studios, informing me my old job for was waiting for me upon my return to Burbank.

My flight made a stop in Atlanta, Georgia, where we were invited to deplane before continuing on to Los Angeles. It was in this city that I discovered something most remarkable. I saw a segregated society for the first time in my life. There were signs everywhere designating where one could sit, drink, or use the restroom. Of course, the separation was made based on the color of one's skin.

Here's what I find even more amazing. I had just returned from a foreign nation where I could pretty much go anywhere I chose. Yet here I was in my own country, being restricted to certain areas of the city because of my color. Adding insult to injury, I was wearing the uniform of the United States military. It appears that the freedoms I was fighting for overseas applied to some people—but not to others.

In the 1960s, I was back working at the Walt Disney Studios when Los Angeles came under siege in the infamous Watts Riots. Because the local news teams were terrified of going into an urban battle zone, my partners and I grabbed our film cameras and headed into Los Angeles. And, if you can believe this, one of the cameras used to photograph Los Angeles going up in flames was purchased from none other than Roy Edward Disney. Roy had used his camera to shoot the Disney nature films so popular at the time. I think even Roy Disney would be amazed to know that

his movie camera was photographing another type of True-Life Adventure, only this one could hardly be called "Disney."

After his departure from the Walt Disney Studios, writer Charles Shows published a memoir of his time at the Mouse House entitled "Walt." Because of the lack of African American artists in the animation department, I was referred to as "the lone Negro." I found this description amusing, because either I was the only black artist at Disney or I was some kind of western hero who fought for truth and justice.

Today, much is made over political correctness when it comes to racial matters. Overly sensitive people see racial or ethnic slurs in every image. And in their zeal to sanitize and pasteurize, they've taken all the fun out of cartoon making. I've had the pleasure of speaking with the late Bob Clampett about his 1940s animated cartoon "Coal Black and de Sebben Dwarfs." I've chatted with Ward Kimball concerning his stellar animation of the crows in Walt Disney's "Dumbo." And, lest we forget, many African Americans still love Disney's *Song of the South*. Although some might call these comical images racially insensitive, I merely see them as funny as hell.

My 1950s Disney days were a long time ago, and the world continues to change. Hopefully, we'll be a little smarter this time around, and better decisions will be made because we won't be blinded by fear and prejudice. We live in incredible times—times I could not even have imagined when I sat at my Disney desk back in 1956. A black president in the Oval Office? An African American princess in a Disney motion picture? I can't help but wonder what the old conservative hardheads in 1950s Disney would have thought of all this. I can almost imagine the tops of their heads blowing off and their jaws hitting the floor, Tex Avery style. As in all walks of life, the animation business had its share of bigots and hardheads. Thankfully, they were few in number, and those that harbored such views were wise enough to keep their thoughts to themselves. Progressive by nature, most artists had a low tolerance for such behavior. Prejudice and narrowmindedness would earn you few friends in the cartoon business.

You might be surprised to learn that I've always given the Walt Disney Studios high marks when it comes to diversity. High marks in particular go to Walt Disney, who always judged people by their ability to do the job—and little else about them mattered. Diversity at the Walt Disney Studios began long before the Civil Rights Act of the 1960s. If you remain unconvinced, you can always speak with me, and I'll be happy to tell you about the Walt Disney I knew.

I'll close this little discussion with a story you might find insightful. I've always been encouraged by what I observed in the Old Disney days when the artists chose sides and yelled and shouted at each other all day long. Politically, some of the artists were progressive, and others embraced a more conservative view. After a day of continually railing

A PRINCESS AND A FROG
There was no way I could
haue imagined a black
princess when I began
my career at Disney
back in 1956.

over each other's dumb beliefs, these arch enemies put down their
pencils and brushes and headed out the studio door to enjoy a drink
together. Suddenly, the differences that separated them no longer
mattered, and ultimately they were all good pals. If crazy cartoonists can
understand this simple truth, maybe someday the rest of the world might
understand it as well.

Walt Disney, Steve Jobs, and What Might Have Been

Two Incredible Men

Both very different
and very much alike.

The small group gathered outside the screening room at the Walt Disney Studios. We had arrived early, and the facility was still locked. Having nothing better to do, we simply decided to hang out and talk until the door could be opened. A young man dressed in jeans, sneakers, and a black mock-turtleneck sweater had his foot on the package he brought with him. It was a gift, and a rather expensive gift at that—a laptop computer made by Apple. Hardly a problem for the young man, because he happened to be the CEO of the company that made the laptop. His name was Steve Jobs.

Once seated inside the theater, Jobs decided to engage a couple of late arrivals in a spirited conversation. This was a special screening, and we were there to get a first look at the new animated feature film being produced by Pixar Animation Studios. In front of me and to my right was the Disney vice chairman, Roy Edward Disney, and to my left was animation veteran and Disney legend Joe Grant. Steve Jobs was seated between the two of them, and he happened to be the guy who owned the fledgling animation company.

THE PITCHMAN
Gaunt, yet still energetic
when he pitched the iPad
at its introduction in San
Francisco.

I'm sure Steve Jobs had already read most, if not all, the books on Walt Disney. However, here was the opportunity to speak with two men who actually knew and worked with the Old Maestro himself. We had at least eight minutes or so before the screening would begin, so Steve Jobs took this time to dig as much information as possible out of these two Disney veterans. "Why did Walt Disney do that," he inquired, "and what was the motivation behind that decision?" Each answer only prompted another question, and Jobs probed deeper and deeper. It became clear that he wanted to know everything about Walt Disney and his decision-making process. Plus, he was able to get his answers firsthand from two men who probably knew Disney better than most.

The partnership between The Walt Disney Company and Pixar Animation Studios was no accident. No one knew that better than Steve Jobs. Though this was in the early days of the relationship, it was already apparent these two creative companies would blend their talent and technology to build great products and would thrive in the marketplace. It was all a matter of time. The years that followed were significant, and tremendous value was added to both companies. Pixar Animations Studios

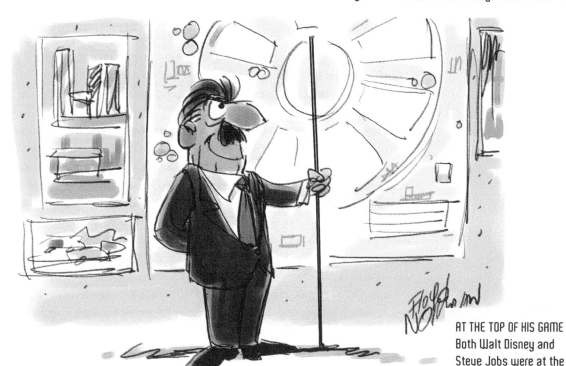

AT THE TOP OF HIS GAME
Both Walt Disney and Steve Jobs were at the top of their game when their lives were cut short. One can only imagine what they might have accomplished next.

wowed the film community by producing a string of hit animated motion pictures, and the Walt Disney Studios continued their expansion in the world of entertainment that included theme parks and cruise ships, as well as other media. Though the partnership sometimes suffered under Disney CEO Michael Eisner's constraints, a truce was finally reached, and Jobs sold his studio to Disney for a fair sum of money. However, the story doesn't end here, and Steve Jobs did not walk away after Disney's acquisition. Steve Jobs took a seat on Disney's board of directors and continued to consult for the company. It was no coincidence that Disney, Pixar, and Apple were beginning to come together. I'm convinced that Steve Jobs had a plan, and that plan was yet to be realized.

In the last year of his life, Walt Disney confided to his son-in-law Ron Miller that he had only one request. Fifteen more years would probably be enough to accomplish the things the Old Maestro had on his mind. Walt seemed convinced that it would take at least that long, and those years were needed to bring his dreams to fruition. Sadly, Walt Disney passed away in December of that same year. We can only wonder what would have been accomplished at The Walt Disney Company had Walt

managed to regain his health. Such was not to be for Disney, nor was it for Steve Jobs. As Apple continued to move toward becoming less of a technology company and more of a consumer entertainment company, I have no doubt that Steve Jobs, much like Walt, had a vision for the future. Clearly, the vision included Apple, Pixar, and even the Walt Disney Studios.

Some people are lucky if they have the opportunity to work with one extraordinary person during their lifetime. I've had the good fortune to work with two such men. Both were complex individuals with the unique ability to identify and connect with the common man—to know people's needs and wants even before they knew it themselves. Both were autocratic leaders who pushed their workers relentlessly, getting them to deliver more than even they could have imagined. How could taskmasters such as Disney and Jobs inspire such loyalty? It would appear that great leaders possess this special quality.

I was told by Disney insiders that the former Apple chairman and CEO attended a meeting here at the Walt Disney Studios only weeks ago. It was fairly well known that Jobs was consulting with Disney, especially in the area of consumer products. I can't help but wonder what else he was up to. As I related earlier, Steve Jobs—much like Jim Henson—was a perfect fit for The Walt Disney Company. Sadly, that was another special relationship cut short, by Henson's unexpected passing. The lesson we've all learned from this is that all men, even great ones—can suddenly be taken away.

Apple and Disney are quintessential American enterprises. Led by visionaries, they created new markets out of nothing but imagination and, in a very real way, invented the future. Walt Disney dreamed of a City of Tomorrow and Steve Jobs devised magical devices that we could hardly have imagined just a few years ago. Both were driven by vision instead of profit, and wise executives would do well to take a few lessons from their playbook.

With the recent loss of Steve Jobs, I can't help but look back on that special screening at the Walt Disney Studios so many years ago. I still remember all the questions Steve asked about Walt Disney, and I remember his insatiable curiosity about the maestro of imagination. What was Steve up to, I wondered. After success with Apple and Pixar, could he possibly have had his sights on another large media company? Perhaps not, but I can't help but wonder what might have happened if he had.

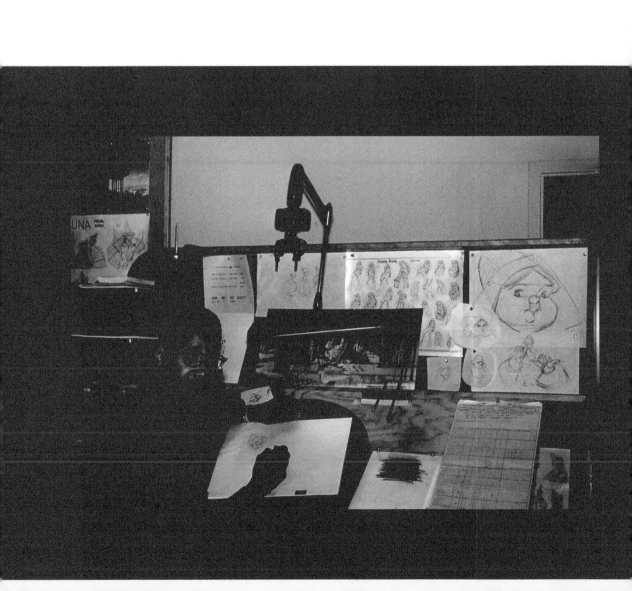

Infinity and Beyond

My First Disney Feature Film

I began this journey more than 50 years ago. The studio has seen many changes, but Walt's magic remains to this day.

I'd like to close this book by considering the old and the new. Much like my old boss Walt Disney, I retain my affection for the past as well as excitement for the future.

I've often been given a hard time by some of my CGI colleagues who view me as either a Luddite or a geezer stuck in the past. I've been characterized as someone who regretted the digital revolution, when in actuality I eagerly encouraged it.

Back in the early 1980s, I confounded my bosses by bringing a computer to work. When I requested a new machine for our department, I was asked the naïve question, "Why would we ever need a computer?" This was Disney's mindset before the company was shaken by the arrival of new management in 1984. A total lack of vision would be an understatement, and Disney management was clueless about this technology, which would one day influence their future and shape the direction of the entire corporation.

In the early 1990s, Disney's fledgling technology team gathered in a Glendale theater to discuss the future. I would venture to guess that I was the only person in the room that wasn't either a tech lead or computer programmer. However, I went further. I attended the meeting when Apple co-founder Steve

Jobs pitched his NeXT computer to Disney, and I invited speakers from an obscure little Northern California company called Pixar. In a bold move that actually got one of our members sacked, we arranged a meeting with then Apple CEO John Scully and Disney boss Michael Eisner.

I doubt many people even knew I was writing the *Mickey Mouse* comic strip on a little Macintosh computer and trying to adapt the early software to do storyboards. This was back in the 1980s, but I had little doubt that we would one day storyboard all of our movies this way. Some of my bosses upstairs actually got the picture and on occasion sent their secretaries downstairs to use my computer. Today, those young executives—Steve Burke and Michael Lynton—run Comcast and Sony.

As much as I love computer technology, I regret the havoc digital production has unleashed on my beloved hand-drawn animation and the promise of its future. Yes, I know that hand-drawn animation is not dead and "old-school" movies are still being produced. But let's get real. How many animated projects on the drawing boards at various studios around town are hand-drawn? Unfortunately, traditional hand-drawn animation has been relegated to a niche craft that is considered quaint or exotic, much like digital prepress and computer typesetting has made letterpress a craft practiced only by aficionados and hobbyists.

AT THE SIGNPOST
More than 50 years later, Walt's magic factory still delights me, and probably always will.

(TOP LEFT) A PROFOUND QUESTION
It's too early in the morning for a question that heavy.

During the heyday of the 1990s, the once-faceless lead animators were beginning to attain celebrity status. Today, even gifted CG animators are essentially invisible, or worse, dispensable. At the risk of offending the many talented CG animators in the business, it is my contention that animating with paper and pencil requires a completely different skill set. That remarkable ability was beginning to flourish during the animation boom of the late 1980s and early 1990s. The animation industry was nurturing a new generation of talented animators who could have easily challenged Disney's finest. The level of drawing ability and performance would have given even the Nine Old Men pause. These kids were good, and they were getting better with each new motion picture. When digital filmmaking forced the downturn in traditional production, most of these incredible artists moved on to other areas of commercial art, while a handful remained, hoping some studio might be in need of their services.

Sure, a number of talented animators have made the jump into CG animation, and more than a few have proven they can be masterful in both. However, this old Disney veteran wouldn't want guys like Andreas Deja or Glen Keane animating on a computer. Call me old-fashioned, but these guys can draw. And let's be honest: will students one day study

virtual frames the way we pore over the sketches of Milt Kahl and Freddy Moore? Will animation eventually produce a group of Digital Nine Old Men? And when all art becomes digital, what exactly will be considered an original?

These are questions I'll let you answer, because animation's future belongs to the young animation artists who will now carry the torch. I began my career in February 1956 in 1-C on the first floor of the Animation Building. I had little idea what the future had in store, but I was at the Walt Disney Studios, and it was clearly the best day of my life. I was given a fairly simple assignment. My task was to sketch a decent inbetween of Donald Duck. However, an animation inbetween was something I had never done before. Luckily, I managed to complete the drawing task, knowing that many more difficult ones would follow. There would be laughs, trials, and even tougher challenges along the way. However, there would be incredible things as well. The D-Wing hallway directory would list my name along with the legendary Nine Old Men, and in time I would attend story meetings with Walt Disney himself. It would appear that my dreams had indeed come true, and fifty years would rush past in what seemed like eight frames. I still remember February 1956 and the journey that began when I first walked through the gates of the Walt Disney Studios. I suppose you could call my experience a wacky modern-day fairy tale or a goofy Disney dream. I call it my animated life, and honestly, I wouldn't have had it any other way.

This may seem odd, but I don't remember ever attending a storyboarding class at the Walt Disney Studios back in the old days. Naturally, by the late 1980s and 1990s, things had changed considerably and young story artists were being tutored by Disney veterans such as Joe Grant, Vance Gerry, Burny Mattinson, and others.

I remember attending several animation sessions with Frank Thomas, Ollie Johnston, and other animators back in the 1950s. There were layout classes with Ken O'Connor as well. However, I honestly can't recall one story class at Disney back in the day. I still find this most unusual since story was so highly regarded at Walt's cartoon factory.

My experience was not unique. Other young story hopefuls moved into story much the same way. Once you were put on production, your apprenticeship began. You literally learned to do your job on the job. Surrounded by veterans, support was plentiful and you earned your chops by working with the best. Your first pitch would be to your director and once he was satisfied, your next pitch would be to Walt.

In a way, it was learning to swim by being tossed into the deep end of the pool. Yet, this "trial by fire" provided the confidence needed to become a Disney story artist. After all these years, I've never attended a storyboarding class and that explains my reluctance to teach story. I'm just not comfortable providing instruction for something that continues to mystify me even to this day. I can, however, pass on some of the things I've learned while doing this crazy job, and the fact that it remains a mystery is what makes it all the more intriguing.

When I arrived at the Walt Disney Studios in the 1950s, many of the old story guys continued to inhabit the coveted story rooms on the second and third floors of the Animation Building. Because there were no restrictions, we eagerly roamed the large and often cluttered offices to see Disney story development firsthand. No one taught story in the old days, and the Old Maestro seemed to know who best fit this rather peculiar profession. For the budding young storyteller, this was a godsend.

Why Do These Storyboards Work So Well?

The first thing I see when I look at old Disney storyboards is how deceptively easy they look. The clear staging, attitude, and composition is always apparent at a glance. What's happening is always clear and the storyboard "reads" immediately.

Good Disney boards have simplicity and charm. They tell the story in an entertaining way. After all, that's our first job—to entertain.

Good storyboards also reveal character—not just what the character is doing. A good board tells us what the character is thinking.

© Disney

What Is Unique about Disney Storyboards?

The ideas presented on the board have been worked and reworked, and time is given for exploration. Other studios usually have one or two passes on a board. At Disney, a board is never done until time or money runs out.

© Disney

Sometimes a single artist might storyboard a sequence. More often than not, a sequence is a mosaic of many ideas from many different story artists.

Apply What You've Learned

I had the opportunity to study the work of old Disney professionals firsthand—guys such as Roy Williams, Ed Penner, Joe Rinaldi, and Bill Peet. I didn't always understand their approach, but I stole from all of them. I had always heard "steal from the best." I tried to apply the many things I learned to my own storyboards.

In time, you'll develop your own ideas and your own style. If you're good enough, people will steal from you.

Tell the Story

© Disney

Be original and clever. What can you bring to this story that is fresh and new? Yeah, I know. It's easier said than done. But now *you're* the storyteller.

© Disney

Develop the Characters

For a lot of people, a Disney movie means appealing characters. If your character can't be adorable, at least make him or her interesting. If the audience doesn't resonate with the character, it doesn't matter what happens in the story.

Springboards for Creativity

Many talented people will pick up where you left off. Animators, directors, designers, and layout artists. It will be your job to inspire them!

© Disney

Entertain!

Don't forget that we're in the entertainment business. Don't bore your audience. Although a good pitch is cool, your performance had better be on the boards.

Learn to Love Rejection

Most of what you do will be thrown away. It's part of the process of developing the story.

Get Used to Tough Criticism

Even the best of Walt's great storytellers got "hammered" by the boss.

Keeping Things Simple

The ideas should be expressed simply. Walt Disney didn't like to be dazzled by fancy artwork. He preferred rough sketches done with a grease pencil or China marker.

There's always room for a variety of story artists, each with different strengths. Some excel at drama, comedy, or action.

The storyteller needs the ability to edit work—not just the storyboard. Find the essence in a single drawing.

© Disney

© Disney

© Disney

Walt Always Focused on Story

With rare exceptions, you'd likely not get a visit from Walt Disney if you worked in animation, layout, or background.

Walt Disney knew that he already had top artists working in his studio. There was really no need to look over their shoulders. However, story was another matter altogether, and he focused in on this department like a laser.

Once the story problems were resolved, the sequence could move into production, and that usually meant smooth sailing until the next screening with Walt. Even as we watched finished color, Walt's concerns were still with the story.

Develop the Ideas

The storyboard is simply a tool for developing an animated motion picture. Developing is key because the storyboard is always in the development stage. Vance Gerry continually reminded me that a storyboard may be abandoned, but it can never be finished.

Preliminary or Investigative Drawings

Avoid the Film Frame

Another note from Vance: the artist should remain free of cinematic restriction and focus on searching for entertainment in the characters or situations.

This approach will free you from trying to create actual scenes or layouts. Concentrate on discovering ideas and situations that can be animated.

The brief sequence in the previous figure is simply a little bit of fun as our main character loses himself in a daydream. It really has little to do with the story, but it provides a little insight concerning our main character; mainly, it's simply a moment of entertainment.

In our many meetings on *The Jungle Book* back in 1966, Walt Disney always looked for entertaining moments in the film story. In the old days this stuff was described as "business," and there was a lot of it in Disney films.

While the story team struggled with plot development, Walt sought out entertaining moments in the story. "You guys worry too much about the story!" he complained to the story crew. "Just give me some good stuff." A simple admonition from Walt Disney that I've never forgotten.

I think I leaned more about writing for film when I wasn't working on one. Back in the 1980s, I took a break from animation and began writing for Disney's publishing department. I was in good company, of course. A score of animation people wrote for print while at Disney.

Anyway, I understand why it takes years to develop a solid screen story, and my mentor, Vance Gerry, explained why story development is a job never completed. But does it really have to take so darn long? Of course, there are advantages. The edge that animated filmmakers have over live action is that we can test and iterate our movie before it moves into production. On the downside, that process often goes on forever.

Oddly enough, one of the things I enjoyed while working for print was that our deadlines were numbered in weeks, not years. That meant as writers, we cranked out dozens of stories every few months. Had I been working on a film, I would have remained on one story for years. Writers learn while writing. It's what makes us better writers. My assignments included scripts, children's stories, comic books, and comic strips. No matter the task—at least I was writing. And, if I was writing, I was learning to become a better writer. I understand the "glamor" component of working on a movie story or screenplay. However, I guarantee that you'll learn a whole lot more working on something else.

Here's a trick I learned from Disney Legend Ward Kimball and his story team back in the 1950s. Everything was wide open when embarking on a new project, so it was much too early to start building a storyboard. The story team instead built a series of boards that included everything related to the project. Multiple items were pinned or sometimes attached to the storyboard. This exercise provided an effective overview of the task at hand. There were photographs and sketches as well as newspaper clippings and magazine articles. Other physical objects were sometimes attached to the storyboard.

Out of this chaotic mess, a rough narrative began to take form, and the story team began building their story. Over time, a rough continuity would be replaced by a more refined narrative that moved its way toward a completed script.

Although this storytelling technique might not be for everyone, I loved the organic nature of Kimball's development process. There was always structure, but things were kept open for fresh ideas and experimentation. Because Ward's space shows dealt with hard scientific facts, the rather technical programs faced the danger of becoming pedantic and boring. Kimball's free and easy storytelling development kept things open, entertaining, and fun.

Story may be king, but characters rule. When Disney's story team complained about the rather lackluster storyline in *The Jungle Book*, we caught the wrath of the boss full force. "You guys worry too much about the story!" Walt fumed. "I'll take care of the story. Just give me some good stuff!"

Even a clueless kid just beginning a story career got his message. Walt wanted more Disney entertainment in the motion picture, and he wasn't seeing it. It became our job to turn things around, and we'd better do it quickly.

© Disney

We were lucky enough to have a stable of delightful and entertaining characters, so we were already good to go. However, some characters proved to be so much fun that the storytellers contrive to bring the characters back "on stage." Such was the case with Kaa the Snake. We gave the crafty Kaa an encore in *The Jungle Book*. Walt Disney liked the sequence so much that he insisted the Sherman Brothers compose a song for Mowgli's second encounter with the wily reptile. As always, Walt's story instincts proved correct.

There are as many ways to approach storyboarding as there are story artists. There's no right or wrong way, and you'll find your own way once you begin the journey. Anyway, here's my brief overview of the storyboarding process.

Script Pages

You've just received your assignment and the script pages. Read them thoroughly and allow the story ideas to sink in.

Discussion

If possible, meet with the director to discuss the sequence. His or her input will prove invaluable once you begin to storyboard.

Dream Time

If time permits, allow your ideas to percolate. I tend to get my best ideas before my pencil or stylus hits the paper. Eventually, I'll begin to "see" the sequence in my head.

Beat Board

Find the main story beats. If possible, build a "beat board" to clarify the key ideas being expressed in the sequence.

Melt Down

Be prepared for trouble if the pages don't work. With the director's approval, you might even be able to rewrite the sequence.

Build a Continuity

Tell your story in a series of sketches. You may be working on paper, although today you're more likely to be working on a Cintiq Tablet.

The Pitch

Next, you'll pitch your sequence to the director and the story team. Take this opportunity to gain valuable feedback from your peers. These ideas will enhance the ideas expressed on the storyboard.

Wash, Rinse, and Repeat

Story development means doing things over, so be prepared for the revisions that will fine-tune your story.

There'll be continual questions, of course. Are your ideas expressed clearly? What's the emotional content of the scene? Does this sequence advance the story?

Welcome aboard.

Story development is an open, dynamic, experimental process for testing ideas. It provides an opportunity to beta-test and iterate your movie before beginning production. I've always found there to be a level of chaos in the story development process. However, that's what makes this amazing job so exciting. You get to resolve the chaos and come up with innovative and surprising ideas.

In this assignment you'll be promoted to screenwriter, story artist, and director, all rolled into one. Okay, begin writing your movie. I'm sure it'll be great, and I can't wait to see it.

Create Your Character

Your character can be a man, woman, fish, or gerbil. Get to know your character, because the better you know them, the more effective your storytelling will be. Your plot will be driven by the character.

Select Your Location

Your location could be Switzerland, Fresno, Pakistan, or Anaheim. This is where your story will take place. Consider a foreign, exotic location or your local neighborhood. It's the stage for your story, and it's your choice.

Tell Your Story

I'm convinced that you already have a brilliant premise, but should you be lacking in story ideas I've included a sample template on the next page.

Okay, here's a rough story template for those unable to come up with story ideas. This is hardly a brilliant story line, but we can't have story artists sitting around doing nothing, can we?

Act One

In Act One, we introduce our hero/heroine by having them...

All is well until his/her world is suddenly interrupted by...

Faced with this challenge, our hero/heroine reluctantly chooses to save the world by...

Aware of what our hero/heroine is trying to accomplish, the evil villain is determined to stop him/her by...

Act Two

Isn't this cool? We've already made it to the second act and we haven't blown our budget or fired our director yet.

The second act of a film is usually the toughest. It's where we develop the ideas introduced in Act One. More often than not, it's where our characters run around in circles and nothing really happens. Should you resort to this cheap trick, at least try and make your "distraction" entertaining.

And that takes us, finally, to Act Three.

Act Three

In the third act, our hero/heroine and villain meet face to face. and in order to save the day our hero/ heroine must...

In a stoke of brilliance and bravado, our hero/heroine...

Because of this heroic action, the world is saved and the king, president, or talk show host rewards our hero/heroine with...

In a cowardly move, the angry villain goes after our unsuspecting hero/heroine and tries to...

However, he is quickly dispatched by our hero/heroine and suffers an ignominious defeat by...(Try to to have him/her fall over a cliff, off a tower. or out of a hot air balloon!)

And with that, our hero/heroine walks away with girl friend, boy friend, or pet gerbil—and with everything resolved, we have our mandatory happy ending.

However, there's one more thing...

Clever Final Twist

You must provide a surprising and unexpected twist to the ending of your story. As our happy couple walk away hand in hand, suddenly they . . .

The End

You've finally completed your assignment, and your movie is ready to move into production. Now you can sit and wait for that invitation to the Golden Globes or the Academy Awards ceremony.

Okay, perhaps this was a pretty lackluster story line. however, consider the cool "business" you might add to make this mundane adventure more entertaining. This was the challenge Walt Disney gave to his story artists when he encouraged us to come up with "business" that would delight the audience. Our work is not always profound, but it should be fun. Never forget that as storytellers, we're first and foremost entertainers.

Index

A

A Bug's Life, 120, 129, 130
Apprentice and master
 animation units, 193
 Kimball, W.
 impressive works, 195
 "Super Science Unit", 194
 team, young and old, 194
 "Mars and Beyond",
 194–195
A Space Odyssey, 10
Assistant animator
 creation, animated film, 23*f*
 Gonzales, R., 25*f*
 job, 24
 "learn to draw", 25
 rough work, finalization, 25*f*
 timing charts, 24
 unique animators
 Davidson, R., 27*f*
 Kahl, M., 27
 Kimball, W., 28–29
 Norman, 28*f*
 Thomas, F., 26
 at work, 24*f*

B

Blumquist, L., cartoon corrections, 15*f*
Bullpen
 animated scene, 13–14
 animation assistants, 13–14
 animation students, 13*f*
 Apodaca, R., 17
 cartoon corrections, 15*f*
 Charvet, J., 15
 Crump, R., 18
 Dagenais, T., 20*f*
 description, 13
 Gonzales, R., 15, 15*f*
 "inbetweens", 13–14
 Jaimes, S., 17
 Leslie, J., 17, 17*f*
 Norman, backlot Zorro set, 14*f*

Bullpen *(Continued)*
 Riek, V., 17
 Shattuck, J., 18*f*
 Sibley, J., 18
 Williams, C., 18*f*
 young artists, 17*f*

C

"Chanticleer", 57–58
Characters development
 appealing, 252
 The Jungle Book, 259
 Kaa the Snake, 259
Cintiq tablet, 262
"Crazy storyboard", 258
Crazy young kids
 animation artists, new team, 189
 forward thinkers, 190
 "new kids", 190
 and old-timers, 189–190

D

101 Dalmatians
 Disney animation, 80
 marketing strategy, 231
 production schedule, 80
 sketch, doggie, 79*f*
 xerox process, 78, 79
Dangers, success
 price, 183*f*
 young artists, Disney
 beginning, 181*f*
 griping, 181
 Nakagawa, Y.S., 182*f*
Development, animated filmmaking
 approval process, 198
 feature animated film, 197
 lessons learnt, 198
 Peet, B., 199
 schedules, 197
 Walt Disney, 198
Digital dinosaurs. *See Dinosaur*
Dinosaur
 budget, 114–115
 CGI, 113
 computer graphics artists and
 engineers, 114–115
 development art, 116*f*
 physical humor, 116
 review, 114

"Rex", 117
 rough sketches, 113*f*, 115*f*
Dismissal
 cartoon property development,
 184–187
 Human Resources Department, 185
 indication, 186
 paycheck, 186
 working, process, 186
Disney, R.E. *See also* Roy's camera,
 16 mm Bolex
 true-life adventure series, 88
Disney storyboards, 251
Disney, W.
 entertaining moments, 256
 focus, story, 254
 rough sketches, 254
 set
 criticisms, 73
 EPCOT presentation, 75
 filming sessions, 75
 front of camera, 73*f*
 hosting, show, 75*f*
 humor, 73–75
 introductions, *Disneyland*
 program, 72–73
 office, 71
 television shows, 71
 unique ability, 242

E

Entertainment business, 253

F

Film frame avoidance, 255
Filming process, 71*f*
Film school
 art center college, 170*f*
 ideas outside, studio, 170
 14-minute film, African American
 writer, 170
 short cartoons, 169–170
 Sullivan, L., 169–170
 USC, 170, 170*f*

G

Gerry, V.
 better visual, 175

not the director, 175
Peet, B. and Disney, W.,
 173–174
storyboarding process, 174
storytelling, 174
at work, 174*f*
Gottfredson, F.
drawing table, 103, 103*f*
Mickey Mouse, comic strip, 97*f*

I

"Inbetweens", 13–14
Inside man
bartender, 158
cartoon factory cleanliness, 158*f*
description, 157
retirement, 159
wise words, 159

J

Jobs, S.
Apple and Disney, 242
iPad introduction, 240*f*
NeXT computer, 245–246
special quality, 242

K

Kahl. M., 27
Kimball, W., 28–29

L

20,000 Leagues Under the Sea,
 43-44
Los Angeles Watts Riot, 1965,
 88–89, 89*f*

M

Marketing animation
bold plan, 229*f*
huge hit, 230*f*
Kubrick, S., 229
motion pictures, 230, 231
Sleeping Beauty, 231
solid marketing campaign, 231

"Mars and Beyond", 194–195
Mary Poppins
Academy Awards, 48
Andrews, J., 43, 44, 48
animation artists, 44*f*
"chalk drawings", 47
choreographers, 46
Ewing, J., 44*f*
Michener, D., 47*f*
musical director, 44
"pencil tests", 46–47
P. L. Travers novels, 44
sodium matte process, 46
"technicolor gloss", 44
Van Dyke, D., 44
Mavericks
artists, strange drawing
 styles, 217
brilliant thought, 217*f*
control freak, 215
risks, story and art direction, 216
wild ride, 215*f*
Mickey Mouse
adventure stories, 101
comic strip, 97*f*
Goofy, 100–101
King Features Syndicate, 101
rough layouts, 101*f*
Miller, R., 73–75
Monster, Bell tower
composers, 109
Hunchback, *Notre Dame*, 105*f*
opening sequence, 110
Quasimodo appearance, 111
"rooftop chase", 111
story board, 110
Monster's Brawl
animated characters, 145*f*
curious Sully, 142*f*
Monsters, Inc., 142
monster sketch, 145*f*
Randall, 142*f*
Ranft, J. and Silverman, D., 145*f*
story boarding, 144
Monsters, Inc.
co-director, 145*f*
description, 142
Oscar nomination, 147
story boarding, 144
Mystery story
animation sessions, 249
apprenticeship, 249
storyboarding class, Walt Disney
 Studios, 249

N

Night school, Disney
 animation master class
 Chouinard Art Institute, Los
 Angeles, 37–39
 course, 37
 Foucher, G., 39f
 Longo, B., 39f
 Meador, J., 39
 O'Connor, K, 39
 pencil animation tests, 39–40
 Stott, H, 40f
 women, 39
 survival, 41
Norman, F. see also Partnership,
 Norman and Sullivan
 animation career, 35
 backlot Zorro set, 14f
 big screen (See The Hunchback
 of Notre Dame)
 comic strip department
 adventure stories, 101
 Connell retirement, 99–100
 "gag a day" concept, 100–101
 rejected gags, 103f
 rough layouts, 101f
 writer, 99
 first animated scene, Disney
 cartoon, 51, 55
 The Jungle book
 C-wing, Animation Building, 59
 Peet, B., 63
 story department, 58, 59
 story lesson, 61
 story team, 61
 meeting
 friends, 123f
 Gottfredson, F., 98
 Howard, C., 99
 Mike and Sully, 146f
 publishing department, editor, 85
 refreshing change, 257
 retirement
 animated assignments, 162f
 animation instructor, 164f
 daily blog, 162
 freelance work, 162
 handprint, Disney legends, 164f
 Hulett, S., 162
 media coverage, 167f
 public speaking, 162
 successive Disney management
 teams, 164
 voted off the island, 162f
 return, animation (see The
 Hunchback of Notre Dame)
 at signpost, 247f
 as story artist, 61f
 Toy Story 2 (see Toy Story 2)
 Walt Disney Studios, arrival, 33

P

Partnership, Norman and Sullivan
 animated films, 92
 Clampett Studio, 91–92
 first meeting, 91
 founders, Vignette Films Inc., 92f
 moviemaking, 95
 NBC, 93–94
 at work, 94f
Pixar Animation Studios
 additional actors, 202–203
 animation sequences, 203
 "brain trust", 129
 campus today, 136f
 elementary school children tour,
 133
 growth and upcoming plans, 127
 Guggenheim, R., 123
 motion picture, rewrite and
 reshooting, 201–202
 Norman, Emeryville, 138f
 partnership, The Walt Disney
 Company, 240–241
 Pixar brain trust, 201
 projection space, 121
 rewriting, script, 202
 storyboarding, 121
 story room and sketches, 123
 Toy Story (see Toy Story)
 visit, 1997, 120–121
 women, 123
 working, 127
Preliminary/investigative drawings,
 255

R

Racial politics
 apartment, Burbank, 233–234
 black princess, 236f
 human behavior, 233
 "Korean Conflict", 234
 old Disney days, 235–236

palette, 233*f*
"Toontown", 233
Watts Riots, 234–235
Reitherman, W., 57–58
Rejection, 253
Reluctant partnership
 art and commerce, 221
 editing, 221
 hopeless manager, 222*f*
 motion picture production, 223
 standoff, 221*f*
 tough managers, 223*f*
 young filmmakers, 222
Risk takers
 cartoon gags, 227
 Disney, W., 225
 fearless people, 227
 high-wire act, 225*f*
 The Incredibles, 225
 off the cliff, 226*f*
Roy's camera, 16 mm Bolex
 Sullivan, L., 88–89
 true-life adventure series, 88
 1965 Watts Riot, 88–89, 89*f*

S

Sleeping Beauty
 Arce, F. and Williams, C., 33*f*
 backgrounds, Eyvind Earle, 7*f*, 9
 Fletcher, J., 32*f*
Spotted puppies. *See 101 Dalmatians*
Springboards, creativity, 252
Stetter, A., 44*f*
Storyboard assignment
 act one, 264
 act three, 265
 act two, 264, 265
 character creation, 263
 end, 266
 location, 263
 story ideas, 263
 unexpected twist, 266
Storyboarding
 beat board, 261
 continuity, 262
 developing idea, 255
 discussion, 260
 dream time, 261
 melt down, 261
 pitch, 262
 script pages, 260
 wash, rinse and repeat, 262

Storyteller, 252
Storytelling
 animated film, 212
 animation and live action, 211
 characters, 212
 comic stories, 211*f*
 comic strip department, 211
 Ferguson, D., 212
 hardest part, film making, 212
 live-action film, 213
 motion pictures, 209
 Pixar Animation Studios, 213
 plot lines, 212
 sessions, Disney, W., 209
 sketches, 211*f*
 Tuning, B., 209–211
 villain creation, 212
Studio custodian. *See* Inside man
"Super Science Unit", 194

T

Technology
 CG animators, 247
 computer, 245, 246
 havoc digital production, 246
 profound question, 247*f*
The Black Cauldron, 83
"The Crazy Frenchman", 15
"The Golden Touch", 40
The Howdy Doody Show, 125
The Hunchback of Notre Dame
 composers, 109
 directors, 108*f*
 Eisner, M., 108–109
 end credits, 111
 Esmeralda's dance number, 111
 opening sequence, 110
 pitching, 108–109
 religious overtones, 109–110
 song sequence, 110
 team, 107*f*, 109*f*
 Trousdale, G., 108
The Jungle Book
 background styling, Peregoy, W., 62
 Baloo the Bear, 58*f*, 63*f*
 composer, Bruns, G., 63, 65
 grease pencils, 61
 Hellmich, F., 63*f*
 Holloway, S., 65
 Mowgli sketch, 65*f*
 Peet, B., 62, 63
 pitching, Gerry, V., 64

The Jungle Book (Continued)
 poster, 66*f*
 Prima, L., 63, 63*f*
 Reitherman, W., 57–58, 63*f*
 screen credits, 67–68
 script writer, Clemmons, L., 59
 sequence pitching, Gerry, U., 61, 61*f*
 Shere Kahn, the tiger, 27, 65*f*
 songwriter, 61
 storyboard, 57–58
 voice
 King Louie, 63
 stork, 65
"The Saga of Windwagon Smith"
 animation assistants, 55
 animation crew, 53, 54
 Captain Smith, color sketch, 54*f*
 evil "coachman", 52
 layout and production design,
 52–53
 Lusk, D., 51
 Nichols, N., 54
 Stevens, 52–53, 52*f*, 53*f*
The sequel, 120, 123
The Sword in the Stone, "touch-up"
 technique, 27
Thomas, F., "straight-ahead"
 style, 26
Tough criticism, 253
Toys, reinventing animation
 "Barbie" sequence, 129, 134
 Bullseye the Horse, 120*f*
 Buzz Lightyear, 130*f*
 Capobianco, J., 131*f*
 cowgirl, voice track, 130–131
 Fulp, D., 133*f*
 The Howdy Doody Show, 125
 Jim and Sanjay, 125*f*
 Lasseter, J., 129–130
 Luhn, M., 123*f*
 meeting
 co-head, 127*f*
 friends, 123*f*
 Mitchroney, K., 125*f*
 Pixar Animation Studios (*see* Pixar
 Animation Studios)
 previsualization, 136–137
 Ranft, J., 119
 Senorita Cactus, 125, 129*f*
 story artists, 119*f*
 storyboard
 multiple, 127*f*
 pitching, 134*f*
 "story jam", 127

 story sketches, 135*f*
 Toy Story, 119
 Toy Story 2 (*see Toy Story 2*)
 "train chase", 131
 T-Rex, mirror reflection, 132*f*
 Woody's Roundup, 125
 working, Barbie, 131*f*
Toy Story 2
 Buzz Lightyear, 130*f*, 133
 off-site meeting, 137
 Rex chasing toy car, 135*f*
 T-Rex, mirror reflection, 132*f*
 voice cast, 132
 Woody and Jessie escape, 137
Transition
 animation renaissance, 85
 backgrounds, animation's second
 floor, 84–85
 Hanson, E., 83
 Stevens, A., 85
 story crew, 84*f*
True-life adventure, 88
Twilight Zone creator, 93

U

University of Southern California
 (USC), 170, 170*f*
USC. *See* University of Southern
 California (USC)

V

Vignette Films, Inc.
 assignment, Shenzhen, 95
 distribution and marketing, 93
 educational films, 92–93
 founders, 92*f*
 setbacks, 94
 Trousdale, G., 93*f*
 Ventura, P., 93*f*

W

Walt Disney Studios. *See also* Bullpen
 animated film, 7
 animation building
 background paintings, 9
 cartoon factory, 158*f*
 D-wing, 177

furniture, 7
hallway, 9
second floor, 9
wing, 9
art directors, 79
backgrounds, animation's second
 floor, 84–85
Burbank, crazy young kids (see
 Crazy young kids)
campus, 7
class, 1956, 10f
101 Dalmatians, 80
hallway, 67f
Ham Luske unit, 9
Howard, C., 99
internal management situation,
 158–159
Iwerks, U., 78
job, 7
Kimball's unit, 10
King Features Syndicate, 101
Lusk, D., 51
moon rocket, 7f
night school (see Night school,
 Disney)
partnership, Pixar Animation
 Studios, 240–241
Pixar colleagues meeting, 123–125
production building, 98
"Reverend Jack" Foster, 10f
Rick and Floyd, 9f
Rick Gonzales, 7f
Sorbus Building, 114–115
television commercials, 10
"touch up", 80
walk of fame and stars of story, 250
wings, 9
Xerox process, 78, 79
Who Framed Roger Rabbit (1988), 110
Wild life
adult themes, 152–153
American pop culture, 151
Baker, H. sketch, 151f

bold cityscape, 149f
color beat board, 151f
costume designer, 153
digital characters, computer
 screens, 151–152
Kitty and Ella, 152f
logo design, 153f
production, 152
Solomon, C., 149–151
storyboard assignments, 151
voice actors, 153
Williams, C.
 Mary Poppins, 44f
 Sleeping Beauty, 33f
Woman's touch, cartoon world
 animation assistants, 179
 Blumquist, L., 179f
 Davidson, R., 177f
 "glass ceiling", 177–178
 Huffine, C., 178f
Wonderland, Southern
 California. *See* Walt Disney Studios
Workers' paradise
 Arce, F. and Williams, C., 33f
 assistant animator, Huffine, C., 34f
 campus and building, 35
 classes and lectures, animation, 34
 "commie-talk", 32–33
 C-wing office, animation building, 31f
 Eigle, B., 35f
 electronics department, 35
 Fletcher, J., 32f
 paternalism, 31
 stamps and mail packages, 34
 strike, 1941, 32–33
Wow factor
 "bad-ass" development art, 206
 bold dynamic innovator, 207
 boldest and baddest talent, 206
 imitation, 207
 impressing boss, 205f
 impressive stuff, 206f
 own business, 205

Printed and bound by CPI Group (UK) Ltd, Croydon, CR0 4YY

22/10/2024

01777637-0002